The Master Book of WEDDING & BRIDAL PHOTOGRAPHY

by J.C. ADAMSON and PIARE MOHAN

Contents

Chapter 1
What Is This Thing Called a Wedding?

What is a wedding? Silly question? Or maybe it's not so silly. A wedding is different things to different people.

As much as anything perhaps, the wedding is theater. It's a production, sometimes modest, often extravagant. There are costumes, sets, decoration, music, oratory. For many, it's the biggest party they'll ever host.

Most of all, and with no doubt, the wedding is for the bride. Mom will cry, Dad may swell with pride, the groom will try to appear calm, friends will celebrate, the minister may pontificate profoundly, and the photographer may create enjoyable art, but this is the bride's day.

The wedding can be a sentimental, emotional event for the bride. Especially in a first marriage, it may also be a great fantasy, a fairy tale production in which she plays the role of the princess. She is the star. Whether the bride is eighteen or thirty-eight, or even older, she may be seeking to fulfill that fantasy. This is a day of glory. Men probably can't fully appreciate the importance of the wedding and its details to the bride. It is a rite of passage. For many brides this may be the moment of adulthood.

The mother of the bride has emotions similar to those of her daughter. The two are on almost the same wavelength. A young bride forms many of her attitudes about the wedding from her mother's attitudes. The mother, for her part, has been there before. She certainly has memories of her own wedding day (or days). She is probably trying to help create for her daughter the splendid day she either remembers or wishes she'd had. She is protector, provider and confidant.

Thoughts From Piare:

My own wedding taught me a lot. Until I went through this marriage thing myself, I had a different way of looking at weddings. I did want to make every bride happy, but I did not quite understand how important the details really are to her. Until I got married, I was seeing from the viewpoint of a man.

I'm even more cautious now to fulfill the needs of the bride, although ninety-nine per cent of my brides were always happy with the weddings I did. In fact, most of the brides I've photographed are like personal friends. Maybe four or five hundred, whenever I run into them, even if I don't recognize them, they make sure I know who they are, and when I photographed them. I recently photographed a bride for her second wedding, sixteen years after the first one.

The groom, on the other hand, may not be so involved with the details of the ceremony. Don't misunderstand: the marriage is vitally important to him, but the wedding itself is often the creation and the dream of the bride. What, then, does the wedding day mean to the groom? The stereotypical view is that he is simply nervous. As with most stereotypes, this one has some truth in it. A young groom may never have participated in such pomp. In part he just wants to get through the day without making an embarrassing mistake. If he's thinking seriously about the commitment he's making, he'll be concerned about the future of his bride and their family to come.

For many young men in our culture, the wedding is in some ways a rite of passage, just as it is for the bride. This may be the only ceremony in his life that acknowledges his manhood. All of this thought and emotion may reside in the groom, but it may not be seen by anyone. Today is the bride's day, and the groom's place is secondary.

The father of the bride may see the wedding ceremony in ways similar to the groom. Even in our age of enlightened gender attitudes, men seem to have an emotional makeup fundamentally different from that of women. The father of the bride may be very emotional when he is actually with his daughter. At other times, he is likely to be more detached from the wedding experience. He either feels less, or he simply withholds his emotions. Probably he is proud of his daughter. Probably he has some real concerns for her future. He probably has some strong and important emotions, but he may very well hold them in check.

For parents of the bride, and often for the bride and groom as well, the wedding is also a financial event. Even a small wedding can cost several thousand dollars. As the event approaches, the expenditures and the emotions surrounding them come into sharp focus. The few days prior to the wedding have probably held some fiscal surprises.

It is probably valuable to realize that the families of the bride and the groom come to the wedding with a wide variety of attitudes, and that their attitudes may be changing quickly. There may be some family members who didn't initially approve of the marriage. They may have thought the couple shouldn't get married, or that they should wait, or they shouldn't have lived together before the wedding. Most people will resolve such feelings, and come around to supporting and encouraging the new couple. Those changes in attitudes may occur before or after the wedding day, or they may be changing during the course of the day. Perhaps ten to fifteen per cent of the time, such negative emotions will still be evident on the day of the wedding. The photographer who is aware of this possible range of attitudes, and is prepared to accept them without judgment, can work most effectively with all the family members.

Thoughts From J. C.: The bride's father has emotions, too.

I recently participated in a very important wedding—that of my own daughter. I had a lot of conflicting emotions. I'd originally hoped she would finish college before she got married. I didn't think she had enough experience in life to make such a monumental decision. And I wasn't quite ready for her to have a different last name.

There is also considerable conflict between her mother and me, although we've been divorced for many years. By the wedding day, though, I only wanted to be with my daughter and support her. I was very proud of her and her new husband. They'd done a terrific job of planning the wedding, and planning the start of their marriage. I felt a lot of love from my daughter, and a lot of love for her. I think I was pretty calm and collected most of the day, but as I walked beside her down the aisle, I glanced over and saw my mother; then I cried.

The groom's family is probably in the shadows at most weddings. This is the bride's day, and her family is in the limelight. The smart photographer will make a conscious effort to involve the groom's family, and give them an appropriate amount of attention. They'll appreciate the involvement, and probably will buy more as a result. After all, they have real and valid emotions about all this, too.

The guests also attend the wedding with a wide range of attitudes. Certainly, many of them are there to support their friends, and share in their joy. They also come to have a good time.

Guests do stay longer and participate more at receptions where food and drink are served. At cake and punch receptions, many guests will skip the reception entirely, or leave early. Probably a few guests come only to be entertained or because of some obligation. Those guests who are very close friends of the bride, groom, or their parents may be quite emotionally involved. It may at times be important for the photographer to recognize the special role of some of the guests.

This discussion has so far ignored a commonplace circumstance that may have great impact on the meaning of the wedding to the various participants. At many weddings, one or both of the families will have been affected by divorce. One or more of the divorced parents may be remarried. The emotional fabric now includes not only a father and mother of the bride and the groom, but

possibly a step-father and step-mother or both. And there may be fireworks, or at least some smoldering vestiges of past explosions. Some of the parties may not want to be photographed together. Some of them may not even be speaking. Even if there are no open hostilities, the memories of divorce will affect the feelings of both parents and children. Sometimes a divorce is recent, and its issues are still being resolved. Other times, years may have passed since a divorced couple have seen each other. A parent of the bride or groom may barely know his or her own child. In such circumstances there may be a variety of unexpected emotions, both positive and negative.

The clergy's view of the wedding is probably unique. Most clergy will be prayerfully working to help begin a lasting marriage. They encourage the couple to work together, with the help of their God, to make the marriage successful. In many cases the clergy will also have some personal relationship with the bride, groom or their families. The minister may have spent a considerable amount of time counseling the couple.

To a rabbi, minister, or priest, this is more than just an hour's work: it's a significant part of his or her vocation. The cleric may be very concerned with the details of ceremony, but is probably also genuinely concerned with the meaning and substance of the wedding event.

Thoughts From Piare: Enjoy the many facets of the wedding.

The wedding, to me is a very sacred, very joyous, and fun occasion. I have the opportunity to meet people who are there, supposedly, in their best mood. It's a fun kind of atmosphere.

It's a time for me to regenerate myself spiritually, no matter what church it is. I personally feel all the churches are the same. God is one. So I am accomplishing so many things while I'm also making money.

I also have the opportunity to be in front of a few hundred people where I can be a professional. Probably some of them will become my customers.

The photographer certainly has a view of the wedding ceremony different from that of other participants. He or she may attend more weddings in a month than most people do in a lifetime. Even a minister may not do as many weddings as a photographer. For the photographer, this is a business and professional opportunity.

There's a distinction to be made between the business and the profession. We'll look briefly at both of them now, and discuss them in depth throughout this book.

The business of wedding photography is about selling a service and making a profit. It is absolutely essential to make a profit if one wishes to continue providing a service. So a photographer at a wedding will be concerned with satisfying the client, meeting new clients, controlling time and costs, and selling. That's business.

The profession of wedding photography is about producing a quality product, and being an effective participant in the wedding event. The professional photographer will work to be creative, to interpret the event artistically, to be helpful to the bride, family and guests. This is the work of the photographer, his or her craft and art. It should be a source of pride and satisfaction.

The wedding has other characteristics for a photographer. It may be a social occasion. A photographer who is building a successful practice will do wedding after wedding within the same circle of people, and will become an acquaintance of many of them, perhaps a close friend of a few. The wedding may also be a spiritual or philosophical experience. It is many things.

Photographers starting out in the business are likely to be more fresh and enthusiastic than those with years of experience. There is some danger of becoming jaded or cynical after putting in a few years behind the camera. A photographer in this situation can't give his or her professional best to the client. It is important for a wedding photographer to maintain a positive attitude, and later in the book we'll discuss some techniques that may be helpful toward that end.

Thoughts from J. C.: You must have fun to do this well.

A wedding is one of the most important events in the life of the client. She deserves to have the day recorded with a spirit that reflects its significance.

In many ways, the wedding is one of the most challenging assignments most of us will ever photograph.

I think it is vital that a wedding photographer enjoy his or her work. I freely confess that I never really enjoyed wedding photography, so in the years that I managed studios I hired photographers to cover our weddings. I always looked for someone who talked about weddings in a spirit of fun.

I also think it is the responsibility of each photographer to keep the work fun for himself or herself. Do as Piare does. Look for and concentrate on the aspects of the experience that are enjoyable. Fun can ease a lot of fatigue. If you're having fun, your work will show it, and your clients will appreciate you more.

The groom also experiences powerful emotions on this momentous day.

To Piare Mohan the wedding is " . . . a very sacred, very joyous and very fun occasion.

What is a wedding? As we've seen, there's no simple answer to that question. Always though, it is the celebration of a life commitment being made by two people. Usually, they invite a photographer to record some of the events and emotions of the day. It is the intended purpose of this book to help photographers accomplish that task skillfully, creatively, profitably, tastefully and with dignity.

4

Chapter 2
A Professional Among Professionals

The Photographer's Role in a Wedding

As one sees the complexity of the wedding event, it soon becomes apparent that the photographer's role isn't simple. Of course, the photographer is hired to chronicle the day, but he or she will do more than take pictures, probably serving as a consultant, surrogate psychologist and friend, as well as an artist and technician.

The person with the camera is a wedding professional. The term, "professional," is not to be taken lightly. It speaks of more than whether a person is paid for performance: it implies high standards of character, spirit and method. A professional is one who is recognized by peers and public alike as adhering to those high standards. In photography, such standards apply to photographic technique, financial deportment, personal behavior, and business ethics. This book will deal throughout with the specifics of photographic professionalism.

At a wedding, the professional with the camera often knows more about weddings than does any other individual present. After a while in practice, a wedding photographer will know by heart the sequence of events in the wedding ceremonies of most denominations. On the day of the wedding, there may be questions to which only the photographer knows the answer.

Much of the photographer's role as a consultant occurs by default. It isn't that no one else knows what's going on, but the photographer may be the only knowledgeable person available at the time of a question or problem. The minister, for example, certainly knows what happens in a wedding, and especially knows the routine for that church. However, the minister may not arrive until a short time before the ceremony and—even if present—will probably not be in the vicinity of last minute preparations. The same may be true of a wedding coordinator. The photographer, however, is there to record the bride's and groom's make- ready, so is also available to answer questions.

There's more. Tears may flow, tempers flare, details be forgotten. The photographer can often help by saying a kind word or making a suggestion. He or she will pin on boutonnieres, tie young men's ties, and fasten hooks. He may even blot an occasional tear.

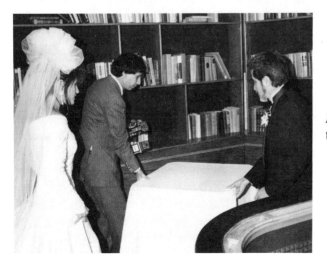

A wedding photographer will do far more on the wedding day than just take pictures.

This book can't possibly prepare a photographer for all eventualities. What it can do is suggest that he or she always be observant and thoughtful. Only experience can teach it all. Later in the book, we'll suggest assisting other photographers as a way to learn about the wedding business. Such experience will certainly be valuable in learning how to be helpful to the bride and her party.

At times, the photographer must direct members of the wedding party, simply in order to get the photography done. By suggesting what they do next, he or she keeps the whole process in motion. Without such direction, the last hour before the wedding could become chaos. Later, at the reception, the bouquet toss might be forgotten until most of the guests are gone, except for the photographer's requesting that it be done for the pictures.

Whether the photographer is invited to help solve a problem, simply steps in when a need is evident, or is compelled by necessity to direct the bride to action, such intervention must be done gracefully and diplomatically. Even though the bride may desperately need a consultant, she didn't hire the photographer for that job. Resentment could easily develop if the photographer appears to be pushy. It is better to suggest than to tell, better to ask whether assistance is needed before plunging in. Moderation is part of the key; sensitivity is the rest. An alert photographer will usually be able to sense whether his aid is being accepted gracefully or grudgingly.

Another caution is in order here. The photographer is hired to take pictures. It is imperative that he or she do that, and do it well. Nothing must interfere with the creation of quality images of the day's events. At times there will be a fine line between rudely ignoring a need for assistance, and professionally tending to the business at hand. Each photographer must develop a set of priorities and a working style that is comfortable and appropriate.

We've already mentioned that the photographer is a sales person on the day of the wedding. Two chapters of this book are devoted to sales, and wedding day selling will be covered in detail. The concept, however, warrants some repetition. The photographer can do a great deal on the wedding day to enhance sales. This is also a wonderful opportunity to showcase the photographer or studio before an audience of potential future clients. Such promotion isn't done with signs and banners. It's done subtly through dignified and professional conduct. At this time, the photographer sells without selling.

What is the photographer's part in the celebration itself? Is he or she to behave as a humble servant, in a non-participatory role? Or should he be one of the crowd, to eat, drink and be merry? Again, there is a gracious middle course to follow, and in this case the best course is probably closer to that of the humble servant.

The first rule: never drink at a wedding. Never. Not even a sip of champagne, not even if the groom is your best friend and bar rail buddy. There are the several reasons for this emphatic proscription. The simplest is that you're charging for your time: you really have no right to be eating or drinking instead of working. If you're invited to eat, and especially if the client insists, it's probably wise to accept graciously. Join in the meal, but drink only coffee or water. In such circumstances it may even be desirable to compensate your client by not charging for an hour of your time.

There is another significant risk in having even a sip of a drink. If a guest sees a photographer drinking, then later sees something out of order, the guest might conclude that the photographer is drunk. Photographers already have an image disadvantage, because they often have cameras or flash equipment slung on their shoulders, pulling their clothing awry. A photographer who is seen sipping wine, then seen with his coat slipping off one shoulder, probably looks drunk. If he then laughs out loud at the joke of a guest, he may be convicted in the minds of some observers.

As a photographer, you should be well dressed and well groomed. Pay attention to the basics. Check your clothing after each wedding for stains, lint, dust, rips, etc. Visit the cleaners often. If you're shooting more than one wedding in a day, it's a good idea to have a fresh shirt or blouse, or even a complete change of clothing in reserve. Each client deserves you at your sweet smelling best.

Your clothing should be conservative, yet stylish. Men should usually wear a suit, rather than a sport coat and slacks, especially for evening weddings. They should always wear a tie, and always keep it snug, with the collar button fastened. (Buy shirts that fit. The collar shouldn't choke you, nor should it look loose.)

A suit is always appropriate for the woman photographer, with darker colors for evening weddings. It might be comfortable to work in less formal attire, but you are a participant, not an observer, at a costumed affair. Dress for it.

There may be exceptions to these rules in the case of outdoor or informal weddings, but proceed carefully. Even though the bride and groom may invite you to dress informally, remember that you are also selling yourself to guests in attendance. It's better to be a little overdressed than underdressed.

John Molloy's book, **Dress For Success**, is probably still the best authority on stylish business attire. If you haven't read it, perhaps you should.

It's essential to be well dressed, but it's not advisable to compete with the attire of the wedding party. A suit is appropriate, but a tuxedo is not in order, unless the wedding is so formal that guests are expected to be in formal wear.

Communication for the Wedding Photographer

Yes, you're a professional. You know thousands, probably millions of things about photography, people, selling and much more. What's in your head, though, isn't too important. What's in your client's head is what's vital. This idea is a key to your success. In later chapters, we'll see it's importance to selling and marketing. It's also vital to successful communication with the bride and groom, families, clergy, and everyone you encounter as a wedding photographer. You must develop an ability to view the wedding from the vantage points of others.

Chapter one revealed something about the various viewpoints. You need to internalize that information. Put yourself in the mind of the bride, groom, guests and clergy. Try to understand how they see the wedding. Learn how they see the events and how they see the photographer and his or her part in it all. Your effort will make for better communication, better photography and better public relations.

The communication challenge begins with the bride and groom and it commences weeks or months before the wedding. The photographer must confer with the bride, and probe for what she really wants, then temper her wishes with the reality of what can be accomplished. Listening is more important than talking, but some judicious questioning is necessary if the photographer is to learn what he needs to know before the wedding. The goals of this communication process are to help the couple make decisions about their wedding photography, and to assure that the photographer understands those decisions.

One major decision is whether photography of the couple together will be done before or after the ceremony. This, of course, includes all the group photographs involving the couple. In recent years, many couples have chosen to have these photos done before the ceremony, even though it requires the couple to be together and see each other before the music begins. The two major reasons favoring this practice are that more time and care can be devoted to these very important photographs, and that it allows the couple to go to their reception and be with their guests immediately after the ceremony.

These two factors work to the couple's advantage, but are even more advantageous to the photographer. By having more time to devote to the work, the photographer can create a better product. He also interferes less in the celebration, thereby making a better impression on the guests. Better work, and a better personal impression are likely to result in greater sales, and more referrals for future business. Everyone wins.

Some couples, however, still prefer to maintain the older tradition, and not be together on the day until they meet at the altar. The wise photographer will tactfully present the case for doing the couple's photos early, then will allow the bride and groom to make the decision they are most

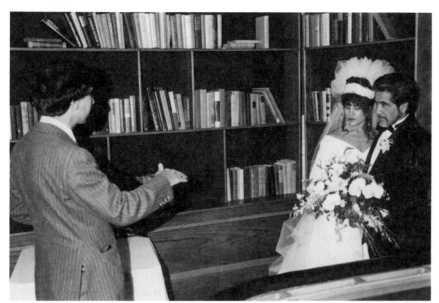

Today many couples choose to have much of the photography done before the wedding.

comfortable with. This is their event. The only correct way to proceed is the way that is right in their minds.

It is quite valuable for the photographer to consult with both the bride and groom before the wedding. The groom may not seem to care about many of the details, or he may simply be overwhelmed by all the energy the bride and her mother are putting into preparations. He may be more comfortable letting the bride do all the planning, but his input is as valuable as hers, and he'll need to know what's scheduled for the day of the event.

Sometimes, the bride's mother or other family members will be involved in pre-wedding photographic planning. While there may be disagreements between the bride and her family about details of the wedding, the photography is usually done as the bride wishes. The photographer can't always hope to please a committee. He needs to listen carefully to everyone's input and work to accommodate as many of their wishes as is practical. (Remember, they all buy photos after the wedding.) In the final analysis, though, the bride is the boss on this job.

A checklist for the bride and groom can be a valuable tool in determining what kind of photographs interest them most. This printed piece lists two hundred or more of the photos that typically may be part of a wedding album. (A sample checklist is included in the appendix at the back of the book.) The bride usually keeps the checklist for several days or weeks, and has the opportunity to discuss it with her mother, friends and family members. She returns it to the photographer, having marked the photos she most wants. The photographer will then discuss the list with her, being sure to cover these points:

1. Be sure that the bride and the photographer understand the same meaning of terms and descriptions on the checklist. For example, does the bride know what a double exposure is?

2. Discuss items where she has asked for the same thing to be done in two different ways. Does she really want them both?

3. Clarify that this is only a guide for the photographer, and that it may not be possible to capture every one of the images she has requested. Point out also that the bride is under no obligation to purchase any particular photo, just because she selected it on the checklist.

4. Suggest that the photographer may photograph some images she has not selected and that she may or may not choose later to purchase them.

5. Be sure the things she has selected are compatible with the time available in the coverage or package she's purchasing. If not, help her edit the list to determine which items are most important, or alternatively guide her to upgrade to a more appropriate coverage.

6. If she has selected far fewer items than will be appropriate for the coverage she's purchasing, get a general idea of the kinds of photos she particularly wants and the mood she'd like her album to convey. This information will guide the photographer in choosing which additional moments to capture on the wedding day.

7. Caution the bride that some events that usually occur near the end of the reception, such as throwing the bouquet and garter may have to be done earlier to include them in the allotted time.

It's helpful to have the bride appoint a family member or friend to assist in setting up the photos. This individual will be someone who knows most of the family and close friends. That person should have a copy of the checklist, and will gather the right people for various photographs. The photographer is thereby relieved of having to keep track of which are the bride's cousins and which the groom's, and whether the bride's great grandmother has been photographed with the groom. This technique is especially useful in large weddings.

Even though the photographer may know the events of a wedding ceremony very well, he or she should always discuss details with the bride and groom. It's important to know in advance about such things as the giving of flowers to the mothers following the vows. Many couples add something unique to their ceremony, and they'll certainly want photos of these special touches. The photographer should never make assumptions about how a ceremony will be done. He should learn the details from the couple.

The bride's wishes can only be achieved if she and the groom are ready to begin the photography on time. Cover this explicitly in pre-wedding discussions. Tell the couple how much time will be needed for various photographic tasks. They don't know: they may never have experienced anything like the kind of photography you'll be doing.

Plan when the photography will begin. That will need to be at least an hour before the ceremony. If most of the work is to be done before the event, you may need two hours or more. The bride doesn't want to be in her gown for hours before the ceremony, but she does want expert photography, and she doesn't want to be rushed. Frank discussion of these points will allow her to make the best decision about the starting time.

Prior to the day of the wedding, the photographer must communicate clearly about policies and procedures. For example, it ought to be communicated that guests and family members should be discouraged from taking pictures at the same time as the professional photographer. This distraction affects expressions and possibly even exposures. Attempting to deal with such an issue on the wedding day is likely to be uncomfortable for all.

In spite of preliminary discussion, a relative with amateur equipment is likely to begin photographing beside the photographer on the wedding day. This is no time for confrontation, and these snapshots won't hurt your sales. In fact, the best approach may be to help Aunt Martha get her pictures. The photographer can diplomatically tell her that attempting to take her pictures at the same time as his may spoil the results of both. The photographer can do each photo, then step aside, let her take her shot, and resume.

The photographer should discuss when flash photographs will and will not be made. The photographer will not want to use flash during the ceremony. The bride may agree fully, and be relieved after hearing of the studio's policy. On the other hand, she may be expecting such photography, and will need to understand why it can't be done, and that beautiful time exposure work will tell that part of her wedding story. If she prefers true-color images of parts of the ceremony, these can be staged before or after the ceremony, and photographed with flash.

The bride's emotions may change as the wedding nears. There's probably no pattern here. One bride who is calm and businesslike at the first meeting, may become rattled and distracted by the time of the last pre- wedding discussion. Another may seem confused and overwhelmed several months before the wedding, but become relaxed and confident as time passes. The photographer shouldn't be surprised by last minute changes of mood or of plans.

Thoughts from Piare: Don't accept every assignment.

Several years ago a couple came to me and said they didn't want any posed pictures at all. Personally, I don't feel that I can create a good album without having that done. I tried to convince them that we should do both, true candids and posed photographs as well. Then, if they wanted to order only the true candids they could still do that. But, they were insistent that they didn't want to spend any time doing posed photos.

I came to the realization that probably I'm not the right photographer for them; I didn't book that wedding. I gave them names of some other photographers, and I had no regrets about losing that wedding. We must be prepared to lose the business where we may not be happy creating the thing we want to create. Photography is not a one way street. It is a combination of the photographer's way of doing things and what the couple wants. If I'm not going to be able to give them what they want it would be a bad idea for both parties if I was their photographer. Communication with the bride and groom will begin two to eighteen months before the wedding. There will usually be at least three contacts with the couple prior to the wedding day. Sometimes the final contact will be by phone, rather than in person.

The first contact may be with the studio's sales receptionist, and the photographer will not be involved. The bride will be given the checklist at this time, and the various coverages or packages will be discussed. The basic working arrangement will be discussed, including the timing of deposits, and subsequent meetings between the couple and the photographer.

It's important to be sure the couple understands what must take place before the photographer can reserve the date, usually that a substantial initial deposit must be paid and an agreement signed. The couple may choose to make that deposit and reserve the date at the first meeting, especially if they are familiar with the photographer through a referral.

At the second contact, the deposit will be paid, and the agreement signed, if these things haven't already been done. The photographer or receptionist will discuss whether the couple will be photographed together before the wedding. The time and place of the wedding events will be confirmed. If the photographer is not present at this second contact, he or she will later contact the couple by phone, or will make an appointment to review the checklist, and discuss the style and mood of coverage the clients want for their day. At this time, the photographer will want to understand both the general and specific wishes of the couple. This contact will usually occur at least two weeks before the event.

The day of the formal bridal portrait, or love portrait, is another opportunity for communication. The sitting itself offers a chance for the bride and the photographer to build rapport. Light discussion of the upcoming event will help establish a mood for the bride, and will enhance her expressions for the portraits. This chatter can also show her that the photographer understands some of her feelings about her wedding. She may leave the formal sitting with more confidence about the photography.

While financial and other details can be discussed on the day of the formal sitting, these matters should probably be left until after the photography is done. Everything that happens before and during the sitting should serve the mood and feeling of the portraits.

The final contact before the event will definitely be between the photographer and the couple. It will often be by phone, and should take place two days before the wedding, or the day before at the very latest. The photographer will review everything that has already been discussed, will ask whether the couple has any additional wishes, and whether any of the plans have changed. He should make notes of any changes on the checklist form. He should confirm the locations and times.

Caution: Assume nothing about location and time. Two nearby towns may have streets with the same name. Imagine discovering an hour before the ceremony that you're supposed to be in a town that's ninety minutes away.

By the time the photographer greets the bride on the wedding day, all the details have been settled. His conversation with her will begin, "Hi, you look beautiful. I know today's going to be fun!"

Thoughts from Piare: Advise the bride not to work on her wedding day.

I tell all the brides when they come to see me the week before the wedding, "Depute (appoint) other people to take care of all the details. You are the queen of the day. You shouldn't be doing any work now. Get others to carry this load. Let the bridesmaids and your other friends do the things you were planning to do yourself." This is in fact how it should be because, emotionally, the bride is so much attached to the situation, that any little thing that goes wrong will upset her. I tell her this is a day to enjoy.

Thoughts from J. C.: You can help the bride with details.

While I didn't personally photograph many weddings in my career, I often created the formal bridal portrait. This was an opportunity to talk with the bride about the wedding. As I adjusted the veil and headpiece, I usually advised her about how they should be attached for the ceremony.

I'd heard from brides that the veil may feel like it's about to fall off as she's walking down the aisle. I could imagine how disconcerting that must be. So I told my brides to be sure the veil and head piece are well secured, and not to worry about whether a hairpin might show.

(Actually, I jokingly told them to nail the head piece in place. It got my point across.) I like to think I made the walk down the aisle more enjoyable for a bride or two.

While all the planning has been done days and weeks before the wedding, there will still be a lot of communication on the wedding day. On that day, the photographer will be a director. He or she may get a lot of help from the wedding coordinator, or from a family member appointed to help, but it is the photographer's responsibility to get all the right people in the right places at the right times.

Beyond these logistics, though, the photographer is responsible for expressions. A hundred or more times during the day, he must direct people into place, pose them, then time their expressions for the exact instant the shutter will open. Good communication is essential here. The photographer should always be mindful of the variety of emotions people are experiencing. He must treat everyone with respect and honor, and must always be pleasant and courteous. If the photographer is having fun, it will be relatively easy to communicate positively with all the subjects.

At the reception, the photographer will have some idle time. While the reception may last several hours, there are fewer photographs made than earlier in the day. Here's a chance for the photographer to chat amicably with guests and family. While maintaining a sharp eye for photo opportunities, he can still engage in friendly onversation. By being a little gregarious, he or she will have more fun, make a better impression on people, and get better pictures. The work of the day has first priority, though; if a chatty guest begins to be a bit burdensome, the photographer can politely excuse himself, and attend to business.

The photographer will also be communicating with other professionals before and during a wedding. There may be little need to actually work with a caterer or florist, but it's advisable to be aware of these service providers. It never hurts to build a professional relationship. As we'll see in the chapter on promotion, these people can be quite important to the growth of your business.

It's useful for the photographer to chat with the disc jockey or orchestra leader if that person is serving as master of ceremonies at the reception. The M. C. will need to know if events such as the bouquet toss have to be done at a certain time to accommodate photography. The M. C. may also have a schedule for such things as the toast and cake cutting, and can provide information that will help the photographer budget time and film.

12

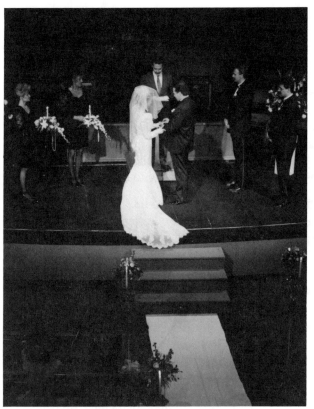

Good communication with the clergy will assure a good working relationship.

All photos made during the ceremony are done without flash and from the back of the sanctuary.

It's essential to talk with the clergy person and the church's wedding coordinator before beginning the day's photography. It's simply a matter of professional courtesy to introduce yourself to them at your first opportunity. More important, though, you'll want to learn of any policies or restrictions that will affect your photography. Some ministers may not want photographers to use certain areas of the church. Most of them don't want flash photography during the ceremony. You don't want to use flash at that time either, but talking about it beforehand will reassure the clergy person.

When talking with the minister, inquire about any unique aspects of the ceremony. You may want to ask how the ceremony will end, so you'll know when to be ready to photograph the recessional. Always honor the wishes of clergy or wedding coordinators. You will probably work often with them, and a cordial relationship will be to your benefit. Your day will go smoother when you're working with someone who has learned to like and respect you. These are professional contacts who can also provide you with referrals to future business.

The minister or coordinator can even be helpful to you while you're working. Some coordinators enjoy assisting during the photography with details such as the bride's train. Ministers, and coordinators too, are usually charitable types, who like to help others. They see a lot of weddings, and a lot of photographers, so they often have a good eye for detail. If they want to help, don't be afraid to use them.

Thoughts from Piare: Clergy can be helpful.

At the first wedding I ever did, the minister did nearly everything for me, but I was very frank and open with him. The studio I was working for as a retoucher had a photographer injured in an automobile accident, while returning from an out of town studio. He was booked for a wedding that night, and no other photographers were free to cover for him.

The president of the company called me an hour before the wedding; he told me the photographer had an accident, "and we have nobody. Have you ever done a wedding?" I told him frankly, "I have seen weddings going through the lab, so I know what's going on, but I've never worked at a wedding in the church." (I had been in the United States less than two months.)

He said, "Do you want to give it a try?"

I said, "Most definitely." So, I went there, opened my heart completely. "This is the situation," I told the minister, "Photography is not the problem, but I know nothing about what goes on, how to conduct myself."

The minister was very kind. After that, for the next couple of weddings, I had the ministers help me, and they were so gracious in helping me do the posing and everything else. I think it's a great idea for any young photographer to ask for help from the clergy. They are very sympathetic people. That is their nature. They are willing to help.

A Schedule For The Day

This book has a chapter each on the topics of lighting, posing, and photographic technique for the wedding. Just as important, however, are the photographic logistics of the day. If the photographer isn't confidently in command of time, it can command him.

Let's say a wedding begins at 11:00 AM. If your agreement calls for you to be there at 10:00, you want to be at least fifteen minutes early, at 9:45. This gives the bride confidence. She's worrying about what seem to be a thousand details of the day, and you're probably connected with a third of them. If you arrive early, calm, professional, and well prepared, she'll get some peace of mind about everything related to the photography. That extra fifteen minutes in your plan will also serve you well if you have trouble finding the location. Think of it as time for getting lost.

Your work, though, starts long before you get in the car to drive to the wedding. You'll do a number of things the day before. Check or charge all your batteries. Check your film inventory. Check any expendable supplies you may use. (Some photographers carry things like hair spray and safety pins that come in handy during the day.) If you haven't already had your last moment talk with the bride, call her and confirm everything. Be sure you have the address. Unless you know the location well, ask for directions.

Before leaving for the wedding, do an equipment check. Check flash synchronization with each camera, each lens, and each flash you might use on that lens. That may seem redundant, but it can be useful. When you check synchronization you are also simultaneously checking shutter operation, synch cords, connections, and the flash itself. By checking each flash with each camera you will use all the synch cords on all the connections, and may reveal a problem you wouldn't otherwise have found.

If you're using a single-lens reflex camera, you may not know that your flash is failing to fire during the wedding. The mirror is up when the flash fires, and you see nothing through the camera. You could change lenses or flashes while working, and easily take several exposures before noticing that you don't have flash. At best that wastes time. At worst it causes you to miss irreplaceable moments of the day.

Checking synchronization is easy: before loading film in the camera, connect the shutter, cords and flash equipment being tested. Turn on the flash. Open the back of the camera. Look at the shutter or lens in such a way that you'll be able to see through the lens when the shutter opens. Trip the shutter. You should see a bright flash of light through the lens. If you do, you have synch. If you don't, you have a problem, and should first check all cords and connections in an attempt to solve it. Incidentally, it's also good to stop and check synchronization whenever you can during the day, when loading film for example.

If you have photographed hundreds of weddings, you may not need an equipment checklist. If you're less experienced, you should consult such a checklist before the wedding, to be sure

you're packing everything you need. On this list will be all cameras, flashes, cords, filters, accessories, film, supplies, etc. There is a sample equipment checklist in the appendix of this book.

You may arrive at the church ahead of the wedding party. Use this time to load film, assemble equipment, and re-check synchronization. Tour the sanctuary and grounds for shooting locations. Look for picturesque scenes such as shadowed archways, carved doors, or graceful old trees that can add to your photos.

Also plan where you'll work during the ceremony. You'll need to find places where you have a clear view of the altar, but will be unseen by the guests. Most often this will have to be from the back of the church, or from a balcony. In some churches there may be fully hidden areas in the wings of the altar. You can only use them, of course, if you can get there during the ceremony, and exit without being seen by guests.

This is also a good time to talk with the wedding coordinator or clergy person. If the bride is dressing, send her a message, telling her that you've arrived, where you are waiting, and that she should send for you as soon as she's ready for the first pictures.

You'll usually do the bride's make-ready photos first. These are the bride and attendants, penny in the shoe, putting on the garter, etc. The groom's make-ready is next, with such traditional photos as the best man adjusting the groom's tie, etc. During this time keep an eye open for true candid opportunities. A tender moment between the bride and her dad, or a cute instance with a small child will add immensely to the feeling of the album.

Now, you'll move into the sanctuary for group photos of the bride, then the groom, with their families, attendants, etc. If the bride and groom do not want to see each other before the ceremony, you'll necessarily do this in two sessions. Be sure to give the groom and his family the same degree of attention as the bride and her family.

If you're photographing the bride and groom together before the ceremony, it's now time for that work. It includes such things as candle lighting and ring photos, as well as group photos that involve the couple, and formal poses of the two of them. If the bride has requested double exposures, you should record the first images for several of these on your backup camera.

Thoughts from J. C.: Offer the bride and groom a special moment.

It's been at least twenty years since photographers started bringing the bride and groom together before the ceremony. There are many reasons why it's a good idea, but some couples are still reluctant to do it. One reason is that it takes away the magic moment when the two lovers see each other at opposite ends of the aisle. Actually, some couples have told us after their weddings that they don't even remember that moment, or other parts of the ceremony. Well, whether that first vision is an instant of enchantment or part of a confusing blur, here's an idea that may substitute nicely for it.

Pre-arrange the time when they'll first see each other that day. It can be in the sanctuary, or perhaps in a small chapel or study in the church. They should both be attired for the pictures that will soon be made. Perhaps the groom should be there first, waiting, so the bride can make an entrance. Let them be alone for a brief time. Perhaps the bridesmaid can arrange ahead of time for a cassette tape of the couple's favorite music to be playing softly in the background.

The photographer doesn't have to be there. If present at all, he or she should stay distant, and if photographing the moment, should not intrude with flash. This should be their time. With a little planning, and just a few moments set aside, it can be every bit as romantic as the bride's entrance into the ceremony. I get a tear in my eye just writing about it!

Later, when the music begins, and the bride starts down the aisle, there'll be plenty of excitement to make that a memorable moment, too.

You'll want to have the bride out of the sanctuary before guests arrive, and you'll want to be finished with all the preliminary photography about fifteen minutes before the ceremony. This gives the bride time to freshen up, and compose herself for the ceremony. It also lets you prepare your equipment. It's okay for the bride to be late for her own ceremony, but it's absolutely not allowable for the photographer to be tardy. You should be waiting inconspicuously at the front of the church, several minutes before the procession starts. In most churches, you'll want to take a seat in the fourth or fifth row, on the aisle, where you can see the back of the church. It's a good idea, when guests first begin arriving, to ask one of the guests or an usher to save you a spot.

When the procession begins, you'll photograph each of the arrivals with flash. After all the principals are at the front of the sanctuary, unplug your synch cord, so the flash won't fire as you do time exposures during the ceremony.

This is where you must know the sequence of events, in order to get everything you're expected to record, and be prepared to resume flash photography at the front of the church after the vows. You'll do time exposures of the key parts of the ceremony, shooting from places where you are completely out of sight of the guests. These are the locations you scouted out earlier in the day. You'll also get the second part of double exposures, by time exposure from the back of the church, and perhaps from outside the church. You can record other scenes that you'll later double with images of the bride and groom at the reception.

Don't be seen, not even as you move from place to place, and don't be heard. This is a sacred moment and it is the starring moment for the bride and groom. Even if they don't mind your intrusion, you don't want to be a distraction for guests. Any part of the vows that can't be photographed unobtrusively should be staged for photographs before or after the ceremony.

In the case of very small weddings, with only family members present, there may be exceptions to this no-intrusion rule. These ceremonies often take place in small chapels, courtrooms or homes. It's not always possible to stay out of sight as you work during the ceremony. Discuss such circumstances with the couple in advance, and proceed as they wish.

The ceremony typically ends with the kiss, and the sacred gives way to the festive. Amidst the loud music of the recession and the beaming smiles of the couple, no one will mind seeing

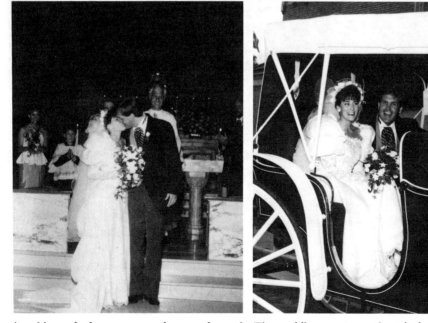

As a kiss ends the ceremony, the sacred mood becomes festive and your flash photography is resumed.

The wedding events are theatrical pomp. The photographer records that spirit.

your flash. In fact, it probably adds to the excitement. You'll need to be at the front of the church for photos of the couple giving bouquets to the mothers. At almost the same instant, you'll have to be back down the aisle for the recession.

If there is a receiving line after the ceremony, you'll need just two or three photos, probably with parents or grandparents. Often the line is done at the reception, or it may not be done at all. Many couples prefer to visit all the guests at their tables, during the reception.

If the group and couple photos were not done before the ceremony, do them now. This may also be the time to photograph the signing of the certificate, the second half of double exposures, and anything you haven't done that requires the church location. Work carefully, but quickly. Use no more than half an hour for all the photography at the church after the ceremony, even if you're doing the groups then. At your first one or two weddings, you may need a little more time, but keep it as brief as possible. The guests don't know the bride requested this work, and they'll be getting impatient. If the bride and groom are too long getting to the reception, some guests may already be gone. Don't put yourself in the position of preventing the bride from enjoying any moment of her day.

Of course, you'll record the couple leaving the church, and entering their car or limousine. This only takes a few minutes, and you'll just need a few seconds at a time to direct. You're primarily recording these events as they happen. By now the couple will be very conscious of the photographer and will expect some direction.

Continually look for the things on which the couple or families may have spent a lot of money, even if the bride didn't check them on her list. If they spent a bundle on a limo and red carpet for example, they'll probably buy photos of that. Don't limit yourself to a three-quarter length photo that doesn't show the carpet. Remember, this is theatre.

You'll probably get to the reception ahead of the couple. If so, photograph their arrival. Do any staged photos you may have been missed earlier, such as people who arrived late or who were working on last minute details. You can still do the second image of a double exposure.

Capture the carefree mood of family and guests at the reception.

It's easy to overshoot at the reception, so concentrate on things important to the couple.

You'll usually do most of the true candids at the reception. It's party time. People are joyous and carefree. There'll be lots of fun moments and good expressions. The small children get to let out some of their bottled up energy and this will give you good opportunities for images.

There's a caution in order here, though. The reception may take half to two-thirds of your time at a wedding, but will amount to only twenty-five per cent or less of the photo album. Budget your photography. It's easy to overshoot, because you've been rushing and shooting fast for an hour or two. There are lots of scenes to record at the reception, but you'll sell very few of them. Concentrate on the essentials, look for the unique, and get a few photos that capture the mood.

As the end of the contracted time nears, do any unfinished photography, such as the throwing of the bouquet and garter. It may be necessary to tactfully remind the bride and groom of these things. Review the checklist, looking for anything undone. Bid farewell to the bride and groom. Wish them a joyous honeymoon. Remind them that proofs will be ready when they return. Also say good-bye to parents, and to any guests you've spoken with who happen to be nearby, especially to anyone you've learned will be getting married in the near future

Before leaving, inventory your equipment, film, etc., to be sure you've left nothing. In the car, take a deep breath and relax for just a minute, before you drive to your next wedding!

17

As your departure time approaches, you may need to remind the couple to proceed with final events.

There is a time during the reception for the photographer to chat amicably with the couple, family and guests. Future weddings will result from this time.

Chapter 3
Getting Started With Weddings

Prepare Yourself

Presenting one's self as a wedding photographer is serious business. A wedding photographer has a great deal of responsibility. We've seen something of the importance of the wedding in the lives of the participants. Imagine the feelings of the bride who returns from her honeymoon to learn that there are no photographs of her wedding. She would be devastated.

Her first thoughts would probably involve a tortured death for the photographer. After a few hours, she's only thinking of a six figure lawsuit. By the time she's read her contract with the studio and learned that she can't collect damages, her plans may move again in the direction of murder.

Ultimately, her most dangerous weapon will be simply to tell all her friends of the disaster. That's bad enough as she may be able to ruin the reputation of the studio or photographer.

Apart from lawsuits and bad publicity, the injury to the bride is inexcusable. A physician is expected first of all to do no harm. The same moral imperative applies to a photographer. Damaged photographs don't cause loss of life, but the ill feelings they can cause is of major consequence.

Photographing a wedding is a serious responsibility. The client needs and deserves your very best. You must be prepared to provide it.

A lot of bad feeling can be generated by the loss of just a few images, even when the inept, or simply unlucky, photographer doesn't ruin an entire wedding. If the bride's aged great-grandmother has traveled thousands of miles for the wedding, and may never visit again, the bride will highly value photographs of the family matron. If photos are made, then lost, of a widely scattered family, together for the only time in a decade, all of that family will feel the loss. Photographs of this kind are valuable when created, but even more, they appreciate in value with each passing year, as people are separated by the ravages of time.

No laws or certification boards prevent an unscrupulous or poorly trained person from walking into a church with a camera and hurting people by doing poor wedding photography. The only protections are the judgment of the client, and the ethics of the photographer. This book can't do much for the former, but perhaps it can help with the latter.

Before you assume the responsibility of doing weddings, there should be some prerequisites. Prior to working solo, you should at least have:

1. A sound knowledge of photographic equipment and technique.

2. Two or more sets of good quality camera and lighting equipment.

3. A familiarity with the kind of wedding ceremony being conducted.

4. A background of assisting in enough weddings to have acquired confidence and competence.

A familiarity with photography isn't enough. Even a familiarity with weddings isn't enough. A wedding photographer, even one new to the business, must be able to work rapidly, skillfully and creatively under difficult conditions. There is significant confusion and pressure of time at a wedding. Equipment will fail. People will be late, will be emotional, will be ill, will be handicapped, will not follow instructions. You must be able to deliver quality images, not valid excuses. As a professional, you must be able to do the job, in spite of equipment problems, time problems, people problems, any and all problems.

This book isn't a primer on photography. If you're reading this with the intention of becoming a wedding photographer, the authors assume that you already:

1. Know your equipment well enough that its operation is second nature.

2. Know the basics of photography quite well, including composition, exposure, films, and light sources. You don't need to be a lab technician, but you do need to know how to buy the services of a lab.

Apprenticeship and Assisting

Assuming that you have these prerequisites, the next step is probably to get some apprenticeship experience. Do this by asking practicing photographers to allow you to assist them at weddings.

The best photographers in your area will be easy to find. Certainly, they'll be listed in the yellow pages. Your camera store will know who they are. Your lab will know. Some of your friends will be able to tell you who did their weddings. Ask around, and one or more names will pop up repeatedly. Start with those names.

Call for an appointment. Tell them what you want to do, and tell them you'd like to come to their place of business, meet them, and show them your work. Be clear in saying that you're not looking for a job, but that you want to assist.

When you go to the appointment, dress as you would for a wedding. That alone will tell the photographer that you're serious, and that you're not likely to be an embarrassment. Don't try to impress the photographer with how much you know, or how good you are. Look up the words "modest" and "humble" in a good dictionary before you go. Tell this person that you want to learn, and to gain experience, and that you're willing to be of service in exchange for the opportunity. Answer questions honestly and show your work without explanation or apology.

After the appointment, write a thank you note, thanking the interviewer for his or her time, and tell him (if it's true) that you are eager to work with him.

If the first photographer you approach isn't willing to use you, call on another, and another. Depending on the number of photographers in your area, the amount of business they have, and the number of other people looking for apprenticeships, you may have to talk to several.

It is usually a good idea to apprentice with more than one photographer before going out on your own. Some will be better photographers than others, and some will be better teachers. They'll also have different styles. They will probably do different kinds of weddings: one may do mostly Catholic or Jewish ceremonies, while another may specialize in lower cost packages, etc.

They may have different comfort levels in the amount of the photography they'll allow you to do. Some may never let you do much more than carry equipment. Others will gradually let you do more and more photography as you show your ability. Some may eventually hire you to do entire weddings for them.

Even if a photographer will only allow you to tote gear, you can learn a lot by observing. Whenever you are working with photographers, and aren't actually shooting, you should be watching and listening. Look for photographic techniques, but also study working style, people skills, salesmanship, professionalism. Look for the little things they do automatically, but which they may not even realize they are doing.

Even if you find yourself working with someone who doesn't seem to be very good, keep observing. You can learn what not to do as well as what you should do. If that photographer is successful, look a little deeper. He must be doing something right. Maybe he isn't the best artist or technician, but he treats people so well that he gets lots of referrals. Look, listen and learn.

How much apprenticeship is enough? When are you ready to fly alone? If possible, you should have worked with photographers who are working in two or three styles, or who are doing two or three kinds of weddings. You should have had the opportunity to photograph nearly all parts of the wedding.

For example, a photographer may not allow you to shoot the procession, but will allow you to do the recession. They are similar, so if you've carefully observed half a dozen processions, and done two or three recessions without problems, you're probably competent to do a procession on your own.

If you've done part of the bride's and groom's make-ready on a couple of weddings, some of the groups on two or three others, some of the ceremony on others, and part of the reception on others, you're about ready. You should probably have assisted on a total of five to fifteen weddings before you try one alone.

The responsibility for your training is yours. If one photographer won't allow you to do enough of the ceremony to adequately prepare you, it's up to you to find another who will give you what you need. If you don't feel confident in one area or another, keep assisting until you know you're ready.

It's also a good idea to simply observe weddings in all kinds of churches. Go to weddings, sit in the back and watch. Especially, go to the kinds of ceremonies with which you are unfamiliar. For example, if you book a Buddhist wedding and you've never seen one, try to attend such a ceremony well in advance of the day. Then, a week or two before the wedding, make an appointment with the clergy who'll be officiating, and talk about the details of the ceremony.

When working as an apprentice, you may or not get paid. Most photographers will pay you for an hour or two of solo work at a reception, which will allow them to return to the studio for sittings, or go on to another wedding. Some may pay you a small salary for all your time assisting, on the theory that you're helping them with equipment, etc. Others may have the theory that you don't get paid to learn, and will pay you nothing.

Remember that they are doing you a favor by educating you. Few photographers will take advantage of you. Most recognize that, when trained, you will be a resource for them from time to time.

If one seems to be getting a lot more from you than he is giving, you can simply be busy the next time he calls. Don't be afraid, however, to give what you can to any photographer who is willing to help you.

A Solo Wedding

So now you've assisted on a dozen weddings, done most or all parts of the day's coverage yourself, and you're ready for that first one by yourself. Now what? Well, there are a number of options. One possibility is that a photographer you've been assisting may hire you to do some full weddings. In this arrangement, you'll usually do only the photography. The studio will provide the film, and possibly even some equipment. They'll hire you as an employee or as an independent contractor, and pay you for your time.

The studio will take the film from you after the wedding, and do all the remaining work. Your earnings will be modest, but you'll be paid as you gain valuable experience, you'll have few if any expenses, and the time you spend will be limited to your preparation and the actual wedding event.

If none of the studios you've assisted for does sufficient volume to hire outside photographers, perhaps another studio in your area does. You can contact them, much as you did when you were seeking apprenticeship. Set an appointment, show your work and ask them to hire you to do weddings.

You can be a little less modest in this circumstance than you were when trying to assist because you now have some background. And, if some of the people you've assisted have allowed you to buy prints of some of your work, you should also have better samples. So sell yourself a little, but be realistic. You're still new at this, and it's easy to sound cocky rather than confident.

If a particular studio doesn't use you, don't be upset. Always be courteous, and if you particularly want to work for that studio, contact them every six months or so to show them your latest samples.

Many photographers have done their first wedding for a friend or acquaintance. If you're very lucky, you may know someone who is getting married, but wasn't planning to have any professional photography. If so, you can offer to cover the event for just the cost of materials, or for a small fee in addition.

If you do offer to photograph a friend's wedding, be completely honest about your background and intentions. Don't misrepresent yourself. Even if you're charging no fee, you should still protect yourself with a signed agreement (more on that later).

Since you'll want to make samples from any weddings you do on your own, you'll also want a signed release from the client, before the wedding. While a release probably isn't legally necessary unless you intend to publish the photos, it is still good practice to get one. There can be no misunderstandings if they've given their written approval. The release can be part of your agreement, so the client only has to sign one document.

In some cities there is a relatively new kind of business arrangement that may be appropriate for beginning photographers. These are loose associations of independent wedding photographers, all doing business under a common name. The participating photographers pay a fee, or percentage, in exchange for some advertising and promotion under the umbrella name. The arrangement is a little like a real estate franchise. The authors of this book are not making any recommendations, positive or negative, about this kind of operation.

In any business arrangement, it is wise to proceed with caution and even skepticism. Contracts, agreements, or letters of understanding should be examined by an attorney before they are signed. A photographer entering into such an arrangement should have a clear understanding, backed up in writing, of how he gets into the arrangement, how he gets out of it, what are its costs, and what are its benefits.

Your goal at this point is not to make substantial profit. Rather, it is to get some experience, and build a portfolio of samples. You'll also be presenting yourself to hundreds of people at the

weddings you photograph. From these contacts will come the beginnings of your business. The next chapter will discuss how you promote yourself from this start.

An Agreement With Your Client

We've mentioned the idea of a contract or written agreement between the photographer and the client. The authors of this book believe that an agreement is essential, for both new and established photographers. It protects all parties, and it prevents misunderstanding.

The agreement should be simple, straightforward and clearly written. It probably shouldn't be written by an attorney, but it definitely should be reviewed by one. Lawyers tend to use intimidating language, and represent the rights of only one party. You want the language to be friendly, and you want to protect your client's rights as well as yours.

Write the agreement yourself by adapting the agreement given in the appendix of this book, or one from a professional organization to which you belong, or have one written by a professional copywriter. Then have it studied by your attorney. Be sure the attorney understands that the agreement is part of your sales presentation, and that it must serve both you and your client. Then do exactly as the attorney suggests. Don't be your own lawyer.

These points should be covered in the agreement:

1. That all the photographs belong to the photographer or studio, and that display samples may be made from them. If properly presented, this idea will be flattering to your clients.

2. That the clients verify they have been presented with a price list.

3. That the clients have made themselves and the photographer aware of any rules the church may have governing photography of the event.

4. That the photographer's or studio's liability is limited to the refund of any deposits paid, and nothing else.

5. Terms of payment, scheduling of deposits, and policies regarding proofs are specified.

6. The agreement may specify the amount of time that will be devoted to photography, and the number of proofs that will be shown. Don't make the agreement too long. Keep its language simple. Print it in type large enough to be read. Discuss the provisions with every client, rather than trusting them to read and understand it in the same way as you understand it. Use it on every wedding. Be sure it's signed at least several days before the ceremony. Be sure you keep a copy of it on file. It's really better to keep two copies, in separate files. Ask your lawyer how long you should keep them.

If one seems to be getting a lot more from you than he is giving, you can simply be busy the next time he calls. Don't be afraid, however, to give what you can to any photographer who is willing to help you.

A Solo Wedding

So now you've assisted on a dozen weddings, done most or all parts of the day's coverage yourself, and you're ready for that first one by yourself. Now what? Well, there are a number of options. One possibility is that a photographer you've been assisting may hire you to do some full weddings. In this arrangement, you'll usually do only the photography. The studio will provide the film, and possibly even some equipment. They'll hire you as an employee or as an independent contractor, and pay you for your time.

The studio will take the film from you after the wedding, and do all the remaining work. Your earnings will be modest, but you'll be paid as you gain valuable experience, you'll have few if any expenses, and the time you spend will be limited to your preparation and the actual wedding event.

If none of the studios you've assisted for does sufficient volume to hire outside photographers, perhaps another studio in your area does. You can contact them, much as you did when you were seeking apprenticeship. Set an appointment, show your work and ask them to hire you to do weddings.

You can be a little less modest in this circumstance than you were when trying to assist because you now have some background. And, if some of the people you've assisted have allowed you to buy prints of some of your work, you should also have better samples. So sell yourself a little, but be realistic. You're still new at this, and it's easy to sound cocky rather than confident.

If a particular studio doesn't use you, don't be upset. Always be courteous, and if you particularly want to work for that studio, contact them every six months or so to show them your latest samples.

Many photographers have done their first wedding for a friend or acquaintance. If you're very lucky, you may know someone who is getting married, but wasn't planning to have any professional photography. If so, you can offer to cover the event for just the cost of materials, or for a small fee in addition.

If you do offer to photograph a friend's wedding, be completely honest about your background and intentions. Don't misrepresent yourself. Even if you're charging no fee, you should still protect yourself with a signed agreement (more on that later).

Since you'll want to make samples from any weddings you do on your own, you'll also want a signed release from the client, before the wedding. While a release probably isn't legally necessary unless you intend to publish the photos, it is still good practice to get one. There can be no misunderstandings if they've given their written approval. The release can be part of your agreement, so the client only has to sign one document.

In some cities there is a relatively new kind of business arrangement that may be appropriate for beginning photographers. These are loose associations of independent wedding photographers, all doing business under a common name. The participating photographers pay a fee, or percentage, in exchange for some advertising and promotion under the umbrella name. The arrangement is a little like a real estate franchise. The authors of this book are not making any recommendations, positive or negative, about this kind of operation.

In any business arrangement, it is wise to proceed with caution and even skepticism. Contracts, agreements, or letters of understanding should be examined by an attorney before they are signed. A photographer entering into such an arrangement should have a clear understanding, backed up in writing, of how he gets into the arrangement, how he gets out of it, what are its costs, and what are its benefits.

Your goal at this point is not to make substantial profit. Rather, it is to get some experience, and build a portfolio of samples. You'll also be presenting yourself to hundreds of people at the

weddings you photograph. From these contacts will come the beginnings of your business. The next chapter will discuss how you promote yourself from this start.

An Agreement With Your Client

We've mentioned the idea of a contract or written agreement between the photographer and the client. The authors of this book believe that an agreement is essential, for both new and established photographers. It protects all parties, and it prevents misunderstanding.

The agreement should be simple, straightforward and clearly written. It probably shouldn't be written by an attorney, but it definitely should be reviewed by one. Lawyers tend to use intimidating language, and represent the rights of only one party. You want the language to be friendly, and you want to protect your client's rights as well as yours.

Write the agreement yourself by adapting the agreement given in the appendix of this book, or one from a professional organization to which you belong, or have one written by a professional copywriter. Then have it studied by your attorney. Be sure the attorney understands that the agreement is part of your sales presentation, and that it must serve both you and your client. Then do exactly as the attorney suggests. Don't be your own lawyer.

These points should be covered in the agreement:

1. That all the photographs belong to the photographer or studio, and that display samples may be made from them. If properly presented, this idea will be flattering to your clients.

2. That the clients verify they have been presented with a price list.

3. That the clients have made themselves and the photographer aware of any rules the church may have governing photography of the event.

4. That the photographer's or studio's liability is limited to the refund of any deposits paid, and nothing else.

5. Terms of payment, scheduling of deposits, and policies regarding proofs are specified.

6. The agreement may specify the amount of time that will be devoted to photography, and the number of proofs that will be shown. Don't make the agreement too long. Keep its language simple. Print it in type large enough to be read. Discuss the provisions with every client, rather than trusting them to read and understand it in the same way as you understand it. Use it on every wedding. Be sure it's signed at least several days before the ceremony. Be sure you keep a copy of it on file. It's really better to keep two copies, in separate files. Ask your lawyer how long you should keep them.

Chapter 4
Promoting a Wedding Business
The Personal Touch

Building With Referrals

With a background of a dozen weddings as an assistant, and two or three solo jobs, you may be ready to begin building your own practice. Or, if you've established a good working relationship with one or two studios, you may want to continue working for them, and just build a following of clientele.

Some photographers make a part time career of simply doing weddings for other photographers and studios. They probably don't support their families that way, but they make a good income on weekends, and they don't get involved with all the time and expense of selling and serving clients.

These part time wedding contractors can provide several valuable assets to the studios that hire them. First they offer high quality work, because they do weddings all the time and become very competent. Second, they allow the studio operator to expand his or her business without hiring full time photographers. They also bring business to the studio.

A good wedding photographer will usually attract a following. When a young woman wants to use the same photographer who did her best friend's wedding, she will hire the studio that employs him. The photographer gets the work, and still doesn't have to deal with the complexities of running a business. It's a good arrangement for all the parties.

Whether you want to build your wedding practice into a full time business, open your own studio, or be a weekend wedding contractor, you'll need to build referrals from the weddings you do. If you're working as a contractor, you'll still photograph the weddings that result from your referrals. You'll simply turn those clients over to the studio that employs you. If you're working on your own, of course, you'll book them yourself and do all the subsequent sales and service.

Referrals can be acquired actively or passively. The passive approach is probably more graceful, and can be very effective. To implement it, the photographer simply does high quality work, maintains a professional and friendly demeanor, and always has a business card handy to give to anyone who expresses an interest in using his or her services.

If you're doing excellent work, and treating people well, referrals are almost automatic. If you've had good rapport with a couple during the course of your service to them, and if you feel that they've appreciated your work, it may be a good idea to give them a gift, such as an 11x14 print of their favorite photo from the wedding, or an inexpensive but tasteful gift item. You're not asking them for anything. You're just expressing your appreciation for their patronage. Most people will be delighted by a benefit they didn't expect. They'll certainly feel comfortable recommending you to a friend.

The active approach to referrals involves all the same things as the passive method, but adds some kind of system to ask for referrals. The easiest way is to simply ask, and here's one way to do that. Arrange to be present at the time the finished album is presented to the client. We're suggesting that rather than simply handing the delivery task over to an assistant or receptionist, you be there personally, as the photographer. Tell the client that you are always striving to improve your work, and that you want to be sure they're pleased. Ask them if they are pleased.

Then tell them that you've been building your business through the kind referrals of people you've served. If you met this couple through a referral, remind them that you were introduced by their friend. (It's a good idea to keep a record of referrals, so you'll remember.)

Next, ask them if they know anyone else who will be getting married soon. Finally, you can then ask them to mention you to their friend, or ask them if it would be appropriate for you to call their friend. Be careful. Don't be pushy. Always be courteous and professional.

If you do call someone who has been referred by a client, introduce yourself, tell this prospect that you've photographed their friends, that they seemed to be pleased with your work, and they suggested that you call. Then simply invite the prospective client to come in to your studio for a cup of coffee and to see your work. Offer to make an appointment. If they show any reluctance, simply thank them for their time, welcome them to call you later, and courteously say good-bye.

If you meet with a prospective client who has come to you by way of a referral, always send a thank you note to the original client. A small gift may even be appropriate.

It's possible to develop an even more aggressive method of gaining personal referrals by offering incentives to people who refer you. The incentive can be additional prints from their wedding photographs, complimentary sittings for future work, or certificates for services or merchandise from other businesses in your neighborhood. You could, for example, arrange with a florist to provide gift certificates or small bouquets to your clients. In exchange, you could allow the florist to give complimentary sittings, perhaps with one 8x10 print, to their customers as part of their referral or customer appreciation program. You could make a similar arrangement with a restaurant, or other business. Whatever method you might employ to ask for or suggest referrals, always ask after you've completed your service to the client and you know they are pleased with your work. Remember that you can only earn the right to ask for referrals by providing exemplary service, and treating your clients very well. The bigger their smile, the more valuable their referral.

Personal referrals can also come from the guests at a wedding. Again, if you're conducting yourself in a professional manner, people may approach you and talk to you about covering a future wedding. Always have an ample supply of cards in your pocket. It is not a good idea to spend more than a moment discussing such future business. Remember that you're on the payroll of your present client, and you owe them your absolute attention. You can, however, encourage the inquiring guest to visit your studio at a later time. If the person has a business card, take it and call later.

Every guest at a wedding is a possible referral for future wedding business.

If you are fortunate enough to encounter an individual or a couple who will be getting married in the near future, you may want to do a bit more. It's very easy to write a note on the back of a business card, offering them a gift sitting at your studio, and a 4x5 print from that sitting. Most couples will take advantage of your offer, and you'll often be able to book their wedding, especially if they have seen you working at your professional best.

Thoughts from Piare: The wedding guests may come to you.

I have gotten many weddings from the guests at weddings, right at the ceremony or reception. I remember a young woman and her parents who were guests at a wedding when I was just starting out in the business and they came to me during the reception.

They introduced themselves, and told me that the daughter was getting married in six months, and they were impressed with the way I handled myself; they'd like to come and look at our work. When they came to look at the work, they booked it on the spot.

I am most comfortable giving my card to people and letting them call me. When you're just starting out, though, you may have to do a bit more selling. I have built my business by pursuing my life long urge to make friends. If someone has done something for me, I feel like doing twice as much for them; it is just my nature. I have breakfast or dinner with an old or new friend as often as ten or twelve times a week.

Your usage of business cards at the wedding doesn't have to be limited to future weddings. They can be used to help promote other photographic business, or simply to make friendships that can be useful in the future. Before the wedding, and especially at the reception, you will have some idle time, and will surely strike up conversations with family and guests. It is perfectly appropriate to offer one of your cards to anyone with whom you've had a such a conversation.

If the individual has expressed an interest in you or in your work, it is appropriate to invite her to the studio for a cup of coffee. It is also appropriate to ask if she has a card, and on some occasions you may find it useful to send a note to someone within a few days, stating that you enjoyed talking with her, and perhaps inviting her to the studio. All such conversations must be brief and polite. You should probably be handing out six or eight business cards per wedding. Much more than that, and you may be seen as more a solicitor than a photographer. If you're using fewer than that, you're probably not promoting yourself enough.

Professional Referrals

Personal referrals are probably the most valuable method of building your business, but professional referrals can also be vital. These are referrals from other wedding professionals, including clergy, florists, caterers, and bridal salons. Again, your conduct at weddings, and the quality of your work will earn you more referrals than all the plans and schemes you can devise. If you're doing good work, other professionals will want to refer you. They'll ask for your cards to give to their clients.

However, there's no need to wait for professional referrals. You can do a great deal to solicit them. The first step is to contact these professionals, and ask for an appointment to visit with them. Take a small portfolio of your work, just enough for them to examine in five minutes or less, and only your very best samples. Show them this work, and ask them if they will be willing to refer you, in exchange for your referring clients to them.

You can also offer to do other things for them. For florists and caterers, for example, you can give them photographs of their work, which you've made at weddings you've covered. This is, in fact, a good way to introduce yourself to these people. If the food table is being set up while you're waiting between photos, you might pose the caterer next to the spread for a quick picture. Or, just take an extra photograph of the food table, or the altar flowers, learn who provided them for the wedding, then contact that business, tell them you'd like to give them the photos and make an appointment to introduce yourself.

After the first meeting, you may want to continue to provide that service to the florist or caterer whenever you photograph a wedding they've done. If they are giving you referrals, you can even supply them with a very nice album to display these photos. They may send you a great deal of business as a result.

Of all the wedding professionals, bridal salons will likely be your most valuable referral source. You'll often meet these people when they deliver a gown for the formal portrait. You can certainly open and maintain a relationship with them by giving them photographs of their brides. You may want to do these from the formal bridal portrait. If you think one salon may be especially important to building your business, you may even want to make several very large prints of formal portraits and frame them for display in the salon. We'll explore this idea in greater depth in the next chapter.

You can use similar methods of introduction for formal wear shops, and even ministers or wedding coordinators. A minister might appreciate a well done photo of the exterior of his church. If the couple seemed to be especially close to the clergyman, he might enjoy having a photograph of the three of them.

Wedding coodinators can be good referral sources, too. Probably the best thing you can do for them is to simply send them a brief note, thanking them for their assistance to you on the wedding day. They'll be sure to remember you for such a gesture. If you are good to people, they'll probably be good to you.

Thoughts from Piare: A Wedding Following

I worked as a photographer for two different employers before I had my own business. When I worked for Jafay/Markay, I didn't do any weddings on my own. When people called me, I gave those weddings to the studios. Then, of course, I photographed them.

Later, when I started working for Don Peterson, they had done only fifteen weddings in that particular studio in the prior year. When I came to them, the first year, it was fifty-five weddings, because all the Jafay/Markay following came to me. Then I opened my own studio in 1981. All the following again followed me. The very first year, I had forty-five weddings.

I believe, when I work for somebody, I should be fully loyal to that person. I also retained my loyalty to my ex-boss. I did not want to take away their business, but whoever came to me, I felt it was appropriate to serve those people.

Meet People, Shake Hands, Kiss Babies

You also want to meet people—all kinds of people—wherever you can find them. The first step is to join, and participate in, business organizations such as your local Chamber of Commerce, Convention/Visitors Bureau, and Better Business Bureau. Don't just join and wait for them to come to you. That won't happen.

After you've joined, go to their seminars to learn some new business skills, and to meet people. Attend the luncheons, breakfasts and after hours events. Put a booth in their trade shows, and exhibit your work. Ask to work on one or two committees.

Don't be put off by the fact that many of the members are there to sell their products and services. People who sell also buy—and they all have friends. It'll take a little while, but those contacts will pay off. That's a promise.

Social and service organizations also offer great opportunities to meet people. The opportunities are everywhere—Kiwanis, Optimists, Rotary, churches, athletic teams, political parties, etc. Whenever you join such groups, participate as much as you can. You'll be rewarded by valuable friendships as well as by business growth.

Even if you're not good at socializing, you can learn those skills. You can take classes like the Dale Carnegie courses, and read self-help books, but you can learn just as much by simply doing it. Here's a short course on attending a Chamber of Commerce after hours event.

Get there right at the starting time. It's uncomfortable to be early when you don't know people, but it may be easier to deal with the crowd a little at a time, as they arrive. You're going to encounter two kinds of people, those who are as shy as you are, and those who aren't.

The easiest place to meet either kind is in the food line. (If you're watching your weight, you don't have to actually eat much.) You're in that line to meet two people, the one in front of you and the one behind you. If it's a relatively short line, just get a couple of carrot sticks, then get back in line to meet two more people.

The outgoing gregarious people may be intimidating, but they're really the easiest to meet, and they're probably most valuable, because they'll introduce you to other people. These people will offer you a handshake and introduce themselves. You then do the most logical thing; shake their hands and tell them your name.

Next, ask them a question. Ask what business they're in. Listen carefully to the answer. Very often you can ask another question, "That's an interesting job title, but what does it mean, what do you really do?" And you're off and running. They'll ask you the same questions, and you get to talk about your business.

Then, before you leave that conversation, do one other thing: give them your business card and ask for theirs. If it does nothing else, that gives them the opportunity to call you if they want to. If you want to call them, you'll also have their name and number.

Meeting that shy person on the other side of you is just as easy, but you'll have to initiate the process. Do it just the way the friendly, gregarious person did for you. Offer a handshake, and tell him your name. He'll probably tell you his name, but if he doesn't, ask, or if you're all wearing name tags, just say, "And you're Jim." If he asks you about your business, you're off and running again, but if not, you simply ask about his, and you're still off and running.

In the couple of hours that these events usually last you can meet fifteen or twenty people, have interesting conversations with half a dozen, and you may make a new friend or get a new customer. If you find yourself in an extended conversation with one person, you should move on because that is taking time in which you could meet others. If that person is a particularly valuable contact, you can probably make arrangements for a lunch, or you can call in a day or two to continue the conversation.

When it's time to move on, you simply look across the room, and say, "I just saw someone I need to talk to; will you excuse me?" Then say, "I enjoyed talking with you and I look forward to seeing you again."

You can also meet people who have display booths at the event, or other people who are looking at those displays. You can extend your circle of contacts by introducing someone you just met to someone else you just met. Others will do the same thing for you. You can learn by watching others. Watch the people who seem to be at ease and comfortable in the crowd. They may be just as shy as you are, but they've learned some simple skills. You can learn them too. You'll always be glad you did.

These tactics work. You may feel awkward the first few times you try them, but you won't look awkward. You can be yourself. People will like you. That's also a promise.

Thoughts from J. C.: It's difficult, but you can do it.

The social graces didn't come easy to me. I learned them because I had to. At one time in my career I took a job selling memberships for the Chamber of Commerce. I had to go to those functions, and had to help new members feel welcome. I did exactly the things we've recommended here, and they worked. I've been doing them for years.

I still feel a bit uncomfortable for the first few minutes in a new situation, but I quickly meet a couple of people, and I am okay. I find that I can put other people at ease, even quicker than I can put myself at ease. Other people now think I'm one of those naturally gregarious types, and nothing could be further from the truth. I have learned to be outgoing, but it was not natural. From childhood I was a shy, scared, insecure person, so if I can do this, I know you can, too. Just try it.

Positioning—It's All in the Mind

Positioning is a marketing concept. It may be the most important concept in marketing, and an understanding of it can be the foundation of your successful wedding business. To describe positioning, we might say that:

The sale is made in the mind of the customer.

That's a simplistic presentation of the concept, but it gets to the heart of it. If you want to thoroughly understand the positioning idea, there is a wonderful book on the subject: **Positioning: The Battle for Your Mind**, by Al Ries & Jack Troutt, copyright 1981, McGraw-Hill. This is the definitive treatment of positioning. It's short, practical and easy to read. It's probably still in print, in paperback, and it's inexpensive. Your bookstore has it, or can get it. Your public library should also have it. You should not only read this book, you should own it.

The title of the Ries & Troutt book tells us what the positioning idea is about. Positioning tactics are all around us. You see positioning being implemented all the time in advertising. A recent auto company slogan is, "Pontiac builds excitement." That slogan, and the entire campaign around it are designed to put an idea in your mind. The idea, of course, is that Pontiac is an exciting car—fast, stylish, sexy. The idea is even carried to the product itself, in its styling, colors and accessories. Everything about the product and its promotion supports the positioning idea.

You can apply the positioning concept to your studio or wedding business. Start with a question: "What do I want my customers and prospective customers to think of me?" Phrase the question a little differently: "What place do I want to have in their minds?" Again: "When someone hears the name of my business, what should pop into her mind?"

With a little work, you should be able to settle on one to four simple statements that define the positions you want to have. Your statements might be something like:

The very finest photography
A friendly, personal place
You can rely on us.

These don't need to be flashy statements, but they should be very direct. You're not writing advertising slogans yet: that comes later. You don't have to have three or four statements. One may do it for you.

Your positioning doesn't have to be about quality or prestige. Yours could be:

The most affordable wedding photography in town.

When you've determined what position or positions you want to have in your customers' minds, you're well on your way toward establishing a marketing identity for yourself or your studio. Be sure you've identified positioning ideas you can live with, then apply them to everything you do in the business.

Keep your positioning in mind when you name your business, when you develop advertising slogans, write ad copy, design your price lists, furnish the studio. Think about positioning as you talk to customers, even as you do your photography. Use the positioning ideas when you're training your sales staff, or assistant photographers. In doing all this, your business will come to assume the positions you've set out for it to have.

Positioning limits you and frees you at the same time. When you decide to position yourself in certain ways, you have to quit trying to be all things to all people. You become able to focus your efforts toward doing a few things very well.

Positioning may mean that you'll actually turn down certain kinds of business in favor of doing a better, more profitable job with other kinds of business. You'll refuse that business confidently and courteously by saying that you specialize in a different kind of work, that you'd like to recommend one or more other professionals to help with the current need, and that you hope to have an opportunity to serve when the customer needs the kind of photography you do best.

Remember that positioning doesn't happen in your mind. It happens in the mind of your customer. Perception is as important as reality. If you are doing the finest photography in your city, but your customers don't see you that way, you're in trouble. You must present yourself and your business in a way that's consistent with your positioning objectives, then you must perform in the same way. Positioning applies to everything from the name on the door, to the style of photography you do.

Your Professional Reputation

> *"...he that filches from me my good name*
> *Robs me of that which not enriches him*
> *And makes me poor indeed."*
> Iago, in Shakespeare's Othello

Reputation is an idea closely related to positioning, and indeed you hope to implement your positioning objectives as part of your reputation. When we talk of reputation, though, we're focusing on just a few issues, such as quality, reliability and attitude. There's only one way to get a good reputation, and that is to *earn* it. It's hard won and easily lost, and few things are as valuable.

The essential first step in winning the reputation you want is to be what you want to be. If you want a reputation for a certain level of quality, you must deliver that, and you have to deliver it consistently. To assure this quality, you have to do a great many things: you have to find a good lab, and work with them until they serve you well; you have to hire good sales people and photographers, and train them well; you have to train yourself and monitor your own performance; you have to spend money on good equipment, supplies and services. All the pieces have to be in place. Otherwise, you'll fall short of your goals.

Similarly, if you want to have a reputation as a friendly, caring business, or as a reliable business, you absolutely must monitor everything you do to assure that it's compatible with those goals.

Once you've gotten your business house in order, and you're doing things as you really want to do them, there are some things you can do to help build your reputation. Your membership in the Better Business Bureau, Chamber of Commerce, and other civic organizations will help. Their emblems on your door give you some small amount of credibility, but the chamber and bureau also offer seminars and other resources to help you keep your business fine tuned.

Your advertising and promotional efforts can also help. If you've done the things necessary to be sure your studio is friendly, and if that is part of your positioning, you can mention friendliness in your ad copy, or even devise a slogan that tells people you're friendly. But if you say you're friendly, and someone answers your studio phone in a clipped, unwelcoming tone, your credibility just went out the window.

Handling Problems

Problems fall into several categories. Some are more or less routine, like the bride who is thirty minutes late getting to the church. Other problems are very likely to happen given certain circumstances, or you can see them coming in time to take action. Late lab orders every fall is an example of a predictable problem. Some problems catch you completely by surprise, but you can still prevent disaster if you think and act quickly. The worst problems surprise you by showing up only after the damage is already done.

In spite of your best efforts, there will occasionally be a problem with a client. Most will be problems of human relations, not of photography. Many problems can be prevented by communicating clearly with your clients and with your staff. Say what you mean and mean what you say.

Some problems can be minimized by prompt appropriate action. If an order is due a week from today, and you've just realized that it'll be late, call that customer right away. Explain the situation, and ask what the customer's needs are. If the date isn't critical, you're out of trouble and the customer will appreciate your thoughtfulness in calling. If the date is critical, you might be able to help by mailing the order for the customer. You might even decide to pay extra to get it on time. But, don't wait for the customer to call or walk into the studio before you discover that you've failed to satisfy her.

Thoughts from Piare: The nightmares that came true.

In my early days photographing weddings, there were two similar mistakes that had the potential for disaster. Both of them happened when I was still working for other studios. I'll give you some of the details of my troubles.

In 1972, I got an assignment to do a wedding from one of the studios, and I got the checklist, with all the details. This wedding was in the 500 block of Broadway, so I went to Broadway. This was an area I was familiar with, but there was no such church. I went up and down the street, and it really wasn't in existence.

So I called the number and found out that the wedding was on Broadway in Boulder, nearly an hour's drive from the Broadway in Denver. No one had written the city on the checklist. So I called the church in Boulder, told the minister my problem. He understood, told the bride and groom not to worry, and agreed to re-stage everything I missed. He knew that I was in trouble and he was on my side.

I got there, and re-staged the whole thing. For the procession and recession, I shot much closer than normal so as not to show the empty seats. In fifteen minutes I did all I was supposed to have done in an hour-long Catholic wedding.

The second problem was similar. I went to the small town of Sedalia, south of Denver for a wedding, and couldn't find the church. It was a small town, and no one had heard of the church. I called the phone number, and an intercept recording told me it was a long distance call. I knew there was a problem.

Then, I got out my long distance card and called again. The minister answered the phone. (Did I tell you I can be very lucky sometimes?) He told me that he was in the town of Salida, not Sedalia, and told me how to get there. I asked how long it would take to drive. He said two or three hours, "...but you're in luck; the wedding is tomorrow." I'd assumed that the wedding was on Saturday, and hadn't noticed that the date was for Sunday.

Next I called the studio. I said, "You guys didn't tell me I had to go so far. I called the church, and it is three hours away." They were in a panic. Once in a while I can get a little humorous, and I said, "Don't worry. I just called a friend who owns a helicopter, and he'll be here in two minutes. This wedding will be covered. Everything is under control.

On Monday, they all wanted to know how it had gone. I said, "Everything was fine; here's the film." Then, of course, I told them the truth.

Both of these could have been prevented by better planning and communication, but the point is: When a problem like that occurs, you don't just accept it. You get on the phone, you catch a cab, you do whatever is necessary as quickly as you can.

When Problems Arise

You will prevent as many problems as possible, through working diligently, communicating with your clients, training your employees, caring for your equipment, and planning carefully.

You'll solve many others through quick action. Still, you will sometimes experience that cold feeling in the pit of your stomach when you realize that a wedding client is unhappy with you or with the service you've provided, and you have to deal with their displeasure. What then?

Before you can solve a problem, you have to understand it. There are two or three very vital steps to arrive at understanding. The first essential step is to listen to your client. Politely ask him to explain the difficulty, and listen carefully and attentively to what he tells you. Really listen, even if you think you already know what the problem is. You may be wrong. If you plunge in and try to solve the wrong problem, you not only leave the first difficulty unsolved, you may call attention to something that hadn't bothered him before, and compound your troubles. As part of the listening process, ask for clarification of anything you don't fully understand. Don't antagonize him by asking a long stream of questions. Just exercise a genuine concern for the customer's problem. Be interested and courteous.

Then, restate the problem. Say something like, "Let me be sure I've heard you correctly," or "Oh, I see, you're concerned about..." Then succinctly state the problem. Don't get carried away. Don't apologize, yet. Don't argue, or blame someone. At this moment, don't accept blame—not yet. Simply repeat, in as few words as you can, what he has just told you.

Sometimes, there's another step to understanding the problem. You may have to investigate something. You may have to talk to someone on your staff, or to the lab that did your processing, or some other involved party. One of these other people may have some information that neither you nor your client knows. This investigatory step probably has to be done some time after your first listening session with the client.

Once you're sure you know what the problem is, you have a chance to solve it. The way you solve it depends on the nature of the problem. Some tactics are always appropriate, though.

1. Don't argue with the client. You can't win by making her feel wrong.

2. Don't blame anyone, or duck the responsibility. Blaming always makes you look bad. If you blame the lab, you're saying you did a poor job of choosing labs. If you blame an employee, you're guilty of poor hiring or poor training. You also look like you're trying to avoid responsibility.

3. Don't grovel. You'll do better by winning your client's respect than by winning his sympathy.

4. Solve the problem in a way that is quick, convenient and fair for your client, even if it costs you money.

5. Try to understand how your client feels. Ask yourself how you'd feel if you were in her place? What would you want to have done to solve the problem? What can make this right? Some problems are simply misunderstandings. The client thinks she didn't get enough billfold prints, when she really got all she paid for, or she thinks she was charged twice for something which was charged only once. These are easy to solve. Simply have her join you in investigating the problem. If possible, do it so she discovers her own error. Otherwise, you discover it, right there beside her. Then, don't blame, gloat, nor even act relieved. Just thank her for her patience and courtesy, and go on.

Often enough, the problem exists because you, or someone else really did make a mistake, but its easy to fix. When you discover such an error, just say, "You're right. We'll correct that immediately. I apologize for our error." Then, fix the problem.

If you've caused your client some difficulty that you can overcome, take care of that, too. Maybe you can mail a print to someone, or send something by overnight express, or make a personal delivery in town. They'll usually appreciate your extra effort.

Rarely, the problem may be very serious and require difficult and expensive action. Your contract with the client probably limits your liability to some minor compensation. We believe that your obligation goes further than your legal commitment. You have a reputation to protect, and you have an ethical obligation to your customer and to your profession.

Before discussing that extended ethical obligation, though, let's talk a bit about the legal obligation. In some extreme cases, where legal action by the client is a possibility, you need to exercise caution. It's possible that you could expose yourself to additional financial liability by making a mistake. In such cases you should consult an attorney, and follow his or her advice. The lawyer may advise you not to attempt any cure of the problem beyond your legal commitment.

Our advice to you is professional, not legal. We're not attorneys. The law is different in each state or jurisdiction, so you should seek and follow the advice of a qualified attorney.

With those cautions stated, our philosophy in handling difficult customer service problems is simple. Always try to rectify the problem to the satisfaction of the client. Do more than is necessary. Do what you would want done if you had the problem. Unless the added cost is likely to put you out of business, ignore it. Often you can turn a negative situation into a positive one. Would you rather have a client telling her friends that you bent over backwards to please her, or that you left her with unresolved problems?

Be creative in solving problems. The best way to do that is to understand the customer's needs and wants. If the worst has happened, and all or part of the images from a wedding are lost, ask yourself what the customer has lost, and whether any of it can be replaced? Perhaps you can borrow negatives from relatives and guests, and have professional quality prints made. Perhaps you can re-stage parts of the ceremony. Maybe you could go to the church and take photos of stained glass windows or other artifacts and combine them with other images for effect.

These things can't replace every lost image and its accompanying emotion, but they can still be valuable to the couple and the families. If you're in this situation, don't try to convince the bride that your make-up efforts are as good as what you've lost. But, do try to get her to see that you can still do something worth while for her. And be generous in what you'll try to accomplish.

Be on your client's side, instead of standing against her. Talk to her and listen to her. You can often defuse her anger. Occasionally you may please her even more than if all had gone well.

Not all problems can be solved. On rare and infrequent occasions, there will be no way to please a client. The impasse may be a result of emotions or other factors beyond your influence. Sometimes the result is permanent ill feeling between you and the client. Occasionally the result is legal action, in which case, you're best protected by your contract and your attorney.

In the case of ill will, your best defense is the reservoir of good will you've built with other clients. If a prospective client hears glowing things about your business from two or three friends and negative things from only one, you probably still have a chance to win the patronage of the new client. Your dividends aren't always paid from the same bank where you make your deposits.

If you've addressed the customer's concern, and taken some corrective action, you may think you're finished with the problem solving process. You're not. There's one more thing to be done, as important as all the other steps. Confirm with your client that the problem is resolved. Simply ask him if she is pleased. Be careful how you ask, because its easy to sound sarcastic here, especially if there has been some tension in the discussions up to now. Try something like, "Mrs. Jones, it's very important to us that you are pleased with what we have done: have we taken care of this to your satisfaction?" Be sincere. Her satisfaction is important to you.

If she's not satisfied, go back to the listening phase, and try again. You see, it isn't enough that you think you've solved the difficulty. Your customer must believe that you've solved it. As with everything else, what's in her mind is what's important. You want her to feel good about the situation, and about you and your business.

Thoughts from Piare: The unreasonable customer.

We had a bride who complained that our photographer hadn't taken two pictures that were on the checklist, including one with the bride and the singer. The photographer said that he reminded the couple of those photos, but that they were busy talking with guests, and wouldn't give him time to complete the photography. The couple had also requested that the photography be limited to three hours; they didn't

want to pay for any more. Still, the photographer stayed an extra half hour, and tried more than once to get the couple to complete the shots. Finally, he said good-bye to them and left.

When the bride complained about the missing photos, she wanted $300 compensation. I offered to do another photograph of the bride and the singer, at the studio or one of their homes, but the bride wanted the compensation. I had to say no.

When someone is unreasonable, or clearly wants to take advantage of you, you have to put your foot down. This is where your agreement protects you through having everything in writing.

Thoughts from J. C.: The problem we didn't cause.

I'll never forget this customer problem that happened years ago. Working in the studio one morning, I was aware that one of our receptionists was having difficulty with a bride's mother. The customer was unhappy with the wedding albums she was picking up.

After a few minutes, the sales receptionist asked for help from our head receptionist. I was sure the crisis would be quickly resolved, because Carol is a real pro, and always handled customers skillfully and thoughtfully. Some time later, though, the conflict was still going on, and Carol finally asked me to intercede. This was a sticky problem, indeed.

I began as I always do, by asking the customer to tell me about the situation. She said she was upset because the color of some of the prints didn't quite match. I knew it was more than that, though, because each of my staff had already offered to remake the questionable prints for her. I also offered remakes, but the woman didn't want that. I asked her to tell me what we could do to solve the difficulty, and she had no suggestions.

After extensive talking, she said she was just very disappointed, and started to walk out of the studio. By this time, I'd run out of ideas, and was happy to see her leaving. I thought we'd have a better chance to find a solution some other time. At the studio entrance she stopped, wheeled around, cast a cold glare at me, and shouted, "...and besides that, my daughter's already pregnant!"

She turned again, and stormed out. I was so frustrated, I went to the back room and threw the album the thirty foot length of the work area. My receptionists were shocked; they'd never seen me behave like that.

We never heard from the woman or her daughter again. I suspect the marriage was already on the rocks. At least we'd learned what the problem was, and that none of us could have solved it. I assured my staff that I'd had nothing to do with the bride's pregnancy.

Chapter 5
The Promotional Tools for a Wedding Business

34

The outstanding film, **Field of Dreams**, suggests, "If you build it, they will come." And at the film's end, thousands did indeed come.

You probably can't promote your wedding business with that philosophy. You can build a beautiful studio, even do beautiful work, and if you stop at that point, very few will come.

We've already discussed some quite valuable methods of personal promotion which will take you far in building your business. You can, however, go much further with a well planned mix of promotion. The promotional tools available to you are many and varied. Some are expensive, some are not. No one method of promoting your business will meet all your needs. Success lies in selecting the most productive promotional tools, and using them well.

The Objectives of Promotion

Before we get into discussing specific promotional tools, it's probably important to be clear about the objectives of promotion. There are four points to consider in setting objectives: target market, positioning, desired action or effect, and communication.

Target market—Whom are we trying to reach?

This one's easy. We want to reach women who are in the process of planning a wedding. In most cases that will be the bride or her mother. We must reach them before they have made a decision on a photographer.

Positioning—What do we want them to think?

We talked about positioning in the last chapter, and the specific positioning objectives for your promotion will depend on the positioning decisions you've made regarding your business. You may want your prospective clients to think it's very important to them that they select a highly reputable photographer, and that you are the best.

Action/Effect—What do you want them to do?

Here are the possibilities: you want them to be aware of your studio, call your studio, visit your studio, book their wedding with you. Be careful of that first one; its a trap. It's easy to think that if people are aware of you, they'll at least call, and that's not necessarily true. The last item on our list—to book with you—is what you really want. If you don't book weddings, you can't stay in business.

Communication—What do you want to tell them?

If you're clear on the other three objectives, you'll be clear on this one. You want to position yourself in their minds. You want to give them a reason to call or come in. You want to ask for their business. As you begin any promotional activity, look at your objectives, and plan everything you will say and do to meet those objectives.

Where Are the Brides?

The first objective is to reach brides. Where do you reach them? When the groom has proposed, and the bride has said yes, where does she go first to begin planning the wedding? Of course she calls her mother first, but what then? It's important to know something about the decision and purchase process, and particularly about the entry points into that process.

There are several major decisions and purchases that will usually be made early. If the decisions are not actually made early, at least the shopping will begin early. These entry points are:

Rings

Location for ceremony and reception

Gown

Photography

Perhaps I flatter the photographic profession by putting it on this list. I doubt that many brides go shopping for a photographer first. They may, however, visit photographers fairly early in the process, and perhaps ahead of some of the other things on the list.

Why do you care? Why is it important whether she visits a photographer, or a bridal salon on that first hectic day of wedding preparation? The answer is that it affects your promotional decisions. You want to talk to the bride as soon as possible after her decision to get married, for a number of reasons. The most obvious is that you have a better opportunity to book the wedding if you talk to the bride early. Being second may be too late, because the first photographer to talk to her may be the one she chooses.

It's also helpful to your photography if you talk to the bride early. If you're going to photograph the couple together prior to the ceremony and you discuss that with the bride early, it's easier for her to plan. She might allow more time for preparation early in the day, and might even select a later time for the ceremony. She'll be considering photography when she schedules delivery of her gown. She may make special arrangements with the florist to be sure everything is in place for the photos. You certainly want to talk to the bride as early as possible.

If a bride is going to visit photographers first in the cycle, you can only reach her in time by promoting directly to her, and you have to be doing enough promotion to contact her within the first few days after the wedding plans begin. If she's visiting some of the other service providers first, you have a little more time in which to reach the bride, and you have a chance to identify her through her visits to bridal shops, jewelers or others.

Some of the ways you can reach a bride directly, and early in the process, include Yellow Pages and ads in bridal magazines. It's also possible to use mass media, such as TV, radio and newspapers, but they are very expensive because you pay to reach a lot of people who aren't planning weddings. You can address the bride later in the process through bridal shows and fairs, direct mail, and cooperative promos with other wedding professionals.

Cooperative Promotions

Cooperative promotions are likely to be one of your strongest and most cost effective methods of reaching brides. Brides certainly begin shopping for the gown early in the preparation process and bridal salons offer terrific opportunities for cooperative promotions. Jewelers, florists, and reception sites can also be useful.

The basic method for structuring a cooperative promotion is the same for all types of businesses that cater to brides. First review your objectives to be clear about what you need. Then talk to the other business owner about what he or she needs. Put together a plan that gives the other business something valuable, and gives you what you need. Make an agreement with the other company, and implement your plan. Monitor it to be sure you do what you've promised, and that you get what was promised to you.

Here are some suggestions you might try with one or more bridal salons. This method can not only put exquisite samples of your work into the best salons in your town, it can have their sales staff talking about your photos. Ask the salon to allow you to photograph a few of their newest gowns each season. There are fall and spring gowns, so you'll do this twice a year. Work with the salon to select one to five gowns that will be popular that year. The salon will furnish the gowns, will fit them to your models, and may even send someone along on the sitting to help you with the styling.

Do your best work on these photographs. Consider using professional models, especially if you can make a deal with the models to provide their services in exchange for portfolio prints. If you can't get professional models, you may be able to use clients of the salon. The advantages of using professionals are several: they will be very attractive; you can choose the ones you want to use; you can often select models who fit the sample gowns; you can do more striking poses with them because they're accustomed to working for the camera.

These photos may be just a bit more than portraits. Look at bridal magazines for posing, location and lighting ideas. You don't want your work to look like fashion photography, but you can borrow some ideas to make these samples a little more adventuresome than typical portraits.

Use interesting locations. Go outdoors, of course, to formal gardens or into the woods and the like, but also try some in urban locations. Maybe some civic building in your town has stately white columns and banisters. They look gorgeous with wedding gowns. Or go modern. Pose one of the models with a fountain, or an abstract sculpture, or against a dramatic piece of architecture.

Make big prints. Make them larger than those you usually sell. Depending on the size of the salon, use 20x24 to 30x40 sizes. Make a print for the salon, and one for your own use. Put the prints in the salon, in frames that fit the shop's decor. Put your name on them, maybe on a brass plate affixed to the frame.

The salon's salespeople will probably do the rest of your promotion with no prompting from you, but a suggestion won't hurt. Tell them how they can use the photographs to sell gowns. When a bride is considering a particular dress, the salesperson can use the photograph to show her how beautiful she'll be in it when her special day comes. That helps the salon sell, and it showcases your work.

You'll also want to keep the salon supplied with your cards or full color brochures, so they can refer you. Then do something nice for the salespeople once in a while. Send flowers, or show up in the morning with doughnuts. If they're helping you book weddings you might even want to take them all to dinner once or twice a year.

You will use your copies of the prints in your studio, of course, but you'll also use them in bridal fairs, and anywhere you display your work. In bridal shows, the salon can display your prints in their booth, giving you credit, and you can show the same prints in yours. You might even do combined contests with the salon. Your work will be noticed.

If it seems expensive to spend a day or two shooting these images and then make 30x40 prints, compare the cost to a year of display advertising in the yellow pages, or a series of small ads in a daily newspaper. Then think how well each will work to reach the brides you need at the time they're making decisions. No promotion is cheap. It's essential to spend your promotional dollars where they're most likely to be effective.

When you present these ideas to the salon, remember to talk about what you can do for them, and listen to ideas they have that can make the promotion work even better.

You can probably think of ways to adapt these same ideas to the needs of a florist or jeweler. Do them all. The more leads you get, the better. And if a bride sees your work at the salon, the florist and the jeweler, she's likely to think you're the best photographer in town.

When you talk with any of these other wedding professionals, ask them about their marketing strategy. Look for other ways you can work with them, and for ways you can adapt their successful promotional ideas to your studio. Share your promotional ideas with them. Work together for the success of all.

Bridal Shows & Fairs

Think again about your target market. It's brides and mothers who are planning a wedding. Where can you find them? One place they're sure to be is at bridal shows. These are sponsored by shopping malls, radio stations, newspapers and others, to bring together a lot of brides and a lot of providers of wedding services. And they work. At the bigger shows you don't want to be standing idly around when they open the doors; you could get trampled.

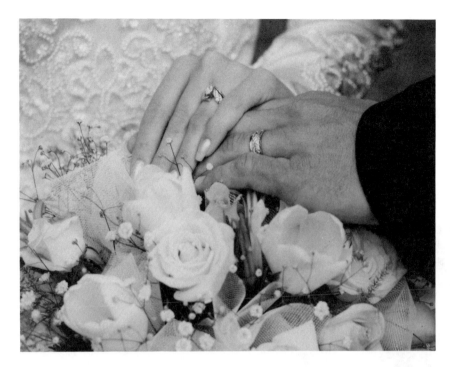

Create photographs that can be the basis of coöp promotions with jeweler, florist and bridal salons.

37

When we say they work, we mean that they accomplish the goal. They bring together a lot of brides, a lot of their mothers and friends, and a lot of people selling to brides. Whether a bridal show works for you depends on how you work the show.

The first thing is to be clear about your objectives. Of course, you want to book weddings, but you may not book any on the day of the fair. So you have to have some other tactical goals in mind. You want to be seen by as many brides as possible. You want to talk to as many as you can. You want to position yourself in their minds. You want to generate some excitement about wedding photography, and about your work in particular. You want brides to call you or visit your studio very soon after the fair. You want to get their names, addresses and phone numbers, so you can call them soon.

Those are a lot of objectives, but if you can accomplish just one of those things with every bride who visits a fair, you'll be swimming in business. What you'll need to do is devise some tactics that will achieve the results you want.

If you fail to make and execute some good plans, its very easy to throw away the opportunity that presents itself at these affairs. Remember that you have to sell in the bride's mind. She's there to see gowns and cakes. She may be thinking about music and other wedding details. She may not be planning to look at photography at all. She will be over- stimulated by dozens of vendors selling all sorts of things she's interested in—and many more that don't interest her at all. You'll have a little competition from other photographers at the show, but a lot more from the other vendors. You have to make a splash.

First, let's talk about your booth. You'll want to reserve your space early. Many shows allot spaces on a first come, first served basis. By being early, you stand the best chance of getting a good location. If the booth prices are reasonable, and you expect a good turnout at the show, consider getting a double booth. You can show more, you look more established, and more people can fit into your booth space.

Plan your booth presentation carefully. Think of the situation. There'll be a lot of people, and they'll have difficulty moving around. People only a few feet from your booth may not be able to see things on tables, or at eye level. You'll want to show your largest prints. A few mammoth prints are probably better than a lot of small ones. You'll want to display some of your best prints up high, high enough to be seen over the heads of the crowd, if show rules permit that.

Show beautiful brides and beautiful gowns. Also show cute shots of children, and emotion-filled pictures of brides with moms, dads, grandparents, etc. Think impact. Use pictures that elicit oohs and ahs. Print them all large enough to be seen and appreciated by people who are in a hurry to see something else.

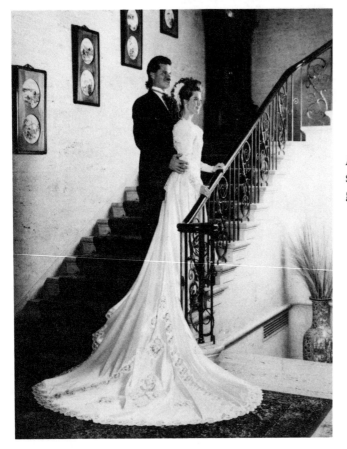

At bridal fairs and shows you'll want to display striking photos of beautiful brides and beautiful gowns.

If you've arranged to have any of your work displayed in the booths of salons or other vendors, be sure to show those same photos in your own booth. Show just a few prints of other than wedding poses. Family portraits are especially good, because some families may be together at a wedding for the first time in years.

You also want the name of your business shown high enough and large enough to be seen. And, you want the name shown smaller and lower, in several places where people will see it when they're up close, looking down, preoccupied with looking at your photos, or just trying to get to the next booth. Do not count on the sign that the show sponsor provides. It will be small and probably tacky looking. You may even want to take it down.

Keep your booth space open. Don't put tables out front next to the aisles. You want people to come into the space and look around. Have your albums on small podiums, so people can comfortably see them while standing. Be sure you choose furniture that won't be easily knocked over; if the show is crowded, people will be bumped around a bit.

Pay attention to the overall look of your booth. Think of your positioning objectives. If you're positioning yourself as the best photographer in town, do you look like the best?

Use colors that help you look as you want to look. Consider buying a carpet remnant, as large as your booth space. Have it bound on the edges, and put it down over the show floor or carpet. Consider using your own table drapes, to get the color you want. You don't have to spend a fortune to have a great booth. You can do a lot of the work yourself to save money. But you do have to plan and give yourself time to prepare your display.

Look at those objectives again. You want to talk to brides, you want them to call you, and you want to be able to call them. That last one is easy. You have a drawing which they enter by filling out a ticket with their name, address and phone number. Don't ask them anything else; they won't take the time to write any more.

Write out simple rules for your contest. The first reason for writing them down is to assure that you know the rules. The second reason is to have them available in case anyone asks to see them. You want to be perceived as being fair and honest.

The prize should be something worth winning. The most impressive thing you can give away is probably a complete wedding coverage, your very finest. You can't afford to do that at every little bridal event, but you can afford to give it away as a grand prize, once or twice per year.

Perhaps you could give away a formal bridal portrait, or love portrait at each show, and then draw from those winners for the grand prize. If a full wedding seems extravagant or impractical, consider a family sitting with a large print or a large album. Give away a complete prize, a formal sitting and 16x20 print, for example. Do not give away a sitting and a 4x5 or 5x7 print. That's not really a prize, the brides know that, and they'll think you're cheap.

If you'd rather not give away your product, you can offer some other prize that will be of interest to brides. You could do something fun like a balloon ride, or a weekend getaway. You might exchange prizes with another vendor; you give away complete floral service, and the florist gives away your wedding coverage. Or, you and another vendor can combine your contests to offer a bigger grand prize, like a honeymoon cruise.

Whatever the prize, be sure you describe it clearly, so contestants know what they're trying for. Be sure it's something of significant value to the winner. Don't require them to buy anything at all to win the prize, nor to make it valuable; such requirements may be illegal, and they certainly make you look cheap. Don't plan on additional sales from the winner to pay for the prize. If they do buy something, that's great, but the prize will be paid for by all those names and addresses.

If you work with another vendor, be sure he or she is reputable, and that you both understand your agreement the same way. It's best to do that agreement in writing.

Many shows have a plan already set up for drawings, with pre-printed entry tickets in the show program. If it's a good system, use it. But be sure it does several things. Be sure the brides enter the contest at your booth; that gets them there to see your work. Be sure you award the prize at your booth; that has them coming back to see if they won. Be sure you get sole control of the entry tickets; that's how you'll compile your mail or phone list for follow-up.

How do you get brides to call you? First, they must have your phone number, so have an ample supply of business cards. It's not a bad idea to have brochures or price lists to hand out. A brochure may be better; if people have to call for price information you have a chance to talk to them. The brochure, or even the business card, might have a reproduction of the most impressive print you're showing in your booth. That will help the bride remember who you are when she's going through all the goodies from the show.

A brochure can be printed in one or two colors, with a black and white rendering of the photo. If you do it that way, though, you should use a very good printer, so you get good reproduction. You should print on good paper to make a favorable impression. You should also use the word "color" often in the copy.

A four color brochure is better. There are some national printers doing them fairly inexpensively. You can probably find those printers through magazine ads. Some commercial photo labs offer a product on photographic paper, printed with ink on the back, that can be folded to produce a very attractive brochure at reasonable cost.

Consider using a graphic designer to plan all your printed material. Designers really can do a better job than you can. They do it every day, and you don't.

All the pieces are now in place for a successful bridal fair, but if you just hang up the prints, set the brochures on a table and watch the people, you won't book a lot of weddings. You're about to earn those bookings by working very hard.

You'll do some things differently, depending on how big and busy the show is. If there is a pressing crowd, you'll want to keep all your conversations pleasant but brief. You probably will concentrate on handing out brochures, and making sure that people enter your contest. If you have a smaller crowd, and a more leisurely pace, you'll get into more extended discussions with visitors. You'll ask them more questions about their wedding plans. You'll extend personal invitations to visit your studio, and you may even have time to book a wedding.

Whether the crowd is full or sparse, however, the basics of working your booth are the same. The first rule is to work; don't just sit. If you're sitting there looking bored, people won't walk into your space, and they won't initiate conversations with you. Be alive. If you're having trouble getting excited, think about how many weddings you'd like to book at this show, and try to see each visitor as one of those brides.

Stand up. If the crowd is thin, step out of your booth space. If there are more people, stand to one side of the space. If it's really crowded, you'll be too busy to think about where you're standing. You don't have to entice people into the booth; your photos will do that.

When someone comes into the booth, give her a few seconds to light in front of one of your pictures, then step up beside her and begin a conversation. It's easy. You can say, "That's a pretty gown, isn't it (referring to the photo)?" You can ask, "When is your wedding going to be?" Or, "Are you enjoying the fair?" Almost any opener will do. You don't want to talk her ears off; just be yourself, and be cordial. If she joins in the conversation, she's probably interested in your services, and you can invite her to visit your studio. Of course, if she seems to really like your work, you'll want to offer to reserve her wedding date right then.

Typically, you'll have a brief conversation with most of the visitors. You always want to do two things. Invite them to enter your drawing, and give them your card, price list or brochure. That last part is easy; just hand it to them. Reach toward them, brochure in hand, just as you would if they had asked for the brochure. Most people will simply take it, with no comment. Try it—it works. If you've done those two things, you've accomplished your objectives. You've made it possible for them to call you, and for you to call them.

At even a lightly attended show, you should be able to meet several good prospects every hour that you work. Think about it. If you work a show for three hours, you might meet a dozen or more brides who are planning a wedding, who like you, and like your work well enough to visit your studio. You might even make a studio appointment with some of them. (Be sure to have your appointment book handy.) You should be able to book half of those weddings.

You probably won't be the only person working at your booth for a bridal fair. Actually, you may not even be there; you may well be busy photographing a wedding. You'll need to rely on your sales receptionist or other assistants to represent your studio. Be sure to plan the staffing of your booth well ahead of the date. You need to make sure you have people working at the right times, and you need to be sure they are well trained.

The people you have to rely on to do this all important selling may not be comfortable with meeting so many strangers. You can help them get comfortable by teaching them the things we've just outlined for you. A little training goes a long way. Remind them of your objectives in doing the fair. Be sure they're focused on getting the results you need. Teach them how to get those results.

It's a good idea to be with your team at the beginning of the show if possible, so you can show them how to be effective. If you can't be there personally, try to have one person there who has done shows before, or who is at least well prepared and comfortable with the idea, and so is likely to do well. You'll also want to reward the people who work with you at shows and fairs. You can do that with a bonus or commission plan, or by doing something like taking them to dinner.

Can you justify the cost of doing these shows? Probably so. If you book enough weddings to pay the cost of doing the show, you're way ahead. In fact, any promotion that brings in enough business to pay for itself is solid gold. That's because you will do a good job at each of your

weddings, make new contacts, get new referrals, and turn each wedding you do into one or more additional weddings. You don't have to make a profit on your promotional business if you use it to bring in additional business. It is the added work that will produce your profits many times over.

Paid Advertising

There are countless venues in which you can advertise. The most obvious are newspapers, radio, TV, magazines, and direct mail. There are also dozens of other possibilities such as sponsoring athletic teams, advertising in theater programs, and more. Most of that kind of advertising does not work. If you want to sponsor a Little League team because you believe in Little League, and because it will help you position your business as a responsible citizen, by all means do it. If you think you'll book weddings from having your name on the back of baseball shirts, think again.

In evaluating the wisdom of any particular advertising approach, you'll want to refer to your promotional objectives. You'll also want to develop a promotional budget, and stick to it. If ads in a particular magazine are likely to reach your target market, if they will position your business as you want it positioned, if they will give you the opportunity to ask for the action you want to get, if they do all those things better than any other way you could spend the money, and if you have the money in your promotional budget, then place the ads. If they won't do those things, don't waste the money.

When salespeople call on you to sell advertising, listen to them, get all the appropriate information from them about the audience they reach, the cost of the ads, etc. Then, evaluate each advertising opportunity with respect to your objectives, and the other ways you could spend that money. If it makes sense, do it. If it doesn't, don't.

One advertising method that may make a lot of sense, is the yellow pages of your phone directory. That is especially true if you're operating a portrait studio. It may be less true if you're doing just weddings. The yellow pages work best in situations where customers know they need a particular service and don't know where to find it. That is more likely to be the situation for someone looking for a photographer for senior portraits or family portraits than for someone looking for a wedding photographer.

The advantage of yellow pages advertising is that the person who sees your ad is almost surely looking for the service you provide. The disadvantage is that many customers will select a photographer without ever having looked in the directory. They'll select someone who has reached them through some other means, such as personal referral, or promotion in a bridal salon or show.

Yellow pages advertising is expensive. You probably will not generate enough business from it to make it profitable by itself, but that is the case with most promotion. If you get enough business to simply pay for the ad, you will have done well. Again, that's especially true if you have a general portrait business. Every senior, or family sitting you get through your yellow pages ad has the potential to generate additional business or referrals. That additional business will be profitable, because you don't have to advertise to get it.

Be careful with the size of your yellow pages ad. You don't have to have the biggest ad to get results. A well designed small ad is probably more effective than a poorly designed larger one. You may want to pay a graphic designer to prepare your ad: most directory companies will prepare your ad for you, but they often do a hack job.

Most advertising has the property of being more expensive than it is worth, but there are a few ad venues that are probably worth more than you pay for them. If you have a portrait studio, you'll probably observe over time that as many as twenty-five per cent of your weddings come from the seniors you've photographed. Advertising your studio in high school newspapers and yearbooks is usually inexpensive, and may generate a lot of business. Such ads typically pay for themselves with the booking of just one sitting or wedding.

There's one other factor to consider when evaluating paid advertising. That is that all your promotional activity works in combination to generate the desired effect. Your prospective customer will probably be reached by several photographers. She may get recommendations from several friends. She may see the work of two or three studios at salons or shows. If she looks in the phone book, she'll certainly see several ads. Yet, she'll probably visit only two or three photographers. Which ones will they be? Many times she will choose to visit the one photographer whose name she hears the most.

If she's looking in the yellow pages, she may call a studio she's heard of before, without even realizing where she's heard of it. So, if she's seen your work at a salon and your ad in her high school yearbook, and knows a friend who has used your services, she's more likely to call you from the phone directory. Neither you nor she will know that all those other things helped bring her to you.

Cross Promotion

If your studio does a variety of work other than weddings, you'll certainly want to use cross promotional techniques. The idea is simple: you look for additional ways to serve your past clients. You know, for example, that high school graduates are likely to be getting married within a few years. There are several ways to maximize the number of weddings you'll photograph for young people you photographed previously as seniors.

The first method is to probe a bit while you're doing each senior sitting. When you're talking about the subject's plans after graduation, its easy to ask if he or she is planning to get married soon, or perhaps go to college first. When you do encounter a senior who is planning to marry right after graduation, offer a complimentary sitting of the couple together. That will give you a good chance to begin the process of booking their wedding.

Your second opportunity to cross promote to seniors comes when you deliver their finished order. Include a brochure on your wedding coverage. It's also a good idea to give them a brochure on family sittings. You'll get better results if you talk with them about the brochures. If they show interest, you can begin the selling process. If they don't show interest, at least you'll know that they noticed the brochures.

Most weddings still happen in the spring or summer. If you keep track of your seniors' names and addresses, you can mail a wedding brochure each February or March, for the first four years after they graduate. If you're going to be in bridal shows, invite them to attend the shows, and see your display.

From your list of attendees from a bridal show, look for names of seniors you've photographed in prior years. This is relatively easy to do if you have the show list and your senior list both alphabetized. If you have a computer, you will be able to match the lists very easily. Either way, it's worth the effort because they're already familiar with your work, and these are going to be your very best prospects. You can call these brides with a lot of assurance.

Don't make it sound like a telemarketing campaign. Do it like a personal phone call. Tell them you noticed their name on the list from the bridal show, and that you remembered photographing them earlier. They'll be flattered that you remembered.

Want to make it even better? Pull the files from the senior sittings, and refer in your conversation to something about the earlier photos. Chat with them briefly. Ask about college or careers. Then invite them in to the studio, or offer a sitting of the couple. Either way, make an appointment right then if you can. It's easy: just say, "Maybe we could set up a time, I'd hate to miss you when you come in."

Two ideal candidates for cross promotion with wedding photography are the bridal formal sitting and the love portrait. The love portrait is a variation on that old standby, the engagement portrait. Add a little romance, even a bit of sexiness, and you have the love portrait. We'll discuss both of these sittings in more detail in a later chapter.

The cross promotion in these cases can work in either direction. If you develop a reputation for the love portrait or formal, you have the opportunity to book weddings with clients who come to you for those services. You can also book love portraits and formals with the couples who come to you for their wedding photography.

These are just a few of the ways you can cross promote. Use your imagination. You can also use cross promotion techniques to book family portraits, seniors, children, etc. Always be on the lookout for a chance to serve a client who is already a friend because of the good service you've given in the past.

Wedding-Oriented Advertising

While a lot of media advertising is expensive and inefficient, there is one class of paid advertising that works particularly well. It's successful because it is highly targeted. We speak of wedding and bridal magazines, some of which are available on news stands. They are also available by subscription, and are promoted through all kinds of bridal businesses.

Two of the popular bridal magazines are Wedding Pages and Wedding Guide. They have editorial content about weddings, gowns, etc., and a lot of advertising. Don't be put off by the number of ads in them; brides read them as much for the advertising as for the articles. These books also have regional editions, which saves you money by allowing you to target your geographic area, rather than advertising to the entire nation.

Advertisers include bridal salons, jewelers, photographers, etc. They receive display stands that show the magazine, and offer subscription forms. So, a bride may see the magazine in a bridal salon, order a subscription for herself, and then see your ad when she receives her first copy. It's pretty effective. A full page ad in one of these books runs $600 to $1200, and you might book as many as twenty-five per cent of your weddings through them.

When you do advertise in one of these wedding magazines, you'll want to use it effectively in your studio, too. Be sure to have the magazine display rack out in plain sight, where visiting brides will see it. You'll want them to see your ad in the magazine, so you should fasten some kind of index tab to the magazine page on which your ad appears. Nearly everyone who picks up the book will then turn to that page and see your ad. That reinforces your credibility.

Albums and Packaging are Promotional Tools

One of your promotional tools is the packaging in which you deliver your finished work. The most important ingredient in packaging is, of course, the bride's album. Your authors believe that the album is one of the most important statements you make about your work. If you use rich looking, high quality albums, your brides will enjoy their photos more; they'll show them more often, to more people, and they'll talk more about the photography.

Your name, discreetly stamped inside the album cover is powerful advertising. People looking at the bride's album will also ask her who did her photography, and she will spontaneously talk about the good work you did. The result is that you will book referred weddings from among the bride's family and friends.

The color of the album is important. White albums look stark and sterile. They don't complement flesh tones. They can make the bride's white gown look less white, and they show dirt and wear more quickly. Ivory colored albums are better, but not much better.

The way to avoid selling white albums is to avoid showing them. Dark browns, burgundies, or grays are preferable colors. A rich brown leather album, with gold-rimmed brown pages is very impressive. Most people who see it will want it.

Thoughts from J. C.: We never sold white.

In my first years managing studios, white albums were the tradition, and they were all we ever sold. When we began showing brown albums, that changed overnight. Even our most conservative customers appreciated the idea of an album that would look good on a table or bookshelf for years to come.

We found that we did a favor for ourselves and our customers by steering them away from traditional white. When we quit showing white, we quit selling it. In the last six years I was in the business, in at least a dozen different studios, I remember selling only two white albums, to people who simply wouldn't have it any other way.

The album is more than just a cover. You'll want to call attention to the kinds of pages you use, and to the way you organize the photographs. Most of the better albums have pages that show the print behind a mat, not covered by acetate. They usually offer a variety of mat shapes, including rectangles, ovals, circles, and gimmicky shapes like hearts. You'll probably want to use a variety of shapes in each album, and use them with some thought. Use oval openings, for example, for images that particularly fit the oval shape, and avoid ovals where they don't enhance the image.

If your album pages don't cover the prints with acetate, you'll spray the prints, probably with a lustre finish spray. Be sure you use photographic sprays. Fixative sprays designed for other applications may not perform well on photographic paper. Even with the right materials, it takes some practice to spray evenly, without getting bubbles, lint, unevenness, or rough spots in the coating.

If the album pages have acetate, do not spray the prints. Spray will often stick to acetate or other plastics. Likewise, never spray wallet sized prints. Sprayed prints will stick to plastic wallet pages.

Some more serious words of caution are also in order here. Spray is dangerous. Do not inhale even small amounts of spray. Breathing it over a period of time can seriously damage your health. It is really best to wear a mask when spraying.

The second caution regards fire. Fire, very hot, fast burning fire. Photo sprays are lacquers. They are highly flammable—even explosive—when being sprayed, but the danger doesn't pass when they dry. Accumulations of dried spray burn easily, and can do tremendous damage. They burn with a hot, smoky flame that is difficult to extinguish.

If you spray prints in your home or studio, you should have a fan ventilated spray booth designed for flammable substances. And you should maintain it well to prevent a dangerous buildup of lacquer. Actually, the best advice we can give you about spray is this: pay your lab to do as much of your spraying as you can. They're better equipped for it.

With an exquisite album before you, along with well sprayed prints, and a variety of pages, you're ready to begin the assembly. Here are some suggestions on how to organize the album. You'll want to open and close the album with some of the best images. Use particularly beautiful, poignant, romantic or sweet photos. That way, anyone who views the photography will begin and end with good feelings. After your opening image, introduce the bride and groom with individual portraits, or a good pose of the couple. The closing might be the couple's departure, the ring photo, or a striking silhouette.

Put the remaining prints in the traditional order of events, not in the order they were taken. Start with shots of the make-ready, then the procession, ceremony, and recession. Group photos usually come between the ceremony and reception images. The receiving line, and car photos should be sequenced as those events occurred. Reception photos fill the last part of the album, and you have a lot of freedom with their order. You usually have quite a few photos that can go anywhere—things like hand shots, double exposures, close portraits, etc.

Our suggestions about the arrangement of photos certainly apply as much to small albums and proof albums as they do to the bride's book, but they also apply to loose prints. Loose prints, of course, won't stay in the order you place them, but why not have them thoughtfully displayed for at least the first viewing?

Thoughts From J. C.: Selling With Personality

Piare and I have long known a photographer in the Denver area who is naturally one of the best salespeople in the business. His secret is in his personality; he loves to have

fun. And his clients love him. When his wedding customers come in to see their proofs, or finished albums, he is always glad to see the people, and raves about their pictures.

I've watched clients open the album, look at the first two or three photos, then leaf through the rest of the pages while they talk and joke with him. They don't even see the images. They look at the last couple of photos, and close the book, exclaiming how wonderful the pictures are. They're completely engaged by this guy's personality. Of course, the photos are good, but they won't really know that until they look at them later with friends.

Our friend sells with his personality, and it's very effective. Of course, with his selling style, its a real good idea to have some of his best shots in the front and back of an album.

Tasteful, attractive packaging should not be limited to the bride's album. If you show and use high quality smaller albums, you'll be able to sell albums for parents, grandparents, and other special relatives and friends. When you sell a small album, you'll almost always sell more prints for that person than you'd have sold without the album. You also create another impressive advertisement for your business, one that doesn't cost you a cent, but which actually makes you money.

No matter how well you sell small albums, though, you'll always sell a lot of loose prints. These, too, should be delivered in attractive packaging. You have several options, including attractive paper sacks, gift boxes, and folder covers. If you use sacks, they should be very nice, expensive looking sacks, probably in a dark color.

Every piece of packaging should carry your business name, attractively printed, or stamped in gold. You can easily make your own covers by buying cover stock at an art supply store, cutting and folding it to size, and gold stamping it with your name. For 5x7 prints, for example, you cut the stock slightly larger than 10x7, and fold it in half.

You may not want to put each extra print in a portrait folder, but you can put all six of Aunt Mary's prints in one folder cover, and deliver that in a good looking sack, or in a gift box. The sales representative who provides your folders should be able to suggest packaging ideas for your loose prints. But don't, don't, *please* don't deliver prints in a plastic bag, with an ugly piece of cardboard for protection.

It's even a good idea to deliver black & white glossies in attractive packaging. Again, you can make your own covers from 10x7 inch pieces of parchment or vellum paper, gold stamped with your studio name. Insert that in a nicely printed envelope, with a protective piece of cardboard (buy some good looking cardboard) and you'll have low cost, professional looking packaging.

Your albums and packaging can enhance or mar the impression created by your photography. It makes sense always to enhance, never to mar.

Virtually everything we've suggested to you in the way of packaging for your work is an idea that some photographer or receptionist began doing in order to offer a little something extra to clients. Now it's your turn. Look for the extras, the pizazz that you can add to your presentation. Look for ways that you can meet clients' special needs. We used to think it was too much trouble for the studio to keep track of which relatives and friends were to receive which loose prints. Now, we do that as a matter of course, and find that it helps us in the studio, as well as helping the clients.

You can come up with the next great idea in packaging by simply listening to your customers. When they talk about some part of the photography process that seems difficult to them, listen! See if you can add something to your service to make it better for clients. Perhaps you can gift wrap the loose prints for close relatives. (Wrap only the box lid, and secure it with gold or silver elastic ties - that way, you can open and re-close the box with ease.) Perhaps you can come up with better ideas. Your customers will love you.

Chapter 6
Nine Steps to Successful Selling

Nine Steps to Successful Selling is an adaptation of a philosophy of selling developed over a number of years by J. C. Adamson. J. C. uses these methods in teaching sales skills to clients and students.

Before we get into a detailed discussion of selling wedding photography, which we do in the next chapter, let's talk about selling in general. Relax, it's not as scary as you think.

Selling has a bad name. Many folks view salespeople with fear and distrust. Very few people can even imagine selling for a living. The most important reasons for this sorry state of affairs are easy to understand. Most of us have had unpleasant experiences with poor salespeople. We've all bought products or services that didn't please us. We don't like to be sold; we prefer to buy. The difference in our minds is in who has control, and we want to be in control.

The truth is that good salespeople don't sell unsatisfactory products. Good salespeople don't sell people things they don't want, or can't use. Good salespeople help their customers choose and acquire the best products and services. That's the kind of selling we're going to discuss.

Thoughts From J. C.: Piare says he doesn't sell.

As Piare and I have worked on this book, I've asked him many times about how he sells. He always tells me, "To be honest, I sell without selling." Then he proceeds to tell me about countless selling techniques and strategies that he uses. He wouldn't tell you, but I will, that he's a skilled professional salesperson, and he teaches those selling skills to his studio staff.

Piare is so much the salesman that when I ask him virtually any question about the operation of his business, he gives me a selling answer. In every aspect of his business, he knows how to increase his sales and profits by meeting his clients' needs. That is professional selling.

Step One: Cultivate a Winning Attitude

Every sales trainer and writer talks about attitude. Some seem to think that attitude is the only thing that really counts, and there is some truth in that view.

I've seen sales people who seemed to succeed on attitude alone. Maybe you've seen them, too. They make a lot of mistakes, but they're always motivated. They're likable. They have fun. They sell, and they succeed. These people seem to have attitudes that can't be damaged. They've learned how to stay on top. Some may have been born that way. Some may simply have learned that it works better. Like Scarlett O'Hara, who just couldn't think about the tough things until tomorrow, they use their energies today on what they can accomplish today.

I suspect that most people have experienced a feeling that the world is their oyster, that nothing can go wrong, and they can accomplish anything they want to do. When we're in that frame of mind, we often achieve our greatest accomplishments. We're almost invincible.

But how about those other feelings. Have you ever felt like nothing could go right? Have you ever felt that you were nearer the bottom of the heap than the top, that the only sensible plan was retreat? I have. It's not much fun, and it's not very productive.

Attitude is important to our success. I don't quite believe that attitude is the only thing that determines our ability to succeed. I do believe that it's an essential element. A person can have skill, talent, knowledge, and ability—and still not succeed. When that happens, the missing element is often attitude.

Which attitudes lead to success, and which prevent success? Certainly the attitudes that come from a healthy self-image are among those that lead to success, and the attitudes that spring from self-doubt and low self-esteem tend to block success.

I think there's a style of thinking that builds positive attitudes. That thinking style also tends to destroy negative attitudes. We'll study this thinking style in four parts.

Part 1: Do It Yourself

I've learned that this way of thinking is entirely my responsibility. Motivational speakers, tapes and books may influence me if I choose to let them. On the other hand, I may be able to sit quietly in my own home, and give myself all the motivation I need. I can, by my own choices, stay emotionally up, or I can push myself down. The key thought here is that no one else can ever do it for me. I must always do it myself. I can ask for help from a counselor, a friend, a mentor or a clergyman, but the responsibility is mine.

The truth is that you can change your own attitudes, and you're the only one who can.

Part 2: Be Happy

At first examination, this idea may seem preposterous. The essential thought here is that your happiness doesn't depend on the circumstances of your life. It depends only on whether you choose to be happy. Happiness doesn't come from money. It doesn't come from having the right spouse, the best kids or the perfect job. It's a choice.

Don't some of those things make us happy, though? Is'nt it possible, for example, to find joy in sharing life with a wonderful person, someone you love and who loves you? Of course it is. There you have it, then—happiness is brought about by a circumstance, right?

Wrong. Is it also possible that a person could be married to an absolutely marvelous individual, and not be happy? It happens all the time. Do you know people who fail to appreciate their spouses. Maybe you've been married to someone like that. Maybe you've been like that.

The divorce courts are filled with marriages that withered because people chose not to appreciate each other. Many of those people had the chance to be happy, and chose not to be. It's certainly possible to choose unhappiness. It must then also be possible to choose happiness.

Abraham Lincoln is reputed to have said that most people are about as happy as they make up their minds to be. Put that way, it has a ring of truth to it. You can spend hours talking with friends about how rotten things are, and you can always get someone to help you decide that your situation is hopeless.

Or you can make other choices. Instead of talking for hours about the junk, you could spend your time trying to do something about the situation. Or, you could just do something fun. That may not solve the problem, but at least you'll feel better. Try it for a while, and see if your outlook improves. Lincoln may be right. You can choose to be happy.

Start watching your own life. You'll find times when you deliberately choose to suppress your own happiness. The bad news is that for the rest of your life you may choose to exercise that option frequently. The good news is that when you become aware of your happiness option, you'll more and more often choose the joy.

Part 3: Believe

In order to sell successfully, you must believe in three things: yourself, your product, and your company. If you're a photographer, the product is your wedding photography, and the company is your studio or your business.

Just as with the concept of happiness, this belief idea is entirely up to you. Let's talk first about belief in your self.

If you're like most of us, you know that you have certain abilities and that you do some things very well. But you're also keenly aware of some deficiencies. And sometimes, perhaps often, you feel that those deficiencies outnumber and overpower your abilities. You try hard to build your self-confidence, but you're nagged by self-doubt. Why does that happen to us?

What follows is not a new theory, so you've probably heard it before. As you read about it this time, however, try to put it in personal terms. Think of examples in your own life—in your past, yes, but especially today—that fit the typical pattern.

Here's the theory. We all receive criticism and praise from others. It begins in our early childhood, and lasts throughout our lives. The running commentary on our worth and performance comes from all around us. It begins with our parents and continues with teachers, bosses, spouses, children, friends, even such impersonal sources as the media.

The problem with all this appraisal is that it tends to be far more negative than positive. Not only do we hear more criticism than praise, but the criticism is usually more carefully constructed than the praise, and it's more thoroughly presented. When you've pleased an employer, for example, he or she may tell you so. The praise—if there is any—will often come in the form of a very few words, such as, "Nice job."

But criticism from the same boss may be handled a bit differently. He or she is likely to call you into the office, close the door, and proceed to deliver a lengthy discourse on what you did, how you did it, why you did it, how it impacted the rest of the corporation, how it threatens everyone's future, how you should behave if you ever earn the opportunity to handle a similar situation again, and what will happen to you if you ever foul up in like manner again.

Sound familiar? Go over your own list of criticizers and see how many of them mete out their appraisals in this way. But wait. The purpose of this analysis is not to build resentment against your boss or your mother. They're just doing what most of us do. In fact if you inventory the way in which you constructively criticize your own children, employees or spouse, you may see that you're guilty of the same tactics. No, this analysis isn't about the way others treat us. It's about the way we react to it. So first recall some examples of how you have been criticized by those around you. Then proceed.

Now, think about your own feelings. When you've been praised, you probably feel pretty good about it. You take the pats on the back, and may add to them by quietly agreeing, and even amplifying the praise a bit. When you're criticized, your reaction is similar. You probably accept the lashing, then take the whip from the accuser and flog yourself a few times more.

What we're doing with this behavior is internalizing the other person's appraisal. We're turning their views into our views. The net effect, over a long period of time, is that we end up internalizing far more criticism than praise. And the criticism we internalize is usually more solidly constructed than the praise.

This scenario is bad enough already, but it gets worse. The next thing that happens is that we begin to doubt the praise. If I've been lightly praised once, then soundly criticized two or three times, and I have internalized all this, I'm poorly prepared for receiving more praise. The next time I'm praised, I may stop and ask myself, "What about all those other times, when I fouled up? I messed up more than I did good. And the foul-ups were worse than the good. So I can't take credit for this accomplishment now." Instead of internalizing the praise, I discount it.

If we begin doing this kind of thing as children, we fall into a pattern of self doubt and self criticism. After a while, it doesn't matter what others tell us. We become our own worst critics.

So much for identifying the problem. Let's look at the solution. It's pretty simple, actually, pretty obvious. If we can trick ourselves into denying our good and focusing on our bad, we should also be able to trick ourselves into focusing on our assets, instead of our defects. What is necessary is that we first become pretty picky about which comments we choose to accept from others.

Start by sorting through the people in your life who are in a position to criticize you. First, list those people whom you truly admire and respect, those who are living their own lives in a manner you'd like to emulate. From those people, you'll choose to listen to both criticism and praise. You won't blindly accept their views, but you'll always listen and consider what they say.

Now make a list of those who are likely to praise you falsely and insincerely. This, too, will be a short list. In fact, there may be no one on it. Anyone who is on this list is probably someone who has something to gain from winning your approval. From anyone on this list, you'll not internalize either criticism or praise. You'll ignore their appraisals of you.

Your third list will consist of the rest of the world, anyone who isn't on the first two lists. From these people, you will internalize praise, only praise, not criticism. Circumstances of rank, and the rules of polite society may force you to listen to their criticism, and you may need to respond to it, but you won't internalize it. When these people praise you, though, you know it's sincere praise because they're not on your list of phonies. You also know they probably criticize better than they praise, so you can assume that you deserve more praise than they're giving you. You're justified in sweetening it up a little.

You can add a few of your own pats on the back for a job well done. You might even pick out one of those people on your first list, the ones you admire and respect, and tell them of the praising you've just received. They'll help you keep an honest perspective while you internalize every bit of the praise that you deserve.

The final step in this process is to begin to honestly assess yourself on a daily basis. Freely praise yourself every day for every good thing you've done. When it comes to criticizing yourself for your shortcomings, do that too, but very carefully. Be sure you aren't condemning yourself unfairly. When in doubt, turn for guidance to those few friends you admire and respect. They won't let you beat on yourself undeservedly, nor will they allow you to deny some behavior that truly is causing you trouble. They'll help you find perspective.

As you become more practiced at this habit of assessing yourself, you'll find that you become better at divorcing yourself from the whimsical assessments of other people. You'll become more confident and sure of yourself, and more able to use your talents and assets to your best good. Where you have genuine shortcomings that stand in your way, you'll be able to recognize them and do something about them.

Believing in yourself is almost entirely up to you.

The next part of this "belief" business is belief in the products or services you sell, and in your studio or business.

Product belief will free you to sell. Most people are lousy at making decisions, and your job is to help them decide to buy your product. If you believe in your product, you'll always feel secure in getting that decision. Guess who's responsible for your belief in your product? That's right, you are. Starting to see the pattern, regarding attitude?

The product we're talking about is your photographic services. We assume that, if you're reading this book, you're conscientious about providing the best possible service to your clients. Sometimes, though it may still be difficult to maintain belief in your own product. Here's how that works.

Every product has some defects or characteristics that aren't as good as its other traits. When we're selling, our prospects often look for those defects. They do that because they're afraid of making a bad decision. Since they're focusing on possible flaws in our offering, they'll often uncover one of the weaker traits. In fact, most of them will discover whichever shortcoming in our product is the most glaring. And they'll tell us about it. They won't work so hard to find the assets in our product. They don't have to—we're doing that for them. But they'll always announce proudly the glitch they've discovered.

This scenario is repeated with nearly every sales presentation. What begins to happen to some of us is that we start to think only of the objection we know we're going to get. We may look only at the one flaw in our work, and quit concentrating on the five, ten, or fifty wonderful things about it. Soon we lose faith in what we're selling, and our doubts and insecurities move in where our belief and conviction once held sway.

In order to protect your belief in your product, you have to sell yourself anew every day. You might do that by looking through your samples every day, and taking a moment to study a couple of the images you really enjoy. You might do the same with your proofs from each wedding. Pick out a few of your best shots, and separate them from the rest. Spread them out, and spend a minute just enjoying them.

Another way to renew your belief in your own work is to spend a few minutes chatting with a satisfied customer.

How about the weaknesses in your work? Well, if there's something that can easily be fixed, just fix it. If its something that's going to take time and practice to correct, begin that process. And while you're working on improvement, keep the problem in perspective. How important is it? After all, which photographer or studio would you choose if you were the customer? You'd choose the best, of course, even with that one flaw. You'd choose your studio.

You'll still have to deal effectively with customers' objections, and we'll talk more about that later in this chapter. But with the right attitude, your honest belief in your product will shine through. When you're convinced, you're convincing. The whole idea is to keep little mole hills from growing into mountains.

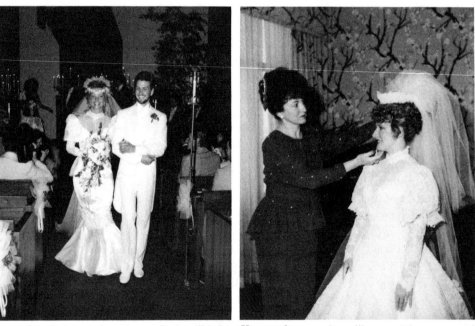

Pay attention to the good work you do; it will help you sell by helping you believe in yourself and your product.

Know whom you're selling to. The parents of the bride will often make many of the decisions.

Part 4: Know Where You're Going, and Commit Yourself to Getting There

The first half of this idea has to do with goal setting. If you have a clear cut idea of what you want, you have a pretty good chance of getting it. Volumes have been written on the subject of goal setting, and I don't intend to write another, but I do have a personal experience to relate.

I used to have trouble setting goals. It seemed like day dreaming, or building unreasonable expectations. I tried to do it anyway, however, mostly because one of my sales mentors was so adamant about it.

A number of years ago, I began thinking about my future health. My father died at eighty years of age, and for the last thirty years of his life he talked a lot about his illnesses and about death. Much of that time he was sick, crippled, and unhappy. It often seemed that the more he talked of his ills, the sicker he got. He never enjoyed the health and happiness he might have had with a different attitude.

My mother, on the other hand, is eighty-two years of age as I write this. She is strong, healthy and vivacious. She's always tackling a new challenge. She has counted river rafting and mountain hiking among her later life accomplishments. She is now competing as a swimmer, on a national level! Her secret seems to be her attitude.

Having seen these two extremes, I have some pretty strong feelings about how I want to live my life in my seventies and beyond. I think Mom's approach sounds like more fun than Dad's. But to be able to tackle a mountain trail at eighty, I'll need a healthy body, and I won't be able to construct a healthy body at that age. I'll have to get there with the body already built.

After going through this thought process, one of my written goals became to be healthy in my old age. I know I can't control every circumstance that will affect my future health, and I also know I'll sometimes choose a second helping of potatoes and gravy over having lower cholesterol and body fat. But having thought all this through, and written about it, I have over several years, made healthier decisions than I was making before that goal setting exercise. I get more exercise, and I eat better every day.

Think it over. There are probably a dozen areas of your life where you have strong feelings about how you'd like your future to be. Write about them. You'll identify some things you must be doing today, in order to be at your destination in a year, or in several decades.

Now, about this commitment idea. It may be the most important of all. And it's probably the most difficult to master. To be honest, even as I write this, I still am searching for many answers regarding commitment. I have a hunch I'm not the only one who isn't totally sure how commitment works, but let's look at what we do know.

If you have a desire to do something, and you're working toward its accomplishment, you have some level of commitment. You may or may not have enough commitment to achieve your goals. That's one of the tricky things about it. There are widely ranging degrees of commitment.

This exercise will demonstrate what I mean. Please do it now, as you read: Lay down the book, but prop it open so you can still read it. Now, hold both hands as high in the air as you can reach. Are you reaching as high as you can? Hold that position for a moment. Now reach a little higher. Get the idea? You probably just exceeded what you had thought was your limit. After I'd asked you to reach as high as you could, you then reached a little higher. It always seems to be that way. No matter how far we reach, we're capable of a little more.

Step One: Commit to Goals that Stretch You

In 1865, British runner Richard Webster shattered the world's record for the fastest running of the measured mile with a time of four minutes, thirty-six and a half seconds. By 1943, the record had been whittled down to four minutes, two and six-tenths seconds, but there seemed to be a barrier at four minutes. Eleven years later no one had posted a time under four minutes. Finally, on May 6, 1954, Roger Bannister ran the mile in three minutes, fifty-nine and four-tenths seconds, in England. Australian John Landy then edged the record down to three fifty-eight the same year! Today the record is less than three forty-seven, and it is broken with some regularity every few years.

What made the difference? When Richard Webster shaved nearly twenty seconds off the record in 1865, was he at his limit? Did he run as fast as he could have, or only as fast as he needed to? Suppose the record then had been four minutes and one-half second: could Webster have broken the four minute mile in 1865? Would he have needed the same training as Bannister, the same diet, or the same shoes? Or only the incentive?

The difference? Is it commitment? How high can you reach? How hard can you work, to achieve your goals? And how hard is reasonable? If you have a financial goal to accomplish, is it appropriate to reach it at the expense of your family or your health?

Or is effort even the key element? Perhaps it's the attitude of commitment. When two closely matched football teams meet for a championship game, does the team that works the

hardest always win the game? Coaches sometimes talk about the team that "wants it the most." I think they're talking not about effort, but about the attitude of commitment.

That attitude may be something in the soul, or deep in the psyche. I can't tell you how to find it, but I can give you some clues.

If you are seeing reasons why your goal can't be achieved, you don't have it yet.

If you know your goal is within your reach, you're getting very close.

If, in your mind, you're accomplishing your goal tomorrow, you're still a little way from the attitude.

If you are achieving your goal today, you probably have the attitude of commitment.

If you are seeing reasons why your goal can't be achieved, you don't have it yet.

If you know your goal is within your reach, you're getting very close.

If, in your mind, you're accomplishing your goal tomorrow, you're still a little way from the attitude.

If you are achieving your goal today, you probably have the attitude of commitment.

If the things you must do to achieve your goal seem to conflict with other demands in your life, you aren't there yet.

If your major goals seem to fit together and require complementary kinds of action, so that you're able to progress on all or most of them at the same time, you probably have the commitment attitude.

If you're starting to understand the attitude of commitment, but you don't quite have that attitude, I hope you're wondering how to get it. I think the first part of the answer lies in the first things we discussed in this chapter. Be happy and believe in yourself. Without those things, true commitment is hard to come by.

I think also that clear goals are essential, and your various life goals have to fit together. If two of your goals are at cross purposes with each other, you probably can't fully commit to either of them.

Focus on your own happiness; focus on your belief in yourself; work on clarifying and unifying your goals.

Step Two: Expend the Effort

Of course, achieving sales requires work. Sometimes it's difficult, sometimes a little easier. Certain skills are useful, but you will accomplish nothing unless you use those skills. When I'm training full time professional salespeople, I tell them these things:

1. The cardinal rule is to put in the time and make the calls—all day, every day.

2. If you are a good salesperson and you make more calls, you will make more money.

3. If you are a lousy salesperson, and you make more calls, you will make more money.

As a photographer, you're not selling full time. As we've discussed, you'll do a lot of your selling while you're actually photographing people. There are times, though, when this important idea still applies to you. You may have to call on bridal salons, other photographers, ministers, etc., to build your business. If you talk to more of those people, you'll build more working relationships with them, you'll get more referrals, you'll book more weddings, and you'll make more money. Yet you may find this kind of selling very difficult to do. Why is that? I have some theories.

One reason that you chose to be a photographer may have to do with the freedom and independence you have in operating your own business. You like the idea of being on your own, of calling your own shots. Many people want that freedom, but the truth is that few people are able to handle the awesome responsibility that is the counterpart of this great freedom. Few people use their time well.

Most successful salespeople will tell you that sales is hard work. In order to sell, you may have to locate strangers who have never considered using or referring your service. You have to

put yourself in a place where you can contact these strangers. You have to contact them, and immediately convince them it's worth their while to spend some time with you. You have to inspire their interest in you. You have to convince them to actually spend some of their money, or refer their valuable clients to you. And you then have to take care of all the details, problems and contingencies that crop up as a result of your work. You bet it's hard work. And, most of us don't really like hard work.

This is where we get in trouble, because the hard work is not optional, it's essential. If we do anything to avoid the hard work, we also avoid the benefits we desire. And, we are incredibly skillful at avoiding the hard work.

One way we avoid the work is to spend great amounts of time getting ready to get ready. We were taught to do it. The Boy Scout Motto has ruined more than one salesperson.

"Be Prepared." Good advice? Well, perhaps, if you're planning a long trek into the woods, but not necessarily, if you're contemplating a sales call. Oh, I'm not advocating that you jump recklessly into your sales calls. What I am saying is that many salespeople spend far too much time planning and preparing. Some of the time you think you're using for sound preparation, you may be wasting.

You usually won't need to know much about the people you're calling on, or about their businesses. In most cases all you need is a name and a phone number or address. You probably don't even need the name of the person you'll sell to.

Am I saying you can sell to people without knowing about their needs, the nature of their work, the place they hold in the company? Of course I'm not saying that. But who has the most complete and accurate answers to all those questions? The customer does, and a few seconds after you pick up the phone you can begin your selling relationship with her by asking questions. In so doing you'll reveal your genuine interest in her and her needs.

How long does it take to get ready for a first phone call to someone? Only as long as it takes to look up the phone number.

By the way, time isn't the only thing you can waste in too much preparation. You can waste a lot of money, too. Some people spend unnecessary money on prepared lists of companies, complete with names of key contacts. All the information on such a listing can often be obtained in a few seconds of phone time, and the information you get will be accurate and up to date. You might even have an employee make those pre- qualifying calls for you. He, she or you simply calls and says something like, "Hi, I need to send some mail to the owner or manager of your company. Can you give me that name, please?" Before you get off the phone, verify the person's correct title. You can even ask questions like, "Do you know if he goes by Dave or David?"

There may be another reason why you avoid the necessary effort of important sales calls. Your job demands that you tend to a lot of duties other than sales. Some of those things, like learning new photographic techniques may be more fun than selling, and some simply have to be done. The answer to this dilemma is to organize your time sensibly and effectively. Make a schedule that sets aside time for your selling activities. Then stick to that schedule. Varying from it will cost you money. It might even cause the failure of your business.

Finally, let's look at the hours you spend working. This is so simple, you probably already know what I'm going to say. But, I'll say it, anyway. Starting at 8:00 as opposed to 8:30 gives you an extra half hour to make calls, and do other work. The same is true for going until 5:30 instead of 5:00. And you have a choice between a forty-five minute lunch and an hour or even two.

If you add an hour of working time to each day, you gain more than six weeks of additional time in only a year. That's a month and a half of time that will produce additional income. It might be enough to pay for your child's braces, or a semester of college. Can you use those extra paychecks?

Step Three: Ask, Listen, & Learn

We've talked about the idea of positioning. One way of stating that is: "You must sell in your customer's head, not in your own."

Let's get a better handle on the idea. If your customer buys your product, it will be because of a very few things. These reasons to buy will be the customer's own reasons. They will be important to him or her. They may or may not be things you think are important.

Why do customers buy? They may carefully compare the features of all the products available, consider costs, financing and other factors, and make a rational decision. Or they may simply like you better than someone else they talked to.

In the customer's mind, there are no good or bad reasons for deciding. There are simply the reasons that matter to them.

As a photographer, you spend hours educating yourself about technical skills, management, business, etc. You know a lot about your profession, as you should.

What many salespeople fail to understand though, is that all this information isn't very important to most customers. Some of us get pretty wrapped up in our own thinking. We study every possible reason a customer might have to buy our service, and every reason seems important. We conclude that if every customer knew all that we know, they'd all buy from us. So we learn all we can, then dedicate ourselves to teaching it all to our prospective clients.

The truth however, is that only one thing (or perhaps two) is important to any one customer. The critical thing may be price. It may be reliability. It may be on-time delivery. It may be something the salesperson never thought of. It may be a different thing for every customer.

It is the salesperson's job to learn what motivates each person, and to sell based on those few essential points. We must sell in their heads. We must answer the customers' needs.

Often, salespeople completely miss the one important point for a particular prospect. They will tell and retell all the things they see as important about their product. They'll cover all the things the last buyer thought were important. But they don't get the sale, and they don't know why.

These salespeople are attempting to sell based on their own thinking and it never works. When they occasionally have a successful sale, it is only because they accidentally delivered the one point of information that was important to the customer.

Simple enough, but how do you find out what is important to each customer? You find out from the one person who knows—that customer—and you find out by asking them questions. They won't mind telling you, and they'll recognize and respect your desire to meet their needs.

The first thing you'll need to know is whether the person you're talking to is really the person who'll make the decision. If you're talking to a bride for example, it's possible that her parents will be paying for the photography, hence they'll make the decision.

If you're talking to the manager of a bridal salon about recommending you as a wedding photographer, it may be the owner of the business who'll decide whether or not to refer customers to you. In the case of the bride, it's perfectly appropriate to ask if her parents, or anyone else would like to see your work before they decide on a photographer. Her answer will tell you how the decision is being made.

With the salon manager, things may be a little more complicated. Early in the conversation you'll want to ask who in the business would make such a decision, and you'll get an answer. But, it may not be the right answer. You may get the wrong answer because the manager wants you to be impressed with his or her power. Or, it may be part of the manager's job to screen the owner from unwanted sales calls and interruptions. In this case, the manager may have the authority to tell you no, but not have the authority to say yes.

The way you learn the truth in this situation is very similar to your method with the bride. At an appropriate spot in your conversation with the manager just ask, "Is there anyone else you

might involve in deciding whether your salon would refer customers to me?" The answer will usually tell you what you need to know.

The more important questions you'll be asking, though, will be about your customer's needs and wants. If you're talking to a bride, you'll ask about the size and date of the wedding, the style of photography she wants, whether she has budgeted a certain figure for photography, whom she'll be giving photographs to, and who among their friends and family may want to purchase photos. Notice that all those questions address things that are important to the customer. The answers will furnish information that is important to you.

Listen very carefully to the answers. If a bride indicates that she's not too interested in price, but very interested in getting a certain style of photography, you'll learn how to sell to her. With this bride, you won't talk about how your pricing structure saves her money. You'll talk about how hard you work to understand and interpret each bride's feelings about her wedding.

Listen, too, for other things she tells you. If she makes a comment about how her grandmother hates rude, inconsiderate people, you know to be very polite, and maybe to slip in an anecdote about how well you've gotten along with one of your clients. You may make a comment at some time about being especially attentive to her grandmother. If you show a genuine interest in that concern, you may be the only photographer she talks to who did so. You may get her business for that reason alone.

When you're selling yourself to another wedding professional, such as a caterer or salon, you'll follow a similar procedure. Ask questions like, "What do you especially like about the photographers you've been working with?," or, "Have you ever had a problem with a photographer you've recommended to a client? What kind of problem?" Answers to questions like these will tell what's important to the person you're selling to.

How you ask your questions, and how you listen to the answers, are as important as the questions themselves. First, remember that this is conversation, not an interrogation. If you just fire one question after another, you'll sound like a detective, rather than a friend. Talk and laugh with your customer. Be interested and interesting. Don't try to act like you're interested; *be* interested. And don't be afraid to talk a little about yourself, your family, your interests, etc. That makes you human and interesting to them.

Listen not just for what customers say, but also for what they mean. You can interpret a great deal about their attitudes and beliefs by listening to the tone of what they say.

Remember, too, that your customers' beliefs are their facts. It doesn't matter whether they're right or wrong in your eyes: what they believe is true to them. If you can show them, based on what they believe to be true, that you're their best choice for a photographer, you've sold them. If you try to talk them into something they don't believe, they'll choose someone else.

Step Four: Present Only What Serves the Sale

The reason for all those questions is to tell you what to present to your customers as reasons to choose you or your studio. They don't want to know everything there is to know about you. Remember that they'll make their decision based on very few things.

Since they're not interested in everything, don't tell them everything. Tell them all they need and want to know to make a good decision, and not one thing more. If something's not important to them, even if it's the best thing about your service, leave it out.

A lot of what you know isn't important to your customers. They probably don't care what kind of film, camera or lights you use. They do care about how the photos look. They might not care about how sharp your images are, and they may not care how clear their pictures are. Those may sound like the same things to you, but not to them. Present what's important to them.

This brings us to the discussion of features versus benefits. A feature is some detail of information about your product or service. A benefit is why that feature is important to the customer. For example, you may always use two lights for your group shots: that's a feature. If you use the two lights properly the result will be softer shadows and better modeling of facial

features: those are still features. Your customer will be able to see everyone's faces and expressions more clearly. That's the benefit! All that other stuff isn't important to the customer. Seeing people's smiles more clearly is important.

Present the benefits to your client. Talk about the features only to support the benefits. Say, "I know its important to you that you have the proofs ready when you return from your honeymoon. That's why I use a lab that always gives me good processing in three days." The first sentence of that statement is the benefit; the second sentence is the feature.

If you use a brochure to help in your selling, use it in exactly the same way that you make the rest of your presentation. After you've listened to what your customer wants, open the brochure, and point out only the parts that show or explain how you will meet her needs. Then give her the brochure to take along. She'll remember the items you discussed with her.

Step Five: Handle Stalls and Put-offs Firmly.

We've already established that your customers aren't going to like everything about your service, and they aren't going to agree with everything you say. Your prospects will often stop or slow the selling process. They'll do it by telling you something they don't like, or some reason why they can't do business with you—at least not at this moment.

Very often the best way to handle a stall is to acknowledge it, ignore it, and proceed with the selling process. If for example, the bride says, "I'd like to think it over," you might respond with, "Of course, this is a big decision," then simply ask the next question you had planned to ask. When she answers that question, use it to talk about another benefit that will be important to the bride. Now you're back in the selling process. You've disarmed the stall, and you haven't made the bride uncomfortable.

Sometimes, you can't do anything with a stall. You simply have to give in to it. If the bride wants to talk to her mother about the decision to use your services, you probably can't do anything but invite her to bring her mother in the next time she visits. You might even try to set an appointment. But, you're not likely to book that wedding that day. You might try one time to acknowledge and ignore the stall, and proceed. If it is just a stall, you may get around it, but probably not.

Don't make stalls more important than they are by paying too much attention to them. They're just a natural part of the selling/buying process. Expect them. Don't be intimidated by them. Remember that your job in selling is to help prospects make decisions that will be good for them.

Step Six: Handle Objections Skillfully

Objections are very different from stalls. An objection is a factual concern that is preventing the customer from agreeing to do business with you at the moment. There are typically three different kinds of objections, and I'm going to suggest a procedure that will serve you well in handling all of them.

The first thing you must do is listen carefully to all of the objection. It's sometimes tempting to jump in before the customer is finished stating the objection, and try to answer it. There are two major dangers in pouncing on an objection in this way. The first danger is that you may cause the customer to feel like you don't respect her concerns. The second danger is that you will misunderstand what she's saying, and answer the wrong objection. So listen carefully until the customer is through stating her objection.

Then be sure you understand what she means. Ask her to clarify her concern. Get more information about it. At this stage, a wonderful thing sometimes happens. She may answer the objection for you. By talking a little more about it, she often figures out that it isn't a problem after all. At least, you'll both understand the difficulty a little better.

Now, when you're sure you understand what the customer is objecting to, you have an opportunity to answer her objection. Objections tend to fall into three categories, and there is a method for each one.

Many objections are simply misunderstandings. These are the easiest, because you simply have to clear up the misunderstanding. Be sure you don't make your customer feel wrong or stupid in doing it. If the customer thinks your fees are too high, and by asking her to explain more, you learn that she doesn't realize her initial deposit applies to the final order, your job is easy. You say, "Oh, I'm sorry. I didn't explain that very well. All of your initial deposit applies to your order." Then you give her an example or illustration of how the deposit works. Notice that in this example you made the misunderstanding your fault, not hers.

Another group of objections arises from a lack of information. Maybe the customer says she wants a more experienced photographer, and she doesn't realize that you have five years experience, and have won several awards for your photography. This kind of objection is also easy to overcome much of the time. Simply provide the missing information. Again, be sure you do it without making the customer feel wrong or ill at ease.

Now for the tough objections. These are the ones that are real and factual. Let's use the last example again. Suppose the bride wants an experienced photographer, and you've only been in business for two months, and have only photographed twenty weddings in your life. You can't explain this one away. The only way to overcome it is to minimize it with other benefits.

Compare this problem with the things the bride has already agreed she likes and which are important. Maybe she's already told you that she likes your style of photography. Perhaps she likes the albums you use, and no other photographer in your town offers them. Perhaps your payment plan is attractive to her. What you do is reiterate the three benefits she has said are important, then minimize the objection in any other appropriate way.

You might, for example, tell her at this point about some nice compliment you got from the bride at your last wedding. If your answer to this kind of objection is less than perfect, it doesn't necessarily mean you'll lose the sale. Few buying decisions are made on only one factor. If there are several things the customer likes about you and your business, and only one she doesn't like, she is still likely to choose you. There's probably something she doesn't like about your competitor as well.

No matter which type of objection you've gotten, and which method you've used to answer it, your procedure now is the same. The next thing you do is confirm that the answer is satisfactory to your customer. Remember, you have to sell in *her* head. It doesn't matter that you believe you've overcome her objection. What's important is that *she* believes you have. You find out by simply asking her if her concern has been answered.

You may think you're finished with this objection now, but the most important part of the process is yet to come. Any time you've successfully dealt with an objection you should attempt to finalize the sale. You may have just cleared up the last objection. If so, you can get an agreement to do business at this time. Step eight teaches you how to close or finalize an agreement.

Step Seven: Use Urgency

People are more willing to make a decision if there is some kind of deadline that urges them to action. That's why companies put expiration dates on coupons, and offer sales events for just three days. If, as a customer, I know I have to respond by a certain date, I'm more likely to just do it now, and less likely to put it off and forget it.

In booking weddings, you have a built-in urgency in the wedding date itself. If the bride is getting married on June fifth, everything has to be done well in advance of that date. You can add to the urgency, because you may have other brides who want your services on that date. You can always encourage the bride to book the wedding today, because someone else might reserve that date tomorrow. If you're already booked up for another date close to hers, or for some date later than hers, be sure to tell her so. All that adds to the urgency.

If you're trying to finalize a referral agreement with another wedding professional, you might use the date of an upcoming bridal show, or the ad deadline for a magazine as an urgency.

58

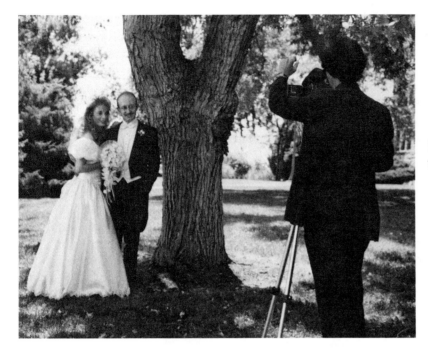

Urgency helps you sell. The date of the wedding is a natural, built-in urgency.

Let's go back to the most important point in selling. You have to sell in your customer's mind, not yours. So, the urgency has to be something that is meaningful to the customer. Your house payment coming due isn't meaningful to her.

Step Eight: Finalize the Agreement

In sales parlance, this is usually called "closing". Much of the time, you aren't actually making a sale. You may be closing when you set an appointment for the bride to come in with her mother. You're certainly closing when you book a wedding. You're closing when you set an appointment for a formal sitting or love portrait. And you're definitely closing when you take the bride's final order. You're closing any time you make an agreement and ask for money. But, if the term, "closing" sounds too much like selling used cars, feel free to think if it as, "finalizing the agreement."

One of the great misunderstandings about closing is the expectation that at some point your customer is going to say, "Yes." The truth is that she probably won't ever clearly tell you she has decided to use your services. What will probably happen is that she and you will simply proceed with the process. That's what's easy and comfortable for her, and it serves your purposes very well.

Your closing technique then is easy. You just proceed as if she had said yes. Let's say you're booking a wedding. If you've talked to the bride for a little while, and she's agreed that she likes a couple of things about your work, you're probably ready to close. If you've just answered an objection, you're certainly ready to close.

The way you do it is to pick up your appointment book, and ask her the time and date of her wedding. When she tells you, check to see if that date and time are open, and begin writing her name, phone number, etc. in your book. (Always use pencil in your appointment book.) Then hand her your checklist, and tell her how to fill it out. Then ask for a check to cover the initial deposit. Then hand her a copy of your agreement and a pen, and point to the place for her signature.

If all of that happens without any stalls or objections, you've successfully closed. There's nothing mysterious about it at all. If the bride isn't ready to finalize the agreement, she'll interrupt you, and give you a stall or an objection. You know how to deal with both stalls and objections. Either one will take you back into the selling process.

If it's an objection, it will bring you back to another closing opportunity. If it's a stall, you'll ask some more questions, until you have an opportunity to talk to the bride about another benefit that's important to her. When you've discussed another benefit, you're ready to close again.

On the second attempt to close, you just pick up where you left off. If the bride stopped you before you finished writing the appointment in your book, simply start writing again.

There are only three ways out of this process. The first is the get the final agreement. The second is to get a commitment to the next step in the buying process—an appointment to talk again, for example. The third is to learn that this particular prospect is not going to be a customer of yours. That third possibility is still good news for both of you. It allows you to end your discussion with this person and spend your time with someone who *will* become your customer, and it allows the former prospect to go ahead and find the studio she'd rather use.

Some salespeople make a big mistake after the close. They keep on selling. They're on a roll, and they want to keep going. The danger is that they sometimes go on to talk themselves right out of the sale. When you've closed, stop selling. Immediately! Don't be abrupt or rude. You'll certainly want to keep talking with your customer until you've finished with all the details, but quit selling. You can talk to her about her other plans for the wedding, or any other pleasant topic. Just don't sell anymore. Finish the business at hand, and pleasantly move on.

In the case of booking a wedding, explain anything about your procedures that hasn't been covered, discuss the use of the checklist, and discuss when you will be talking with the bride again. Always thank your customer, and talk about the fun you're going to have working together.

Step Nine: K. I. S. S. - Keep it Simple and Sincere

It's all too easy to make the sales process complicated and intimidating. It should never be so. The process is as simple and natural as breathing. It is a conversation with a purpose. You are simply helping your customer make a good decision. You believe in yourself, your product and your company. As long as you're acting out of those beliefs you'll be comfortable selling your services.

The attitude you have toward your customer is vitally important. The key thing is to honor her knowledge and intellect. Your customer wants the same thing you want. She wants to make a good decision. If you honor and respect that need, you'll be treating your customers well in the selling process.

Part of the idea of keeping the selling process simple is to keep it light. Have fun. Enjoy what you're doing. And don't take anything too seriously—not your work, not your profit, not your customer, and especially not yourself. You can almost always have fun with the people you're doing business with. You simply have to decide to have fun.

The actions you take in selling are prescribed by the circumstances. You simply do all that's necessary to help your customer make a good decision, and do nothing that's unnecessary.

One last thought about that "sincere" part of this step. Be yourself. Be genuine. Most of your customers will recognize that, and respect it. It will be the foundation of building a strong, healthy, productive business.

Chapter Seven
Selling the Wedding

In the last chapter we talked about selling in general, with a few examples about applying those principles to selling wedding photography. Keep those Nine Steps to Successful Selling in mind. Use them as background for the information in this chapter. Now we're going to take you step-by-step through the process of selling a wedding.

Before we begin, let's review a few points from the last chapter. The successful salesperson isn't pushy. The best sales presentation will never be perceived as hard sell. In selling wedding photography, you're sowing seeds at every stage of the process. Every time you talk with anyone involved in a wedding—bride, groom, parents—you're building good will and positive feelings. You do it with genuine friendliness and light humor. You're always making suggestions. Never, *never* sell through intimidation or coercion.

If you are doing the sales job well, you know what your customer needs and wants, and that's what you're giving her. Always remember that you are selling in her mind. If she perceives your product to be valuable, she will happily buy it.

Thoughts From Piare: A Solar Sales Shark

Back when the energy crisis first happened, and the government was offering tax breaks for energy conservation measures, I got a phone call about putting solar heating in my studio and home. I told the woman on the phone that it was then the middle of our busy season, and I couldn't have the studio torn up with construction during that time. She asked me if I could give a salesperson just fifteen minutes to explain their product, and then I could decide later if I wanted to proceed with the conversion. I told her I would give the sales person only fifteen minutes, but that I'd be happy to talk to him, and we set an appointment.

When the guy got there, he wanted to see the house, and was very critical of the way the heating was installed. He told me I really needed his solar heating, and must have it installed right away.

I told him the same thing I'd told the woman on the phone–that I couldn't have it installed during my busy season. He didn't seem to be listening. He got angry, and told me that I had wasted his time, that he could have been selling to someone who was ready to buy.

If he had been willing to understand my needs, he might have been able to sell me the solar heating. He could have made a sale in January, after my busy season was over. The tactics he used just assured that I'd never buy from him.

Selling This Wedding and the Next One

When you're selling your wedding services, you're always doing two sales tasks. You're selling this wedding, and the next one. At every stage of your dealings with the couple you're building your personal relationship with them. It is through that personal relationship that you gain their confidence, which will allow you to book their wedding, and maximize your sales from that contract.

It is also through that personal relationship that you'll get referrals to their friends and family for future weddings. If you always book one new wedding from every wedding you do, and occasionally book two new ones, you'll ultimately have all the business you can ever handle.

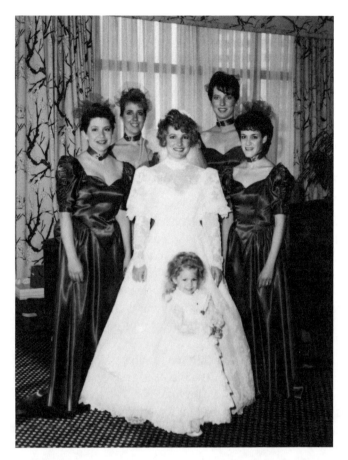

Every wedding has the potential to lead to more weddings. There may be five new customers in this picture, though one won't call immediately.

Throughout the process, you're also going to be making suggestions, and offering possibilities regarding additional photography, or additional print sales. In this way you build their expectations about how much photography they're going to buy. They'll never buy all, or even most, of what you suggest, but the more you suggest, the more likely they are to buy some of it. Of course, you'll always be trying to make suggestions that fit your customers' needs and wants. You'll always be selling in their mind.

Another way that you should always be selling is by simply doing your best possible work. Again, the customer's perception is what's important. If you have positioned yourself as a lower priced photographer, doing your best work means something different to your customer than if you've positioned yourself as a prestige studio.

In the case of the lower priced service, it means being sure that you give your customers good value. You want them to feel that they got their money's worth and a little more, and that they enjoyed the process. Deliver full value. Gain their respect and good will. Always make a good impression.

Thoughts From Piare: In Business at Fifteen

When I was fifteen years old, I plunged into my own business in India. I truly believed that, in the State of Punjab, there was no other photographer who was better than I was. I don't know why I had this feeling inside. I wasn't a bad photographer, but by no standard was I the best. Still, I truly believed in my mind that I was. That comes through to the customer, because you're striving to produce the best possible results. I was always trying to work to the best of my ability. That enthusiasm shows in your work. Even the best photographer might not have that enthusiasm. That is fifty per cent of the battle right there.

If you're positioning your business as a higher priced, prestige studio, your job may be even easier. Often, the person who is spending a great deal is easier to get along with than the one who is watching every penny. The two of us (Piare and J. C.) have managed both prestige studios and economy operations. Our experience is that customers of the fine portrait studios were more enjoyable to work with, more forgiving of mistakes, and more receptive to ideas. They appreciated our work more, and were generally more cordial.

The point here is the same as we made in the last chapter. Confidence in yourself and in the value of your work will help you sell. Sometimes, charging more actually helps build your confidence—and that of your customer. We caution you, however, against arrogance. Don't boast that you're the best, just believe that you are, and demonstrate it in your work.

Who Will Do Your Selling?

Everyone who comes in contact with your customer must be a salesperson. Every contact with the client is a selling contact. This means that everyone who answers the phone in your business must be—at the least—courteous, professional and attentive to the customers' needs. Everyone who may answer questions for customers must understand the importance of selling.

There are a few special considerations if you're operating your business out of your home. The first is that all the family members who might answer the phone have to be on your team. Your phone must always be answered courteously. Phone messages must be handled professionally.

This doesn't mean that you have to send your teenaged children to sales training classes. It does mean that they must know how to say things like, "He isn't available to answer your questions just now, but I'll be happy to take your name and number:" "He should be able to call you back in about an hour:" "I'll be sure he gets the message:" "Thank you for calling." Then they have to be responsible enough to get the message to you. Even teenagers can be trained to be thoughtful and courteous.

If you have younger children, it's probably best that they simply don't answer a phone where business calls are likely. No matter how intelligent and polite small children are, their young voices don't inspire confidence. You may be impressed with your four-year-old's charm, but your customer may not be.

If you can't civilize your adolescents or keep your toddlers from picking up the phone, you might consider installing a separate phone line for business calls. That phone should be equipped with a good answering machine or a live voice answering service, and should never be answered by anyone who isn't prepared to work with a customer.

If you have a studio, you'll probably have a receptionist who will answer the phone much of the time, and will certainly do a lot of your selling. Actually, you may prefer to call that person a Sales Receptionist, so the work title accurately reflects the job you need him or her to do.

Hiring and training good sales receptionists is an important part of operating a studio. If you're a portrait photographer, and do senior photography, you have a ready pool of talent available to you. You can hire students to work part time, helping you with ordering and production jobs and answering the telephone. An especially good source for these part time employees is the school drama and singing groups. These students often have a great deal of poise and self-confidence, and they probably have the ability to control their emotions.

Start your part time employees in production jobs, where they can observe you and your staff, and where you can observe them. Look for two things. If you have someone who gets excited about your best photography, and who genuinely likes people, he or she has the potential to be a good salesperson.

If you're not hiring students, the same things apply. Look for people who are genuinely excited about quality photography, and who really like people. Nearly anyone who has those qualities can sell. People will do well at what they enjoy.

It takes time to train sales receptionists. The first step is to have them observe how you and the rest of your staff interact with customers. You want to build an atmosphere of friendliness and professionalism in your studio. Demonstrate to the new people that your working style is to be interested in your customers and dedicated to meeting their needs. You can tell that to new people, but you can *show* them better than you can tell them.

Tell your new salespeople about your objectives. Be sure they understand how important it is to get business, to maximize sales, and to please customers. Make sure they understand how you want to position your business in the minds of your customers.

You'll want to have some clear working guidelines for your staff, covering everything from how they are to answer the phone to how many coffee breaks they get. Your employees have to know what is expected of them before they can provide it. Seek uniformity. It's important that your customers get the same level of service, no matter whom they talk to in your studio.

As you train new salespeople, you will slowly give them confidence by letting them participate in customer contact and selling. You may want to have them try their first solo efforts with customers they already know and like. That will reinforce the idea that selling should be enjoyable, and that their primary job is to care for their customers' needs.

Expect mistakes, and some poor performance. Don't worry too much about how that affects your customers. Most people are pretty compassionate when they see a new person trying to do a good job. If a mistake causes inconvenience for a customer, just step in and correct the situation in the best way you can. When your new people make errors, correct them carefully. More important than pointing out every mistake, is to notice, reinforce and reward all the things they do right.

The first line salesperson, however, is the photographer. If that person is you, you're going to have to be the best salesperson on your staff. And you can be. Actually you don't have a choice. At least half of the selling opportunities occur when only the photographer is present. The skills you need to be a good salesperson are many of the same skills required to be a good photographer. In fact, if you're not a good salesperson, you probably can't be a good portrait or wedding photographer. It is very much a people business.

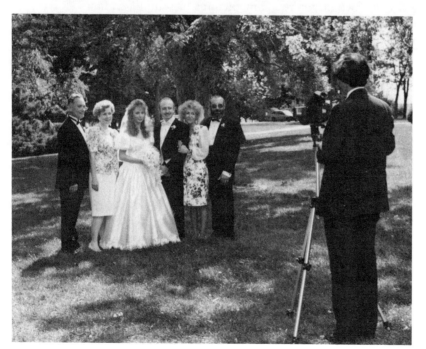

You are your own best saleperson, and you have plenty of people to sell to.

Training your other photographers to sell, or training yourself, is very similar to training receptionists. A good portrait photographer is a salesperson, psychologist, and performer, as well as a photographic technician. The photographer must constantly manipulate people's emotions and draw them out of themselves so as to achieve mood and expression in the photography. He or she must be one in spirit with the subject. The successful image is made through a union of the photographer and the subject.

The skills that allow a photographer to develop mood and heart in images of people also equip that photographer to be a successful salesperson. Both are jobs of the emotions.

You, or a photographer on your staff, may not believe that he or she is a good salesperson. The ideas we discussed in the last chapter about building a winning attitude will help correct that problem. In implementing those ideas in your sales training, you will want to do the same kinds of things you do in training a new sales receptionist. One of those techniques is to have that photographer begin by selling to the people he or she already likes, and has developed some friendship with. It's important that they have fun.

Thoughts From Piare: A Shy Stranger in a New Country

When I first came to the U.S., I was a very quiet, shy person. I'm naturally pretty quiet, anyway, but back then I didn't have much confidence in my English, nor in my familiarity with Western ways of doing things. My first selling experience was at the Markay and Jafay studios. Those studios had been sold to a new owner, and he was reorganizing a lot of things. We didn't have enough help at some of the studios. He offered me a $200 raise, but told me I had to do whatever needed to be done in the studio, including selling. I told him I didn't know how to sell, but he said that didn't matter.

Those first couple of orders were tough for a shy person. We had a delightful lady working with us, whom I very much admired, for she was a superb salesperson. The customers loved her, and her sales were great. I was so shy, and she was so outgoing, so I just watched and studied how she interacted with the customers. She's the one who gave me a little clue about having fun.

Fun is an important ingredient whether you're taking pictures or selling. In fact, when you are selling too hard, you're defeating the whole purpose. It should be fun for both the person selling and the person buying. Good selling is second nature. It doesn't feel like selling.

No matter how skilled a salesperson you are, and no matter how much you enjoy selling, as your business grows you'll have to have other people trained to sell in your operation. You simply can't do it all.

Selling At the First Contact

Let's assume that the first contact a prospective bride or her mother makes with your business is by phone. She will call, and probably ask about prices, or say she needs some information about wedding photography. You are selling from those very first words.

There are two reason why the first thing you'll do is ask the date and time of the wedding. You may already be booked for that time. If you are, both you and the bride need to know that right away. Even if you're not booked—even if you only have two weddings on your calendar for the next year—you want to act as if you might be booked up. When the bride thinks you're very much in demand, it gives her confidence in you, and it even helps you to begin expecting good things to happen in your business. Always check the date first, even if the wedding is scheduled a year or more in advance.

The next thing you'll ask is how the bride found your studio. This is important information. One obvious reason you want to know where she heard of you is that it helps you evaluate the effectiveness of your promotions and advertising.

A more important reason, however, is that it gives you valuable information about how you're going to sell to this bride. If she has come to you because you photographed her best friend's wedding, or because you created her senior portraits and she loved your wedding samples, you probably already have her wedding booked. You'll certainly want to proceed with the confidence that you do. If, on the other hand, she is just beginning to check prices, and called you from the yellow pages or some other promotion, you will have more convincing to do.

If the caller begins by asking about prices, it's very important that you give her some price information early in the conversation. Don't ever let your prospect think that you're withholding information, or that she can't get from you what she needs.

You don't have to go into great detail about your price list just yet, however. You can say something like, "Our prices for complete wedding coverage start at $XXX and can be quite a bit higher for the larger weddings. May I ask just when you've planned your wedding, so I can first see if I have that date open?" You told her what she asked, in a few words, with no hesitation, then you took control of the selling process by asking a pertinent question.

If your caller asks more questions about price, or anything else, give her good information quickly and in a very friendly manner. If she asks you to mail a price list, be very happy to do so. Get her name and address. Ask for her phone number, too, so you can follow up, but go on with the rest of the call, as we're about to describe it to you.

Whenever you're talking on the phone to a customer, try to visualize her in your mind. Even if you've never met her, imagine any face, so you'll be conscious that you're talking to a real human being. Smile, just as you would if you were talking to her face to face. Keep your conversation polite, but light-hearted and fun. If you do those things, your prospective customer will feel that you're someone she'd like to meet and do business with.

Regardless of the source of this phone call, your next step is the same. You will invite her to visit your studio. Ask her to come for a cup of coffee with you and to have a look (or another look) at your work. It's a good idea to make an appointment for this visit.

If the caller has been referred to you, and you're confident that you're going to be able to book this wedding, you'll want to mention that all she has to do to reserve the date is to make a deposit (tell her how much) which will apply in full to her final order.

Never be shy about discussing price. If you're talking to someone who simply can't afford your services, you need to know that as soon as possible. If you're talking to one of those people who don't plan to pay for your services, she needs to know she can't get away with that. Anyone else is best served by knowing how much everything is, and when payment is required. If you're confident in discussing price, it gives your client confidence that the price is fair and appropriate.

Don't shrink from discussing any issue about your services. Anything you're hesitant to discuss with the prospect will just become a bigger issue to her. Talk frankly about your prices, policies, philosophies of business, and the style of your work.

If this caller has only seen an advertisement of your work, don't suggest that she bring the deposit money with her. She needs to know more about you before she can make a decision. Instead, invite her in, and suggest that she visit other photographers as well. You can almost give her instructions, "I'd like for you to see our work, but please visit a couple of other photographers as well. That way you can better judge who will do the best job for you." Your can even give her some pointers about what to look for in good photography.

It's okay to suggest that she visit other studios. She's going to do it anyway. By making that suggestion, you're indicating that you think like she does, and that you're not going to pressure her into a decision. And you're not.

Look back at all the things you've done in the first few moments of talking with this prospective customer. If you've done it well, you're likely to book this wedding. You can see why it's so important that anyone answering your phone be a good sales person.

Selling at the First Visit

When the bride visits your studio, you want to be friendly and hospitable. Welcome her (or them) and invite her to sit where your albums are displayed. An ideal arrangement is to have a glass top coffee table in front of a love seat or small sofa. The table should have a shelf between its top and the floor. On that shelf, you'll store all your sample albums, visible to your customers, but out of the way. This lets you present one album at a time, while showing that you have plenty to look at. You should probably have about six albums, featuring different sizes and styles of weddings, as well as younger and older couples.

Offer your guests something to drink. Have some variety, at least coffee, tea, and some kind of juice or herbal tea. Some studios like to offer wine. Use your own judgement.

Then, get out one album for them to examine. Select one that's likely to appeal to your customer. You know by now where the wedding is going to be. You can see how old the customer is, and how she is dressed. All these are clues to the kind of wedding she's planning. Start with an album from a wedding that may be similar to the kind of ceremony she'll have.

Now, excuse yourself, and let her go through the album at her own pace. Don't hover over her. After a few minutes, come back and answer any questions she might have. Offer her a second album to peruse, and excuse yourself again.

When you return the second time, sit across the table from her and begin to chat. At this point, you should be assuming that she is going to book the wedding with you. She probably is. Getting her to visit your studio is about sixty per cent of the sale, especially if she is familiar with your work. Answer any questions she has. Ask her some questions, such as which of the albums she liked best, or which photos she especially liked. Use questions that show your genuine interest in her needs.

This is a good time to show your checklist, and explain how you use it. If she hasn't seen your price list, you can show it as well, and indicate which of your coverages might be most appropriate for her needs. Briefly explain in her terms how your pricing works. By that, I mean that you should talk about how she can select what she needs and wants, and how it will be priced for her. Remember that you're selling in her mind!

Selling at the Time of the Booking

You're almost home. It's time to begin closing the sale. Remember what your attitude should be. You're taking for granted that you will photograph her wedding. All you have to do to close the sale is to go forward with the details of completing the booking.

You should have a form that gets the basic information—addresses and phone numbers of the bride and groom, time and location of ceremony and reception, etc. Ask her to fill it out. As she does, you can keep asking questions about the ceremony, her taste in photos, special guests who'll be attending, etc. Those are all things that will help you talk about the benefits of selecting your studio.

If she starts writing, and keeps writing, you've got this booking. The only other things she might do are to ask a question, stall, or object to something. You know how to deal with all of those possibilities.

While she is filling out the form, mention that all she needs to reserve the date is to make a deposit that applies in full to the order. Tell her how much the deposit is. Also explain that the balance will be due after the wedding, when you deliver the proofs.

Get your appointment book, and open it to the date of the wedding, and write in the appointment. When she has completed the form, ask, "Did you want to make the deposit with a check or a charge card?" She'll either start making the payment, or she'll question, stall or object. You know what to do.

When you have the deposit, hand her your agreement. Say something like, "We do have a simple agreement, so it's clear what we will be doing for you." Then you proceed to explain each

part of the agreement in simple terms. Discussing it openly and in positive terms, assures that she understands it, protects you legally in the event you ever have to enforce it in court, and helps the customer know that you're not hiding anything.

Specifically, you'll want to discuss that you can't guarantee to photograph everything on her checklist. You'll make every effort to do so, but time, weather, etc., may make some photos impossible.

Call it to her attention that she's signing a release which allows you to show and publish samples from her photos. Most people are flattered that you might do that. Explain the liability limitation. Use words like, "If, God forbid, the studio should burn down, or something like that happen at the lab, you will get all your money back, but you're agreeing not to take me to court."

Don't be too serious when explaining these things. Keep using the same good natured humor you've used since she stepped into your studio. Then point out that she is acknowledging receipt of the price list and that she understands it.

All the way through these details, remember that if she doesn't stop you, she is hiring you to do the work. If she does stop you, it will be with a question, a stall or an objection, and you know what to do with each of those.

If the bride has come to your studio alone, she probably won't book the wedding that day, but proceed as if you expected her to. If you're talking to the bride alone, she'll probably tell you she needs to talk to her fianc or her mother. You tell her, "Of course. This is an important decision. Listen, I'd love to meet him (or her,). Can we arrange a time for that?" Make an appointment, and proceed.

When you have the date on your book, the deposit in hand, and a signed agreement, you've made the sale. If any of those is missing, you haven't.

With those three details completed, you go on to the next selling phase. Discuss how you and the bride will use the checklist. And discuss how the photography will be scheduled on the day of the wedding. If she hasn't brought it up before, this is where you talk about doing the couples and group shots before the ceremony. We've already covered how to approach that question. The important thing is to do it now. Don't wait until you're closer to the wedding day. Get the decision made early, and get it behind you. Whatever they choose, they'll become more comfortable with their decision as time passes.

Selling at the Preliminary Conference

You may talk with the couple several times between the booking, and the ceremony. Each of those conferences is a selling opportunity. You'll certainly see them at least when they return the checklist. At this time, you'll go over all the information about their wedding. Double check everything. Be sure you have all the right times and addresses. Be sure you have accurate phone numbers for the bride and groom, the parents, the minister and the church. If something goes wrong on the day of the wedding, any one of those numbers may save the day. Leave nothing to chance. We talked in chapter two about how to discuss the checklist with the bride, so we won't go into it again here.

You'll also want to review your shooting schedule for the wedding day. Be sure the bride knows when she, the groom, the wedding party and family members need to be available for photos. Explain that mix-ups in scheduling can delay some of the events of the day, or cause her to miss some of the images she wants.

Solicit and encourage any questions the bride or groom may have. This is the best time to communicate any information you or they need to know.

There are several real selling opportunities at this conference, too. Take the opportunity to go over the price list. Show the bride that additional print prices are lower than first print prices, and point out that all the family and guests can save money by ordering any photos they may want at the time of the original order.

Also show how small albums can be more economical and useful than ordering a lot of loose prints. Most people order parents' albums. Recommend that small albums are also a good idea for grandparents, aunts and uncles, and even close friends who may want quite a few prints. Note that with these suggestions, you're already selling the final order.

You might book the love portrait, the bridal formal, or both at any time. You may sometimes photograph the love portrait before you've even booked the wedding. If you haven't sold those sittings yet, this is the time to do it. It is best if you do them early enough that you can make a 20x24 or larger print to display at the ceremony or reception.

You can make one more suggestion that may generate hundreds of dollars in additional sales. The week of a wedding is a great time to do family portraits. Everyone is in town, they've brought their best clothes, and they're all in a festive mood. It's perfect. Of course, you'll be photographing them all at the wedding, but they'll be in tuxedos and gowns, and you'll only spend a moment on each pose. If you do an outdoor or home portrait a day or two before the ceremony, you can create beautiful images that the families will want to use for family albums or wall portraits.

Thoughts From J. C.: Sell Family Albums

Whenever I photographed families, especially extended families with all the children, in-laws and grandchildren, I used to offer them family albums. I used high quality albums, like my wedding albums, in several sizes. I developed special pricing, higher than wedding candids because these were all retouched images, but lower than regular portrait prices.

I could sell an album to each of the family units in the larger family, and they each wanted prints of all the others. It's possible in this way to get an order from one family sitting that will be larger than most of your wedding orders. Think about a $2,000 portrait order with no prints larger than 8x10! You can make profits that way.

Selling at the Love Portrait or Bridal Formal

These are terrific selling opportunities, and you may be surprised at what you're selling at this time. This is your best opportunity to get referrals from this couple for the future weddings of their friends. And you'll do this selling without even mentioning referrals.

People will refer their friends and relatives to you only if they like you and trust you. The love portrait and bridal formal are wonderful occasions to build friendship, loyalty and trust. You'll spend quite a bit of time with the bride or the couple. You'll be able to talk and laugh with them. After these sittings, they'll think of you as a friend. Now you only have to do a good job on their photography, and the referrals are on the way.

Thoughts From Piare: Love the Love Portrait

I love to do the love portrait, and my clients love to have it done. If the couple comes together to book the wedding or to return their checklist, I'm going to book that love portrait; there's no escaping it.

I like to book it far enough in advance of the ceremony that I can make a large print to display at the wedding. The guests enjoy it so much.

I do far more love portraits in recent years than I do bridal formals. Maybe it's because I like them better. Also, I photograph so many high school seniors during the peak bridal months. It's easier for me to work an outdoor love portrait into my senior schedule, than to do a bridal formal.

I always book the love portrait first, then attempt to book a formal sitting.

The final opportunity that comes with the making of a bridal formal or love portrait is the chance to display it at the wedding, then sell that print to the couple. Make the print large: one

size larger than the wall portrait size you usually sell in your studio. For example, if most of your wall portrait sales are 16x20, make the display print a 20x24. Don't be afraid to do that. It will be just as easy to sell the larger print, once it's made.

Frame the display print, and take it to the ceremony, with an attractive display easel. Show it to the bride, tell her you liked that pose so much you made a sample, and ask her if she'd like to display it in the church lobby, or at the reception. She won't say no.

Don't put any advertising on it, other than your usual, small, studio stamp or signature in a lower corner. People at the event will certainly notice the portrait, and if they have a wedding coming up in their family, they'll pay attention to the studio name.

You have several chances to sell the display print to the couple. The best opportunity is probably at the time they return their wedding proofs, but you can also sell it before or after that, even several months after the final albums have been delivered. You will sell most of them if the photography and printing are good. You'll sell the frames as well. And you'll easily sell enough of the larger size to make up for the occasional print you don't sell because the couple thinks it's too large.

Thoughts From J. C.: The Challenge of the Bridal Formal

I always loved to create the bridal formal, as much as Piare enjoys doing love portraits. I did them in the studio, with simple but exquisite props, or I did them outdoors, in formal gardens or sylvan settings.

It is such a glamorous portrait. And brides are so excited at that time, it's fun to work with them. Our bridal formal portraits became some of our most dramatic studio samples.

It's also a challenging sitting. Lighting, and attention to detail are very important, yet those things must be accomplished while keeping all the emotion of this time in the bride's life.

If you do restorations of old photographs at your studio, you'll occasionally get a very old bridal formal portrait, or a formal couple's portrait. Make samples of them. They help your brides understand how important such things will be to their children and grandchildren.

Selling at the Wedding

We've talked in earlier chapters about the selling you will do at the wedding event itself. Review the important points, however. You're selling yourself, so your attire and working manner are vitally important. You're continuing to build the loyalty and trust of the couple you're photographing, and that will help you maximize the final order from this wedding. You're also selling future weddings to guests and family members who are in attendance.

Everything you say and do at the wedding affects the impression you create. It is the most important promotion you do.

Selling When You Show the Proofs

This is the time you build the wedding order. If you've done all the previous steps well, the bride and groom like you and your wedding staff. They're excited about seeing their photographs. Now is the time to turn all that work into a good order.

This selling opportunity begins when you get the proofs back from your lab. The proof albums must be assembled with care. Review the material in Chapter Five about how to arrange prints in finished albums. The same things apply here. Open and close your proof albums with exciting images. Put prints in the order of the day's events, not necessarily in the order in which they were photographed.

Here's an exception to the rule of always putting your best foot forward. If your proof albums are too good looking, you may sometimes have more difficulty getting the couple to return the

proofs, and place their order. We're not suggesting that you use ugly proof albums, but you may not want to deliver proofs in brand new, shiny albums. Of course you have to buy new albums periodically, but you can break them in by using them first for large weddings that require two proof books, and delivering one new album with a used one. They should be just old enough that the couple is anxious to bring them back and exchange them for the beautiful finished albums you've been showing them.

The assembly of proof albums is part of the selling process in another way you might not have considered. The person who puts the albums together gets the chance to see all the images, and is probably seeing nice images. This individual will be excited about the albums because of the photography, and because of his or her part in putting them together. The person who just assembled the albums should immediately call the bride and groom to tell them their proofs are ready. Before she calls, you might ask, "How did you like that wedding?" You'll probably get an enthusiastic response. Then say, "Be sure you tell that to the bride."

That phone call should open something like this, "I just finished getting your proofs ready, and you're gonna love 'em; they're really pretty." Of course, all that enthusiasm must be genuine. The phone call should convey the excitement that the sales receptionist really feels about the photos. You can also begin upgrading at this time, with a comment like, "I'll bet you there's no way you can buy that small album now," or "There's one that will make a beautiful wall portrait."

Always make a firm appointment for the couple to pick up the proofs. The first reason for the appointment is that you want the couple to come to the studio in person. You need to have that selling opportunity, and you need to carefully show them the ordering process. It simply won't do for them to have someone else drop in to get the proofs on the way home from work.

The second reason for the appointment is that you want to be sure you have a good salesperson available with ample time to properly show the proofs. You don't want to be rushed.

When the couple arrives to see their proofs, be sure to display the same excitement and enthusiasm that they heard on the phone. Invite them to be seated, and present the proof albums with pride, as if they were fine jewels. Remind them again, before you let go of the albums, that they are going to love these photographs. Hand them the albums, being sure that the first album is on top, and wait to see their initial excitement. Say something to reinforce it, like, " See, I told you you'd like them."

After they've started to go through the albums, offer them refreshments, and leave them alone for a few minutes to enjoy the images. Then return, and get involved again with their excitement. Be enthusiastic, and enjoy the couple's enthusiasm. The more fun this time is, the better your final order will be.

There are really two things you must accomplish when you show the proofs. The first is to sell well, in order to maximize your order. The second is to explain the mechanics of the ordering process, so the couple will succeed in getting their order properly recorded and communicated to you. That's the only way they can get the prints they want. The two goals are achieved at the same time.

Weddings are your business. You work with them every day. You know all kinds of details about a wedding photography order. Your client, on the other hand, has probably never been closely involved with a wedding before. She knows little if anything about photography. It's easy for you to assume that she should know something she has no way of knowing. For example, she may not know she's supposed to show the proof albums to all her relatives. She may not know that there is any difference between the kinds of pictures you've taken and those her uncle took. If you want her to know those things, you should tell her.

It's also easy to assume that the bride, or the groom, knows about the process because you've already told them. Don't assume that either. Anything you've told them up to now may have been forgotten in the excitement of events. The day you show the proofs may be your last and only chance to help the couple understand some of the details of their photography order.

When you show proofs, you will make suggestions, and plant ideas about how the couple can enjoy their photos more and thereby order more. Such suggestions will include a larger bride's album, small albums for relatives and close friends, gift photos, and wall portraits.

The larger bride's album is a simple idea. The couple will probably want to order more prints than they had first intended. Just be sure you let them know its okay to order more than they've contracted for, and that they can still upgrade their album.

Many couples' parents order small albums, but many people don't realize that small albums are a good idea for anyone who is ordering more than six or eight prints from the wedding. Grandparents, other relatives, and friends often end up with a stack of prints and nothing to do with them. They'll set out one or two in frames, and put the rest in a drawer, then forget where they are. A small album solves that problem. It also encourages them to order a few more prints. If you structure your pricing right, your client will also have a monetary advantage with the small album order. Be sure you point these things out to the couple.

Suggest to the couple that one or two of their favorite images will make good holiday gifts for family and close friends. It probably won't be practical for the bride and groom to show the proofs to all their friends and relatives. Gifts are a good way for them to share the joy of the wedding with people who couldn't attend, and to share the fun of the photos with those who don't have an opportunity to see the proofs and place an order.

Of course, you've probably suggested wall portraits on several occasions. At this time you want to remind them that wall portraits can be enjoyed by the couple, their parents, and especially their grandparents. When the couple comes to pick up their proofs, you'll want to have their large formal portrait or love portrait framed and proudly displayed on the wall. Be sure they know the price, and ask if they'd like to purchase it that day, and take it with them.

Tell the bride that the entire order is done at one time, and show her that prints she orders now are less expensive because they are priced as "additional" prints. If she, or anyone orders later, they will have to pay "first" print prices again. Explain that the couple will need to show the prints to any friends or relatives who want to order prints, and show them how your order forms help them keep track of all the orders.

Be sure the couple understands that friends and relatives usually pay for their own prints. Sometimes the bride and groom think they have to pay for additional prints. Show them how to use your order form to price each person's order, and figure the sales taxes. Suggest that they have each friend or relative write a check to your studio for the amount of their order. Explain that such a procedure is easier for the couple, and assures that they won't have to pay for any of the extra pictures.

Remind them that the proofs belong to the studio, and must be returned or paid for. Suggest that they return the proofs within a week. If they will need extra time to mail them out of town, you might suggest two to three weeks, depending on circumstances. Remember that urgency helps you sell. You'll get larger orders if you get the proofs back within two weeks. The longer they're out, the less important they'll seem to the couple and their family.

Tell the couple that you prefer to have them call and set an appointment for returning the proofs, so you can set aside time to handle their order carefully.

Now, you've got a couple of business details to take care of. Have the couple sign a delivery receipt for the proofs. That formalizes the idea that they must be returned. Then collect for any part of the basic wedding price that hasn't been paid.

As the couple leaves, fire up your enthusiasm and friendliness again. Ask the couple to say hello to their parents for you, and perhaps make a comment about some photo that a parent or family member is especially going to like. Thank the couple sincerely as they leave.

Selling at the Proof Return

If the couple hasn't called to set a return appointment by a week after the time you'd agreed on, you should call them. Never make that call less than two weeks from the proof showing. Be

very friendly on this call. Ask how everyone is enjoying the photos, and simply say you were calling to schedule an appointment for them to come in again.

When they come in for the proof return, you want to maintain your excitement and enthusiasm, but recognize that most of your selling has been done. You may increase the order a little by making suggestions now, but most of their buying decisions are made and carefully written down. As always, welcome the couple into your studio, ask them to be seated and offer refreshments.

The most important thing for you to do at this appointment is to be very careful in taking the order. Go over every detail to be sure you understand what the couple wants. Caution at this point improves your profit by minimizing mistakes.

You also want to explain all the details to your clients. This is when you clear up any misunderstandings about quantities and prices. Explain how the finished order will be delivered—that all the albums will be assembled and filled, and that extra prints will be sorted according to the person who ordered them.

If you see that someone has ordered enough loose prints to justify getting a small album, suggest that again. If you haven't sold the display print, suggest it or other wall prints as gifts, perhaps for the bride's parents.

When the order is completed, have the client sign it, and collect in full for any additional prints that have been ordered. Be clear about the date you expect to deliver their final order.

Your Last Chance to Sell

When the finished order has been assembled, you again want to call the couple and be enthusiastic about their order. Excitement is still important. At this point it will enhance their enjoyment of the photos and build your chances for getting referrals.

When they come in to get their albums and photographs you will, of course, be friendly, polite and enthusiastic. Relax with them. Enjoy the photos with them. When they compliment you, say thank you.

You may still have opportunities to sell wall photos or frames at this time. If there is any last money to collect or other business to transact, be sure you take care of the details.

Thank your clients (and now friends) for allowing you to work with them. Suggest that you hope you'll have an opportunity to do weddings for some of their friends or relatives. Invite them to drop in and say "Hi" once in a while, and let you know how they're doing. Enjoy the warm feeling of having provided a valuable service. If you love what you do in your life, success often results. This is one of those times when you can particularly enjoy what you do.

Within a few weeks you may want to make a follow-up call to be sure everyone was pleased with your work. It might even be appropriate to make that call to the bride's mother if you have worked with her during part of the process. Most people appreciate that you are interested enough in them to call again. It will surely help your referrals.

Chapter Eight
Managing the Wedding Business

You Must Make a Profit

We've talked a great deal about how to start your wedding business, how to build it, and how to make it grow. Now we're going to talk about how to keep it healthy. There is one overriding concept in any healthy business; that is the idea of profit.

Profit. The word has gotten a bad rap in recent years. We read headlines about huge corporate profits. Those stories sometimes involve a labor contract under negotiation, or damages awarded in an environmental lawsuit. Seldom, if ever, do the news stories explain how the profit of an auto maker or an oil company relates to the capital investment or the sales of that company.

Profit is not a dirty word. There is nothing wrong with making a profit, not even if it's a huge profit. Large profits almost always result from large investment, great risk, and a lot of good planning and hard work. Who would be interested in working hard and taking risks if there were not an appropriate return? Profit is what makes our economy work.

Theorizing about the merits of capitalism isn't going to help you run your business, though. The concept of profit is important in a more down to earth way. It's simple: if you want to stay in business, you must make a profit. There's no other way. If you lose money, you will be forced to close your business. If you only break even it isn't worth your investment of time, money and effort. You must make a profit.

Just so we know we're speaking the same language, we should probably define the word profit. Profit is the amount of money you take in (your revenue), minus all the money you spend on operations (your expenses). We specified the amount you spend on operations, because you also spend money on capital investment, and it is not directly charged against your revenues. We'll talk later about how that works.

It's usually pretty easy to figure out the revenue side of the profit equation. In a wedding business, your revenue will come from just a few sources. Most of the revenue is from selling photographs, albums and frames. You may occasionally make a little money on investments, or on the sale of a piece of equipment. And that's about it.

Study The Costs

The expense side is always more complicated, yet you must understand it. There is immense danger in failing to know where your money is going, and it's going places you may not even think of. So let's analyze your costs and begin to get a handle on managing the money in your business.

First, you're going to need to know that you have two very different kinds of costs—fixed costs and variable costs. It's important to know the difference, because the two work together to determine how much you must charge for your product, and how much business you must do to show a profit.

Fixed costs are those expenses that remain about the same month after month, whether you do a little business or a lot. Variable costs are those that go up as your business volume increases, and go down as your volume decreases.

Some examples of fixed costs are your rent, insurance, and base phone service. You have to pay them whether you photograph anyone or not. Those expenses are there just because you're in business, and they don't change as a result of the amount of business you do. If you sell twice as much this month as you did last month, your basic phone bill will still be the same.

Fixed costs aren't necessarily always constant. We call them fixed costs not because they never change, but because they don't change due to fluctuations in business volume. Your utilities, for example, may be higher in January because the weather is cold. Yet you do less business in January, than in other months.

Examples of variable costs are film, lab services, and shipping costs. If you do twice as many weddings this month, you'll need about twice as much film, you'll pay twice as much for processing and printing, and you'll have more photos to ship.

Some of your costs may be partially fixed, and partially variable. Utilities can fall into that category. It costs you a certain amount of money to heat and light your studio for twelve months, regardless of the business you do. However, when your business exceeds a certain level, you probably work longer hours, so you use more electricity and gas. You probably use some electricity for things like mounting prints, or running your processor if you do your own printing. Those costs are higher if your business volume is greater. So, you might count a certain amount of your utility cost as a fixed expense, and anything over that as a variable expense.

Here is a list of the kinds of expenses you might have in your business. We haven't attempted to list them as fixed and variable costs because that can vary from one business to another, and some items are part fixed and part variable. You can make that division yourself. Just remember that variable costs are the ones that increase as your business volume increases. Everything else is a fixed cost. We also do not intend this as a complete list. You should analyze your own operation and its costs very carefully, and should probably talk with your accountant in the process. The list:

 Advertising & Promotion
 Answering Service
 Accounting Services
 Albums, Folders & Packaging
 Automobile Costs
 Bad Debts
 Bank Service Charges
 Cleaning & Laundry
 Commissions On Sales
 Contributions & Donations
 Delivery, Freight & Shipping
 Dues And Subscriptions
 Depreciation on Equipment
 Depreciation on Other Capital
 Employee Benefits
 Entertainment
 Equipment Rental
 Film
 Insurance
 Interest
 Janitorial Services
 Lab Costs
 Legal Services
 Licenses & Business Permits
 Maintenance
 Office Supplies
 Payroll Taxes
 Photographic Supplies
 Postage
 Rent

Repairs And Maintenance
Salaries And Wages
Shop Supplies
Taxes
Travel
Telephone
Utilities

You'll note that this list doesn't include anything for purchase of cameras, furniture or property. That's because those things are what are called capital costs, and you account for them differently than you do for operating costs. Here's how it works: if you spend $2500 for a camera, it doesn't make any sense to take that cost out of the profit on the next wedding you shoot, or even the next month's weddings. You might use that camera for fifty weddings a year, for five years, at $250 per wedding.

What makes sense then is to apportion the cost at ten dollars per wedding, or perhaps at $500 a year for five years. That's exactly how you account for the cost of capital expenditures. The process is called amortization. There are a number of ways to do it. Your accountant can help you figure out a good method.

The important idea here is that you must calculate depreciation on your equipment as a real fixed cost. Do that even if your equipment is old and is paid for. One way of looking at it is to recognize that your equipment will wear out, and you'll have to replace it. You must pay for that replacement out of your profits.

Before you can do any of your business financial planning, including pricing, you need to analyze both your fixed and variable costs. The fixed costs are easy. Just list all the things that qualify as fixed costs and how much you pay for them. You can do this summary on a monthly, quarterly, or yearly basis. Because wedding business is so seasonal, an annual basis probably is most useful. In other words, you're almost surely going to lose money in January, should make a lot of money in the summer, and may make a little before Christmas. To know how much money you are really making, you'll have to look at an entire year.

Analyzing your variable costs is more difficult, and there are several ways to do it. Let's look at just one cost factor as an example. You buy prints for your finished orders from a lab. You also buy film processing and proofing from a lab, but we're going to look at just the cost of printing. And let's look at that cost as it relates to the total of all your wedding business, as it relates to one wedding, and as it relates to one 8x10 print.

If you want to study this cost with respect to all your wedding business, you'll need to analyze your lab bills for a year. Separate those into *bills for processing, for proofing, and for printing. Maybe your lab bill for one year is $10,000, with $1,000 of that for film processing, $4,000 for proofing, and $5,000 for printing. If your total retail wedding business for the year was $50,000, your printing costs were ten per cent of your dollar volume.

To study printing cost as it relates to the price of a wedding is similar. We'll use the same numbers as in the previous example, and add the assumption that you photographed one hundred weddings in the year. The $5,000 you spent for printing, divided by the 100 weddings, equals $50. So your printing costs averaged $50 per wedding.

If you want to know how much it costs you to print one 8x10 print, that's easy. Just look at your last lab bill, and see what they charge. Suppose it's three dollars. Here's a summary of your analysis of printing costs:

Printing costs

Per year	Per wedding	Per 8x10 print
$5000	$50	$3

You will need to do at least one of these three kinds of analysis for every variable cost you have. Don't do it yet, though. Let's see how it will work first.

Before we go on to study how to assure you'll make a profit, there's one more important cost to discuss. It's actually in the list we gave you, but it's hidden. It could be listed as a separate line—Owner Salary. That's right, you have to pay yourself a salary, or some fair form of compensation. Your salary is not paid out of the profits. Your kids need to eat every day. They can't wait to find out whether you made a profit for the year.

You can pay yourself in different ways, just as you could pay an employee in different ways. Your compensation might be a straight salary, a commission, bonuses, or a combination of the three. You might, for example, take a salary of $1000 per month, plus $50 for each wedding you photograph, plus seventy-five per cent of the profit at year's end. (The other twenty-five per cent of the profit might be reinvested in the business or applied to a profit sharing plan for employees.) This formula gives you regular income, more income when you're busy, and an extra payday if you have a good year.

How you structure your compensation is up to you. The important thing is that you include yourself. We know you love photography, but we think you'll love it even more if you're getting paid for it.

Your own compensation should be treated just like any other cost. It can be a fixed or variable cost. In the example we just gave, the $1000 per month is a fixed expense, and the $50 per wedding is a variable expense. The seventy-five per cent bonus is only accounted at the end of the year. In a sense, it is below the bottom line, or not counted in the company's gross profit figures.

The Break-Even Point

The purpose of all this work is to get a handle on the amount of profit you will make. If you don't do enough business, however, you won't make any profit at all. You can estimate the amount of business you have to do in order to make a profit. You'll need to know all your fixed and variable costs, and have an idea how much dollar volume is generated by each wedding.

Let's do a very simplified example. Your fixed costs will be:

Example 1.

Cost analysis

Rent, Phone, Util.	$7,500	per year.
Salary	$16,000	per year
Depreciation	500	per year.
Total Fixed	$24,000	

And, your average variable costs:

Film	$ 25	per wedding
Lab Costs	100	per wedding
Albums, Folders	50	per wedding
Total Variable	$175	per wedding

Your average total sale:

Average sale	$475	per wedding

Now we can calculate your Gross Margin:

Average Sale	$475
Less Variable Cost	-175
Gross Margin	$300

With these round figures, it's easy to see how many weddings it takes to break even. The break even point is the number of weddings required to pay the combined fixed and variable costs. After you pay the variable costs for each wedding, you have $300 left over. At $300 per wedding, it takes eighty weddings to pay the $24,000 in fixed expenses.

Fixed Costs Per Year

Break Even =

Gross Margin Per Wedding The graph shown here makes it easy to visualize.

Example 2.

Break Even Point

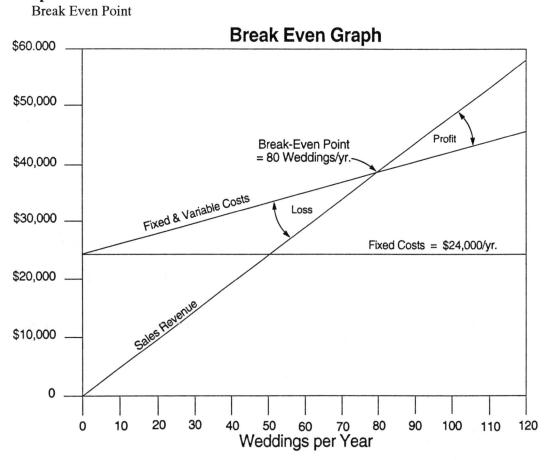

In this example, if you do more than eighty weddings per year, you make a profit (over and above your $16,000 salary). In fact, you'll make $300 profit per wedding after you reach the break even point.

If you don't want to do eighty weddings per year to earn $16,000, you'll either have to reduce your costs, or raise your prices, or both. Before you decide, let's look more closely at pricing.

How Much Should You Charge?

Pricing is difficult for many photographers. Most haven't any idea how to determine a fair price, or how to be sure it's a profitable price. The answer for many is to snoop around and find out what the competition is charging, and charge the same amount, or maybe a little less or a little more. But how do you think that photographer you're copying arrived at his prices? That's right. He did the same thing! The price is like a rumor; no one knows how it got started. If the guy who started it went broke, everybody in town may be in trouble.

Actually, this method of pricing has some merit. We even give it a name. It's called competitive based pricing. It's valid in industries where buyers do lots of price checking and comparison shopping, and that is more or less true of the portrait/wedding business.

Competitive based pricing isn't the only pricing method you should use, however. Here's a list of possible bases for pricing strategy.

Pricing Strategy Can Be Based On:

Competition
Cost
Positioning
Demand
Perceived value
Financial goals

Price is also affected by discounting In reality, price is often based on more than one of these factors. Your pricing should certainly consider several of them.

Let's talk about this list. We've described competitive based pricing. Cost based pricing relates the price to the cost of producing the product, and we'll study it more deeply.

Positioning based pricing relates to the concept of positioning that we discussed in the chapter on promotion. In short, if you want your customer to think of you as a prestige business, you'll probably charge higher prices.

Demand based pricing lowers the price until it meets the level of demand and the product begins selling. If the product is already selling, it raises the price until sales begin to decline.

Perceived value pricing is based on what the customer thinks the product is worth. A good example is perfume. It costs almost nothing to manufacture, but its perceived value is high. So a bottle of perfume can easily sell for a hundred dollars or more.

Financial goals pricing is based on the amount of profit a business person wants or needs to make.

There is no one price that's right for your product, but rather a range of prices that you could charge. You could probably figure out a way to price a small wedding package for $300 or less. You could possibly charge $1000 or more. The lower end of the price range is almost always set by your costs. The upper end of the range is set by competition, demand and perceived value.

Look at the pricing strategy list again. You can probably see how each of the items can apply to your business. You probably should consider each of them in developing your strategy. Since costs set the low end, let's look at cost based pricing first. Go back to the example we used for finding our break even point. It's a pretty good model for a cost based analysis of minimum price.

From that example, if you can't reduce your costs, don't want to make a lower salary, and don't want to photograph more than eighty weddings per year, then your average wedding sale must be at least $475.00. That's an average, and includes add-on sales, so your lowest priced wedding would be less than that

The absolute minimum price would be calculated something like this:

Example 3.

Minimum Priced Package: Three Hours of photography, select from fifty proofs, bride's album with twelve 8x10 prints. Fixed Costs Per Wedding: $240 ($24,000 divided by 100 weddings).

Variable Costs: Film (six rolls)—$15, lab costs—$69, economy album—$18, total variable costs—$102.

The minimum retail price must cover the fixed and variable costs of $342 and show a profit. If we want a five per cent profit ($21), we must charge $363 for this minimum package. This is the minimum price for the simple example we've been using. Notice that we put the number of weddings at 100 for this calculation. That's probably about as many as one photographer can plan on shooting.

Now, let's put some financial goals into this calculation. Suppose you want to make the same $16,000 per year, but only want to photograph fifty weddings per year. We'll go back to the average variable costs used in example one.

Example 4.

Pricing Based On Financial Goals

Fixed Costs	$480 (24,000 divided by 50)
Variable Costs:	$175
Total Costs	$655
Plus five per cent Profit	33
Average Total Sale	$688

To earn $16,000 per year while photographing fifty weddings, with the costs estimated in these examples, you'd have to attain an average total sale of $688 per wedding. That's an average; you'd sell less on some, more on others.

Can you do it though? Will your average customer pay that much for your photography? Here's where demand, competition, positioning, and perceived value come into play. If the customers want your services, and have the ability to pay for them, then the demand condition is met. If they don't have that much money, or if they don't want your work enough to pay that price for it, they don't demand it.

In businesses where customers shop for price, competition is an important pricing factor. Photography is such a business. If photographers who are doing work similar to yours are charging as much or more than you are, you won't lose customers to them because of price. If your prices are much higher than theirs, without a quality difference that is readily seen by customers, you will lose weddings.

"Perceived value" asks whether your customers believe that your work is valuable enough for them to pay the price you're asking. That's closely related to the positioning idea. If you want to sell higher priced weddings, you will plan your promotion, your selling style, your studio furnishings, etc. to put the thought in your customers' mind that you are worth the price, that they're really settling for second best if they don't choose you. If that's the position you want to achieve, charging a higher price for your weddings is perfectly appropriate. It fits.

To summarize basic pricing strategy: You have to analyze your costs so you know your price minimums. You have to study your competition, the demand for your services, and the perceived value of your product to establish pricing maximums. Then you make final pricing decisions based on your financial goals and positioning goals.

We're not finished with pricing, however. There are two other important considerations. The first is sale pricing and discounting. Let's suppose you decide to offer a twenty per cent discount for weddings booked at a particular bridal fair. In essence, you've reduced the price of those weddings by twenty per cent. You've also reduced the average price that you receive for all your weddings. When analyzing your pricing structure, you should do all your calculations based on your discounted prices. The discounted price is the selling price.

This leads us to the final consideration in pricing—price changes. What happens when you raise or lower a price? What happens to sales, and what happens to profit?

It's easy to calculate what happens to profit. A price change always goes entirely to the bottom line. Price changes don't affect either variable or fixed costs. If you raise your prices by $50 per wedding, your costs stay the same, and you raise your profit by $50 per wedding. The same is true for price reductions. If you offer a twenty per cent discount on a $500 wedding, you will reduce both the selling price and the profit by $100. If you only had $80 dollars profit in that wedding to begin with, you're now losing $20.

It's much harder to predict what will happen to your sales volume as a result of a price change. If your prices are about in the middle of your competitors' range of prices, a moderate price change will probably have little effect on volume. If your prices are very low or very high, a change may have greater impact on the number of weddings you do. Discounts generally have greater impact on volume than do overall price reductions. (That's only true for discounts of twenty per cent or more; people typically ignore ten per cent discounts.)

It is generally true that price increases of less than fifteen per cent scare away very little business. Since the price increase goes entirely to profit, it usually makes sense to raise prices periodically.

Because discounts have some benefit in bringing in additional business, it often makes sense to set base pricing a bit high, and use discounting to help promote the business. The one major exception to that advice is for a business that positions itself as the best, and sets its prices high to help implement that positioning. Such a business defeats its purpose by discounting.

The Price List

Your price list is more than its name implies. At the very least it functions also as a brochure, carrying a sales message about you and your business. It should be carefully written and well printed, so that it makes a positive impression.

Often your customer will take your price list home, or carry it as she visits other studios. She may use it to talk with her parents or the groom about your studio and the others she has visited. If this is the setting in which her decision is made, you don't get to be there. Only your price list or other printed material will represent you. It should help position you in the mind of your customer.

There's still more to the price list than prices and positioning. In writing your price list, you have an opportunity to do a little product development.

Think again about how your customer perceives your product. The bride you're hoping to photograph doesn't need any photography time. She doesn't need any proofs. She doesn't need any inches, as in eight inches by ten inches. What she needs is memories of her wedding day. She needs those memories for herself, and for her friends and family, now and in the future. Since we have discovered that we must sell in her mind, and sell her what she needs, we would do well to pay attention to her needs.

Sell complete packages of wedding memories, not hours, proofs and inches. Your customer shouldn't have to take a course in wedding photography to select the coverage that's right for her. She shouldn't have to figure out how many hours of photography produce how many proofs and how many finished album prints. It's your job to do all that, and you do it on your price list.

Offer your customers three or four wedding packages. Explain each one clearly and simply. Then make it easy for them to add the most common items to their package, so it fits them just right. Give each package a simple, attractive name. That works like a brand name on a product. It gives the customer a handle, something to identify that package. Give each package one price.

A package will include a certain amount of photography time, a specific number of proofs from which to choose a specific number of finished prints, and a certain album or combination of albums. Keep it simple. Here's an example:

The Magic Memories Wedding $695
We photograph up to four hours of your
wedding and reception. We present seventy
to ninety proofs for your selection.
Our finest Showcase Album displays your
carefully finished prints:
12 10x10" Master Candid Prints
32 5x5" Master Candid Prints

This example does specify the size of prints and the time involved, but it doesn't make the customer do any calculations. She just compares this description to the other two or three packages, and selects the one that fits best, probably matching the coverage to the length of her wedding and reception.

It's wise to limit the length of time that will be devoted to the photography. This should be clearly stated on the price list and—if properly done—it can work to the benefit of the

photographer and the client. You're not going to walk out at precisely 4:01 in the middle of the cake cutting, but a clear understanding of the time constraints will prevent problems, and allow you to charge for additional time if you're kept very long past your agreed departure.

Pricing with packages only makes sense. No one is likely to want 150 proofs and three large albums from two hours of coverage. With packaged products, clients can select the coverage that best fits their needs, and they clearly see the relationship between price and product.

The price list should provide clients with whatever information they need to understand the product, prices and studio procedures. All of this must be stated so that it answers the clients' needs, and stresses the benefits they derive from the product and policies.

Staffing a Wedding Studio

Up until now we've discussed the management of your business as if pricing and profit were the only considerations. They certainly are not.

If you're building a very large operation, you'll reach a point where you'll have to make some important decisions about your own role in the company. There are really three major functions in a studio—photography, management and selling. There will come a time when you'll have to concentrate your talents on one or two of those, and hire people to do the others. You should concentrate on doing the one or two of those things that you love the most. If the photography is what lights your rocket, develop good people to manage and sell for you. You can still know all parts of the operation and be involved in all parts of it, but you will succeed best if you apply your talents to the things you really enjoy.

Thoughts From J. C.: I Made Myself Dispensable

At one time, I managed nine portrait studios at the same time. It was essential that I turn over vast parts of that operation to good employees. I couldn't have done it all if I had wanted to. In time, I actually trained others to do everything, even the hiring and training. I had a head photographer, a head receptionist, and a production manager, all of whom supervised their respective subordinates.

This approach freed me to do a variety of things. If we were trying a new promotional idea in one studio, I could work there. If our sitting schedule was overloaded, I could do photography. If it was time to make price changes, I could spend a couple of weeks doing cost analysis.

Every year, in November and December, I worked in production. We did most of our business in the fourth quarter. Sales and sittings built all through the fall, approaching the holidays. In order to have a good year, we had to take sittings and orders as close to Christmas as we possibly could. By personally monitoring production, I could be sure I knew that every order we took was completed and delivered on time.

I remember one year when we had 160 orders at an out of town lab two days before Christmas. They all came in on time. A couple of them had problems, but I had a small (and very expensive lab) standing by to do last minute printing. We delivered every last print on time, to happy customers.

By maximizing our fourth quarter sales in this way, we maximized profits. At the end of the year, all the fixed costs were covered. Every order was sold at a high profit. A good year-end strategy can allow a studio to make as much profit in December as in the other eleven months combined.

The positions you have on your wedding staff may include, Head Receptionist or Sales Manager, Studio Manager, Head Photographer, other sales receptionists and photographers, plus production or clerical employees and support staff. Obviously, only a very large operation would have all of them. The most likely situation is that you will do several of those jobs yourself, and

hire a very few people to do the others. You'll probably combine jobs. Your clerical and production work may be done by your sales receptionist and photographer, for example.

Hiring your staff is something you'll probably have to learn on your own. You'll probably be pretty good at it, however. As a photographer you have good people skills, and that's important in screening people. Trust your instincts. If you think a job applicant will fit into your organization, you're probably right. If you think she won't, you're also likely to be right.

Don't expect to be right all the time. When someone doesn't fit into your operation, or when they've misrepresented themselves during hiring, you'll have to make changes. Dismissing people is always difficult, but if they're not working out, you probably know it, and the situation isn't going to get better. The accepted procedure is to talk with them about the problem and give them a chance to correct it, then if the correction is not forthcoming, to terminate them.

When you begin the termination process, you should be concise and objective about the problems you're addressing. You should ask the person how he or she perceives the problems, and attempt to come to an agreement about what the problems are and how they can be solved. It's appropriate to write out briefly what you have agreed upon and ask the employee to sign it. You should set a specific time at which progress will be reviewed.

If the employee corrects the difficulty, be sure to follow up with him, and show your appreciation. If he goes immediately in the wrong direction, and make things worse, it may be best to proceed with the termination, and not even wait for the agreed review time. If at the end of the agreed time, no substantial progress has been made, do the person and yourself a favor and dismiss him.

If you're clear about what you expect from people, and if you treat them fairly and with dignity, you probably won't have to terminate many. In fact, if you find yourself firing people very often, you'd better take a serious look at your working conditions and employment philosophies.

Good supervision and training will solve many problems, and turn good employees into exceptional ones. There are countless books, seminars, etc. to help you with employee relations.

Photographic Assistants

As your business develops, you'll soon come to a place where you can't grow further without employing photographic help. At first, and maybe later, you'll want to use part time help or assistants.

Assistants can be useful. They are often eager to learn, willing to work for reasonable fees, and easy to train in your particular work methods. You can hire people with little or no experience if you primarily need them to carry equipment and back you up on a little photography. You'll need to hire people with a few weddings in their background if you want them to cover part of your photography for you.

It's usually a good idea to start assistants working right by your side for a wedding or two. You want to know a few things about them before you trust them with your valuable clients. You want to know how they dress and act, and you want to see a little of their work, done under the conditions of a wedding. You also want them to see how you work, and how you treat clients and guests.

The first time or two that you work with a particular assistant you should probably hire him or her for only the first two hours of the wedding. That covers the preliminaries and the ceremony at most events, which is most of the photography. If you have a high confidence level in the photographer, you can have him cover a few things on his own, maybe do a couple of the groom's photos while you're working with the bride. Then you'll probably do a few more with the groom, just so no one feels that the groom's images were slighted.

Whether or not you have high confidence in the assistant, you'll want him to spend most of the time just assisting you in your work, carrying equipment, etc. At idle moments between photos,

discuss the shots you've been taking, and be sure the assistant understands what you've been doing. Remember to talk about how you're communicating with people, not just about photographic techniques.

When you've done one or two weddings with an assistant, you can begin to use him or her in more useful ways. A common way of using assistants is to have them do some parts of the ceremony or preliminaries on their own, working with both the bride and groom, so the couple gets to know the photographer. Then the assistant can do the last hour or so of the reception as a solo effort.

This kind of use of assistants allows the principal photographer to go on to another wedding, or attend to other work. With such a method, one photographer and one assistant can cover three or more weddings in a day. It's how you get through June in the wedding business.

When you've used a particular assistant enough to have confidence in his or her abilities, you may want to assign full responsibility for some weddings to that photographer. A caution is in order here. If you have positioned your business as being personal, and have sold your individual talents, some customers may want you to do their weddings personally. If you sell with the stress on the studio, rather than your own personality, you can usually use other photographers more effectively.

Thoughts From J. C.: Whose Name is on the Door?

When I managed studios, they always operated under a corporate name, not the name of a studio owner. Piare's business is called, "Portraits by Piare Mohan." These two practices create very different situations with respect to the use of wedding photographers and assistants.

In the case of our multiple studios operating under a common name, customers didn't expect one particular person to photograph them. It was no problem to use assistants, or to hire as many wedding photographers as we needed to cover the events we booked. Of course, we promoted the studio name rather than the names of particular photographers.

In Piare's business, it's a very different matter. With his name on the door, people may expect him to be behind the camera. They don't mind if he hires other photographers; they just don't want those other guys doing their wedding. They would feel cheated. Piare promotes himself, rather than his business. This kind of promotion is very effective, and results in a loyal following of customers. It does, however, limit the ways he can use assistants. It practically eliminates the possibility of having another photographer do an entire wedding.

Neither of these working methods is right or wrong. It's entirely up to you. You can certainly grow to a larger operation if you can freely hire and use photographers, but you can operate very successfully as a small studio, too. Just decide which course you want to follow, and don't try to straddle the fence. If you're going to promote yourself and use your name as the studio name, don't expect to be able to use other photographers to cover entire wedding events.

However you use assistants, you should have a clear understanding with them about what you'll get from them, and what they'll get from you. You'll give them assignments and perhaps the use of equipment. You'll pay them a fair wage, and pay it on time. You may want to pay them a small commission for new weddings they book, or which are booked from weddings they worked.

They'll provide photography that meets your quality standards, they'll represent your business according to your standards of dress, courtesy, etc. They will represent only your business while working for you, and will not promote themselves, their business, nor any other business.

It's probably a good idea to prepare a simple written agreement covering these points, and have assisting photographers sign it. At least be sure you discuss these ideas with your photographers. Never assume that they know how to conduct themselves.

Working with photo finishers

It usually doesn't make sense to do your own film and print processing. The lab you use for that work probably has half a million dollars or more invested in equipment. They process several hundred rolls of film per day, and make thousands of prints. They probably have sophisticated quality control equipment, and on-line assistance from one of the major photographic manufacturers. They have fast, accurate video color analyzers. They can do photofinishing cheaper and better than you can do it.

Some photographers say they do their own processing because it gives them better control. They're probably kidding themselves. Most very small labs, the kind photographers can afford to put in their studios, can't do as good a job on their best day as a quality professional photo lab does on its worst day.

With that said, there are some things about labs that are less than wonderful. The first is the same thing that makes them so efficient. They print thousands of prints every day, and your print is only one of them. They also have hundreds of customers, and you are only one.

Quality control in a photo lab is the most important determiner of quality. Part of quality control involves remaking a certain number of prints. If they tighten their quality control standards they have to remake more prints. If they reduce standards they remake fewer prints. Remakes cost money.

With any lab, no matter how high their standards, they make decisions all day every day about prints that are of borderline quality. Some get shipped, some are remade. As hard as this is to believe, it is their customers who determine which ones get remade. You make the decision. Every lab sets its standards, then tends to work toward a lower level of quality until their customer returns indicate that they've slipped too far.

It is to your advantage to return work to your lab when it doesn't meet your standards. It helps the lab set and maintain their overall level of quality, but it also helps them know what they have to do to please you. You can almost hear the conversation in the lab between a print checker and a supervisor: "Sally, should I ship this or redo it?" "Oh, it's for ABC Studio—better redo it." They just learn that some customers are pickier than others, and it does affect their quality control standards.

Never return work just to be returning it, however. If you do, it tends to have the opposite effect in the lab. They begin to think there's no way to please you, so they ship all the marginal work.

If you're watching the incoming work carefully, and you have a good lab, you should probably be returning something like one to five per cent of your prints.

If your lab is causing you any kind of consistent problem, always tell them. If it doesn't get fixed tell them a bit more assertively, or tell a different person in the organization. A lot of things can happen that the lab isn't aware of. For example, they never see the condition of the work when it arrives at your studio. If prints are being damaged in shipping, or if they've packaged them so well that you damage them getting them free of the packaging, your lab needs to know. Only then can they solve a problem.

Likewise, if you see a way your lab could do something that would make your job easier, tell them about that, too. If it would work for you, it would probably work for other photographers, and the lab might create a new product or service in response to your idea.

For instance, virtually all labs now number their proofs and negative envelopes, but they didn't always do that. It started with one studio telling one lab that matching negatives was a costly and time consuming problem. That one lab devised a way to number proofs. They did it

by hand at first, then with a computer printer. Soon competing labs had to offer the same service. Now, it's commonplace.

If you do a large amount of business with a lab, and if you're otherwise a good customer, you may be able to ask for some other things. Your lab may not have a co-op advertising program, but if you ask, they may develop one. In a co-op program, they pay part of your cost on ads, with the understanding that you'll send all the work to their lab.

You might get similar participation in a special price offer. If you're going to offer a twenty per cent discount at a bridal fair, you might be able to get the lab to give you some discount on that work.

These kinds of arrangements aren't common in the photography business, but they are routine business practice in other industries. Sometimes photographers don't receive because they don't ask. It's just like working out cooperative promotions with florists and bridal salons. If you offer them something that is good for them and for you, they might do it.

So much for what your lab can do for you. What can you do for your lab? The first thing is to pay your bill on time. Cash flow is a tremendous problem for labs. They aren't in business to finance you. They probably have to borrow operating money at times, and they pay interest on those funds. Don't be a part of their problem.

The next thing you can do for your lab is to communicate clearly with them. Write your instructions clearly. When something is amiss, talk with them about how it happened, so you can learn if you were partially at fault. Train all your staff to communicate well with the lab.

Ask for special favors only when you really need them. Don't cry wolf. If they get pleas for expedited work every week from your studio, they don't pay much attention. If you ask for a special rush only a couple of times per year, you can bet they'll try to meet your needs.

Thank them. Hardly anyone does that, and they appreciate it. Send flowers or candy to the staff. Send a thank you note when they've done something special for you. Thank the person who did it, but thank that person's boss too. You'll be surprised how well it works.

Do Unto Others—Business Ethics

Business ethics aren't complicated. The Golden Rule is usually appropriate. Treat your suppliers, your customers, your competitors, and other wedding professionals as you'd like to be treated. Be fair.

You know when a business practice is ethical. If one party is being hurt by something they don't know about, there is probably an unethical practice in there someplace. Not everything that causes difficulty for someone is unethical. A competitor might go broke because he lost too much business to you. If that happened because you offered higher quality at a lower price, and he just refused to meet your challenge, then nothing unethical happened.

On the other hand, if you were able to offer a lower price because you operated at a loss for two years, then raised your prices after the competitor went out of business, that's unethical. If you and another photographer agreed to operate at a loss for a while until all the other photographers went out of business, that's both unethical and illegal.

Ask yourself how the newspaper would headline a story about your business practices, and in what part of the paper they'd publish it. If the headline is on the front page, and starts with, "Local Photographer Swindles . . . ," you know its wrong.

If the headline starts with "Local Photographer Wins . . . ," and it is printed in the business section, you're probably okay.

If you're still in doubt, ask yourself if you'd clip out that article and send it to your mother. If you wouldn't, maybe you're not really comfortable with the practice.

Here are some other questions you might ask yourself about your business ethics:

If your competitor were suddenly hospitalized on Friday night, would you send your assistant to cover his Saturday weddings?

If your lab failed to bill you for twenty dollars of work on a hundred dollar order, would you call them?

If a prospective customer asked you about a competitive photographer, how would you answer?

If you needed to know how your competitor prices a particular kind of work, how would you find out? Would you call her to ask?

Is there any competitor you'd be uncomfortable meeting unexpectedly in a public place? Any supplier? Any other wedding professional? Any customer? Only you have the answers to these questions, and only you know what your answers mean.

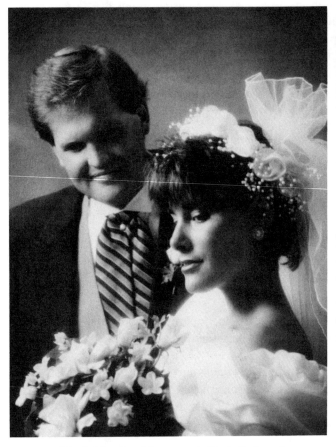

The bride who visits your studio isn't shopping for photography time, proofs, or prints; she wants memories of her wedding.

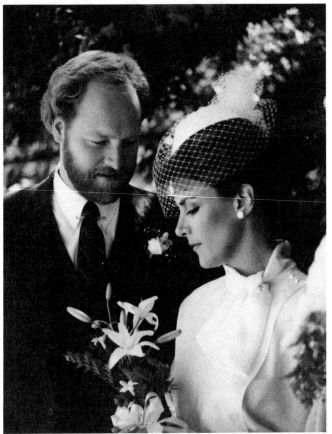

Many of the prints you sell will be given as gifts. You can maximize your profits by maximizing sales during the holiday season.

Chapter 9
Posing People for Wedding Photographs

The Foundation For a Natural Pose

A natural pose is not a complicated thing to achieve. We can demonstrate the basics of natural posing with a simple experiment. Have someone help you do this; it takes only a moment. Seat your subject at an ordinary table, in an ordinary chair. Hand him a book or magazine, and ask him to begin reading it. Position yourself several feet in front of the subject, and a little to one side. Your subject is still reading.

Now, ask him to look at you. At the instant your subject turns, you'll see him in a natural pose. It looks and feels natural. If he holds that position for more than a few seconds it will begin to feel very awkward, but that's only because he's remaining motionless in a position he'd normally assume for only a second or so.

Let's do the same experiment standing. Have your subject stand comfortably, looking at the book. You stand in front of and to one side of him, then have him look at you. You get the same natural, relaxed position that can be the foundation for good posing.

With the experiments behind us, let's study how to create that natural look when posing real people in real situations at a real wedding. Since most such posing will be done standing, we'll start with the basics of creating a good standing pose. Have your posing subject help you practice this.

Ask the subject to stand facing slightly to the right of the camera position. Ask him to stand with his weight mostly on his right foot (the foot farthest from the camera), and to let his left knee bend. The left foot should be a little closer to the camera than the right foot. Have him drop his hands to his side. You now step back to the camera position and ask the subject to look at you. It's that simple. You have a good pose.

This simple experiment shows the foundation for a natural pose.

The pose works the same whether the subject is sitting or standing.

For wedding candids you'll use the basic standing pose for most of your work, everything from full length photos to head and shoulders.

If you want the subject facing left instead of right, just do it all in reverse: weight on the left foot, right knee bent. If you're only photographing your subject's head and shoulders, you still do the pose exactly the same way. We'll see why.

Let's analyze the pose a little more in depth to be sure you see all that's happening here, so you can avoid making mistakes with it. There are just a couple of important concepts that are essential to all natural posing. The first idea is weight distribution. You had your subject stand with the weight on one foot. That's natural and relaxed. Watch people waiting for a bus or an elevator. They very often stand with more weight on one foot than the other, and probably shift their weight periodically from one foot to the other.

You asked your subject to put her weight on the foot farthest from the camera. It's amazing how many things that simple act accomplished. It made the far leg wide, solid and not very attractive, but simultaneously hid it behind the near leg, which became slender and assumed a graceful curve. Shifting the weight slenderized the near hip by lowering it slightly, caused the spine to curve a bit, and strengthened the appearance of the shoulders by raising the near one just a little. It probably also tilted the head slightly.

If you had to instruct your subject to do all those things you'd drive her crazy, and your pose would take all day. Fortunately, you have only to tell her to put her weight on the right foot, but you must *tell* her to do that. If you don't, everything about the pose will be wrong, and you can't correct it.

The second critical concept in posing is that of direction. You started the pose by facing the subject a little to the right of the camera, then did two important things. You moved the near foot a little forward and closer to the camera, and you turned the head toward the camera. A whole list of directional things happened with those two movements.

Stated simply, you sequenced the direction of all parts of the body. The far foot is facing somewhat away from the camera. The hips are pointing more toward the camera, the torso more toward it, the shoulders still more, then the head, then the eyes, which are looking nearly at the camera. Each body part, from the floor up, faces a little more toward the camera. That sequence of directions gives the feeling of movement to your pose, preventing it from looking static. By having all the movement be toward the camera, the pose is cohesive. Of course it duplicates the natural situation that occurs when one person turns to look at another.

You can achieve an entirely different pose by turning the head a little farther, until it crosses the camera axis, and having the subject look straight ahead. In other words, the feet, hips and shoulders will be facing to one side of the camera, and the head and eyes will be looking to a spot on the other side of the camera.

All that weight distribution, balance, direction and movement are essential to a good pose, yet they all happen naturally as a result of a few simple instructions. To review, the instructions are: "Face this direction (a little to the right or left of the camera). Stand with your weight on your right foot (or whichever foot is farthest from the camera). Put your left foot (the near one) forward just a little. Look at me." It's so simple.

Again, you do it exactly the same way for a head and shoulders pose as for a full length photo. It might seem that foot position wouldn't be important to a close-up, but it's essential. The sequence, or flow, of direction starts with the feet. Weight distribution starts with the feet. You see the effects of that foot placement in shoulder position, tension of neck muscles, head tilt, and probably some other places. If you have it right, your head and shoulder pose will look right; if you have it wrong it never will.

Your subject won't always be standing on a flat surface. You may want to use stairs, steps, stools and a variety of other props to add variety to your poses, but the basics are the same. Put the weight on the far foot, and turn the head toward the camera. You'll often photograph the subject from behind, or in profile. Nothing changes. Weight on the farthest foot, turn toward the camera. You can get dramatic poses of the bride by having her stand facing almost directly away

The basic standing pose can be created in seconds. Study its direction and weight distribution.

Start with the right foot pointing to one side of the camera, and end with face and eyes pointing to the other side.

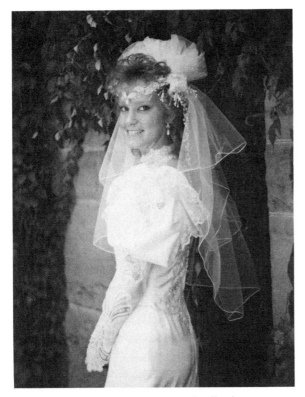

Correct direction and weight distribution are foundational - and easy when you know how.

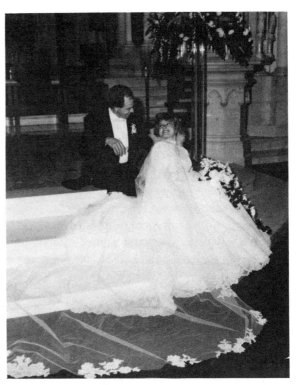

Weight distribution is vital to all posing: all the weight is properly supported for both figures. Note the relaxed position of the man's hand.

from the camera, turned slightly to the right or left, then turning her head in that same direction, to the profile position.

Sometimes you'll pose people leaning or resting against props. The idea of weight distribution is critical here. The weight distribution must be natural and logical. If you put your subject's elbow on an object, you must have him put weight on that elbow. If he doesn't commit some weight to the elbow, he will look off balance, and the pose will be strained.

These fundamentals of building a good pose are identical for men and women. You may not have thought the bride's foot position was very important under the gown, but of course it is. You'll see her direction and weight distribution in every detail of the pose.

Here are a couple of final details that will finish off your pose. You'll often have to correct the head tilt. It's not complicated. If the head tilt looks unnatural, just ask the subject to tilt his head a little to the right or the left. It's easier if you direct the tilt by using your hand to show the movement you want.

Similarly you usually need to tilt the head up or down, and turn it slightly toward or away from the camera. The easy instructions to achieve what you need are, "Turn your chin toward me (or away from me) a bit," and "Chin up (or down)."

If you make one of those final head position changes just as you release the shutter, you'll accomplish the finishing touch. That last bit of movement relaxes muscles, and makes the pose dynamic rather than static.

Seated Poses

Seated poses are almost as easy as standing, and the basics are the same. To get proper weight distribution have your subject sit forward on the chair or stool, so that his feet are supporting some of his weight. Have him sit up and arch the small of his back, as if he were being poked in the back. Rest his hands in his lap. Sometimes, you may want to move the near hand a little farther from the camera than the far one, just to broaden the shoulders slightly.

For good direction, simply start by seating the subject facing a little to one side of the camera, then have him look toward the camera. That automatically sequences the directions of the body parts, just as it did with the standing pose.

The standard seated pose uses the same basics of direction and weight distribution as the standing pose. When the foundation is right, the pose will be easy and natural.

The rest of the basic seated pose is the same as a standing pose. Get the final head tilt and direction, and release the shutter.

The Bride at the Altar

Let's pose a bride at the altar. The first thing to decide is which side of her face you want to photograph. Don't make that decision complicated. Have your bride face toward any light source—your key light, a window or whatever. Stand directly in front of her, and have her slowly turn her head from side to side. You can hold up your hand, have her look at it, and move the hand to direct her head movements.

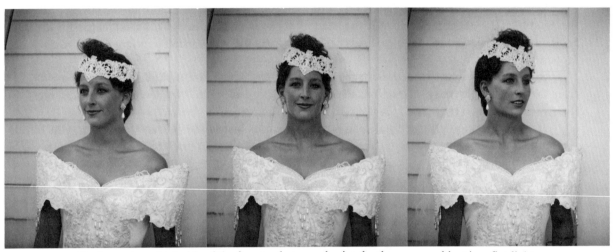

To determine which side of the face to photograph, simply place your subject in a flat light and turn her head from side to side. Choose the direction that looks best to your eye.

As her head direction changes from left facing to right facing and back again, simply watch to see which side of the face is more pleasing to you. Watch especially to see if the nose looks more straight one way or the other, then watch the outline of the cheeks and forehead, then the size and shape of the eyes, then hair, etc. Sometimes the nose looks better from one side, but the cheekbones, or the hair, look better from the other side. In such a case, just look at the two effects and decide which side is more pleasing in total. About eighty per cent of people look better when photographed from their left side.

When you've identified the bride's best side, escort her to the altar, show her where you want her to stand, and which direction you want her to face. Then do all the arranging of the gown, your lights, background items, etc. Do all of that before you do your final posing.

If the gown has a long train, spread it behind her, and trailing to one side or the other, so you can see most of it from the camera position. If you have room to frame the photograph with lots of space around the subject, you will probably want to show the train on the side opposite the direction the bride is facing. If she is facing to her right, show the train on her left side.

If your space is crowded, and you're going to have to crop pretty tight, you may want to have the train on the same side as the bride is facing. The difference is that you always want to have a little more picture space on the side she's facing toward. In other words, you want her looking into the picture space rather than out of it. Try it both ways; you'll see what we mean.

To position the train, stand behind the bride and hold the hem of the train in both hands. Quickly lift and lower the train, allowing air to billow up under it and spread it. It's the same motion you'd use to spread a blanket on the ground at a picnic. Do this gently, don't lift the hem more than a foot or so, and do it just once or twice. The train will fall naturally into place. Don't stretch the train out too far behind the bride. It should curve gracefully from her waist to the floor. Once it is in place, look for any awkward folds or wrinkles. Look at the whole train, from the waist to the hem.

If you're using multiple light sources, set your lighting, then return to the camera position to see how everything looks from there.

Watch for details. Look for candles, lights and other props that may appear to be growing out of her head or shoulders. Look again for awkward folds or wrinkles in the gown or train. Be sure none of the little loops sewn into the seams of the train show against the background. Look at the bride's hair, jewelry and neckline to make sure everything is properly positioned. Assure yourself that everything that should be showing is showing, and everything that should be hidden is hidden.

If the neckline, or a low hanging necklace is amiss, ask the bride's mother or an attendant to adjust it for you. It's also a good idea to ask Mom and the bridesmaid to help you watch the details all day long. They'll catch things you don't see. Remember that your subject is wearing a dress that may have cost a couple of thousand dollars. It is exquisite. She wants it to look perfect.

With the details set, begin the final posing phase. Ask the bride to stand with her weight on the proper foot, and bend the other knee. In directing her, say "right foot," or "left foot." Brides aren't four legged; they don't have front and back feet, or near and far feet. It's often helpful to stand next to the bride, facing the camera, and demonstrate how you want her to stand. Tell her, then say, "Like this," and show her.

When the stance is set, pose her hands. Elaborate hand posing is usually unnecessary. Her hands will often be concealed by the bouquet which is usually held in front of the bride, but slightly off center, toward the camera. That's necessary to have it appear centered in the photograph. The height of the bouquet can be anywhere from considerably above the waist to the lowest position at which the arms can rest comfortably. If you are photographing the bride in profile, you can have her hold the bouquet only with the hand nearest the camera, and rest it against her hip or thigh.

The basic hand position features a slightly arched wrist and curved fingers.

If the hands do show, either because of a non-traditional bouquet, or because you have chosen to show them, it is still not a good idea to do elaborate hand posing. Remember that your subject is not a trained model. If you pay undue attention to any part of the posing, or take too long doing it, you'll make her uncomfortable, and will get an awkward pose.

The easiest way to set the bride's hands in position is to place them where you want them. There are two advantages to this method if it is properly done. It is simply easier to move the hands and fingers than to describe what you'd like the bride to do. The second benefit is just as important. The brief, firm, relaxed touch of your hand tells her to relax the muscles of her hand without your saying a word. She may be holding her hands stiffly or gripping the bouquet or a prop too tightly, but when you easily and comfortably move her hand and adjust the finger position, she will usually relax considerably.

Use these elementary rules in positioning the hand. The wrist is usually arched back slightly. The fingers are curved, with the index finger being the straightest, and each one curving a bit more, the little finger usually curved the most. Sometimes this is varied by straightening the pinky slightly. The thumb either holds the prop against the index finger, or lightly touches the index finger. Position the hand so that you photograph it from the edge, looking at the thumb or the pinky. Avoid photographing the full width of the palm or back of the hand.

Posing men's hands is almost the same as posing women's. Men's fingers are usually curved more, almost to a loose fist. The wrist is arched less than with women's hands, and the pinky is never lifted.

One of the best things you can do to learn hand posing is to practice posing your own hands. When you know how a pose feels, it's easier to position your subject.

The most important thing about hand posing is to do it quickly. If you don't have exactly what you want in four or five seconds, photograph what you have. If you fool with it longer, it'll only get worse and your subject will become progressively more self-conscious and uncomfortable.

So, you've instructed your subject to stand correctly and positioned her hands. Return immediately to the camera position and direct the final adjustments from there. Get the head and eye position you want, get the expression (more on that later), and release the shutter.

The entire process of posing and lighting should consume no more than a couple of minutes. If you take longer you will be frustrating your subject. Two minutes seem much longer to her. If you take longer on every pose, you'll never get through the day. Think about it. You have one hundred or more images to create in about three hours. That's an average of about a minute and forty-five seconds per photo.

One way you save time in posing is to maximize the benefit from every set-up. We can easily see how to get several additional images from the bridal full length we just posed. First, move your camera a little closer and do a three-quarter length photo. All you have to do is re-pose the hands so the bouquet is held higher. You might have the bride cradle the bouquet. Or, you could move in still closer and do a long head and shoulders pose, placing the flowers near the face. Each of these photos will require only half a minute or so.

Now move the camera in again, let the bride rest her hand comfortably at her side, and make a close-up portrait. That should take only a few seconds.

Want more? Stay in close. Move the camera to the bride's side and get a profile. You may have to adjust the lighting a bit, so this one may consume a minute or so. When setting the lighting, watch the full height of the subject because you're going to do three-quarter or full length poses again.

Move the camera back for a profile at three-quarter length. Then, if the background is appropriate, back up again for the full length in profile. Each of these will require only thirty seconds or so.

From this one posing of the bride, you've made five or more images. Your total time will be about five minutes. You can vary the photos further by using different expressions, head and

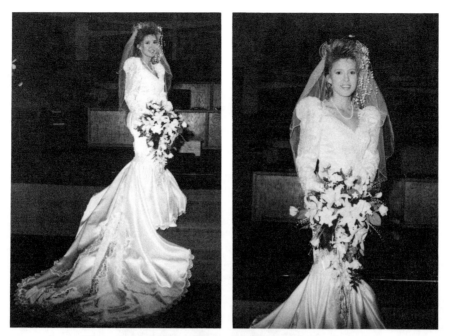

When posing and lighting are set for the full length photo,
simply move closer for three-quarter and close-up views.

eye positions, and camera heights. You can use soft focus on some, and sharp focus on others. People seeing the proofs will have no idea that the images were created so quickly and easily. This is professionalism in practice.

There's a major variation available for full length bridal poses when the train isn't too long. Start this pose with the bride facing away from the camera, a little closer to the camera than you'll want her to be in the final pose. Arrange the train approximately as you want it. Then have the bride take a step or two, into the final place where you'll want to pose her. At this point she still has her back to the camera. That little step allows the train to flow naturally, as it will when she walks down the aisle.

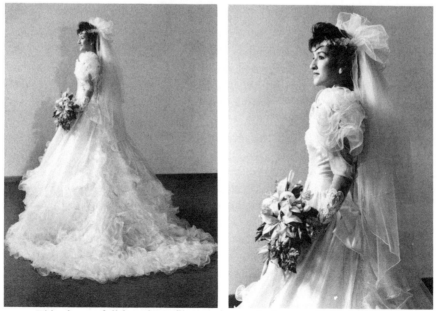

This elegant full-length profile pose is popular because it shows the back
of the gown. Move closer, make slight adjustments, and create several
additional poses in a couple of minutes.

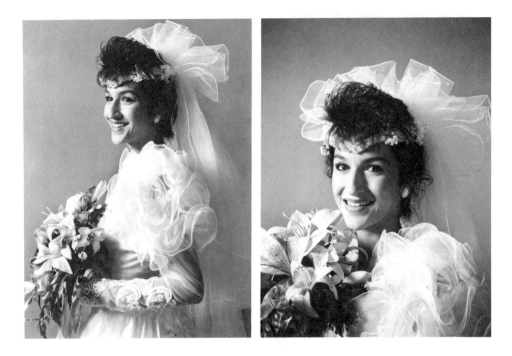

Begin the photography by turning only the bride's head to the profile position. Make final adjustments to the train, build the pose and do a full length, followed by three-quarter length croppings. These can be dramatic photos. A variation is to have her look down at her bouquet for a reflective or pensive mood.

Now, have the bride step and turn to bring her torso to a full profile position. Then ask her to turn her head toward the camera. Capture full length and three-quarter images. Turn the bride again to the front pose position, and do three-quarter and full length images again. For all of these, the train remains spread between the bride and the camera. Customers like these poses because they show the gown so well.

You may need to move the train aside to allow room for your tripod as you move in for the close-ups.

Don't Be Touchy.

Put yourself in the bride's place, and try to imagine what it's like to be photographed a hundred times in the space of three hours, by someone you hardly know, on a day that you've fantasized as a time of bliss. Now, imagine this stranger touching you two or three times for each photograph. He touches your hair, your hands, your shoulders, your arms, perhaps moves your head. Maybe he touches you two or three hundred times. This is not the guy you've dreamed of touching you on this day!

The groom may also be a bit jealous. He may not want anybody but himself touching his bride—especially hundreds of times.

We advise photographers to minimize the touching of subjects as much as possible. This is as true for posing the groom and other subjects as it is for the bride. It's uncomfortable to have someone's hands near your face. Many people don't even like to be touched by family members. Others don't mind the contact so much, but you have no way of knowing which people are touchy about being touched. It's safer to assume that no one wants to be handled by you.

You can learn to direct nearly all posing by words and hand signals. It's easy. Just tell your subjects what you'd like them to do. Use hand gestures to indicate direction and to reinforce your spoken suggestions.

It's also very helpful to demonstrate by assuming the positions yourself. That actually helps you as well as the subject. When you experience what the subject is experiencing, it helps you know what has to be done to complete a pose, and it helps you know how to direct it.

Almost all posing directions can be given verbally and with hand signs. It is rarely necessary to touch the subject.

Hand posing should be relaxed and natural.

We've already discussed the major exceptions to the no touch rule. Little adjustments to the hair, sleeves, etc., almost have to be done by the photographer. The subject can't see to make the corrections, and there will be hundreds of them during the day. These aren't very disturbing to most subjects because the skin isn't touched, and the action is obviously necessary. Even here, though, a caveat is in order. When adjusting the hair, be sensitive to how it feels to have someone's hand near your eyes. Try to bring your hand to the subject's face from the side, so she doesn't feel attacked by rapid hand movements toward her eyes.

The other exception is hand posing. We've talked about how the touch can help communicate. Even with hands, though, good voice direction will work most of the time. After the first time or two that you pose a bride's hands she probably gets the idea. From then on, you can just tell her where to place her hands, and only touch her if it becomes necessary to correct something.

Be sensitive. If you can tell that a particular bride is uneasy about the slightest touch, simply avoid even that touch.

Occasionally, you may have a subject who is so nervous, he or she just can't take direction well. You tell the bride to turn her chin to the left and she lowers it instead, or she just can't tilt her head to the side, even with demonstrations and gestures to help her. In a case like this, you may be able to simplify things by more than the usual amount of touching.

Here's the approach to use. Tell her what you're going to do first, with words like, "Let me help you get that position." Say it as you're reaching to help. Then, to adjust head tilt, for example, touch each side of her head firmly but lightly above and behind the ears. Say, "Just relax and let me move you." Then adjust the position. After you've done that once or twice, she may relax, and also understand better what you mean. If it doesn't seem to be working, stop doing it.

Experiment with different ways of saying what you want the subject to do, and with different hand gestures that clearly communicate your intentions. You'll quickly learn what works best for you.

The Fine Points of Posing

You probably can't do consistently natural posing until after it becomes second nature to you. When you no longer have to think about all the details of posing, you'll begin to work faster

and more smoothly, and your poses will look better. The catch, of course, is that you can't get that ease in posing without doing lots of poses. So, beginning posing will be a bit uncomfortable for you and your subjects. There's probably no other way.

One way to make it all easier is to learn your posing in stages, a little at a time. If you can master one standing and one seated pose, and learn a couple of variations for hand and head position, you can do a good wedding. In the beginning, stick with only the things you can do comfortably. If a pose is easy and natural for you to do, it will probably look natural.

Then gradually start experimenting with new ideas. You'll learn four poses, then six, then eight. In a short time, you'll quit concerning yourself with a repertoire of learned poses, and you'll begin to feel that you simply know how to pose. By learning the basics first, you'll soon be able to improvise posing to fit any situation you encounter. It will all be easy, comfortable and natural.

As you do three, four or five variations on a pose, your subject may begin to feel that she's been frozen. If she feels that way, she'll look that way, too. Of course, you want to work quickly so you don't keep the subject in a pose too long, but there are some other things you can do to avoid the frozen look. One way is always to tell your subject to relax after each photograph. Ask her to keep her feet in place, but otherwise encourage her to move a little.

You should also vary each pose. As you move from full length to three- quarter length to close-ups, make changes with each view, the arms lower in one pose, and higher in the next. At some point in the sequence, ask the bride to step a few inches forward or to one side, then resume the pose. You can also change the direction a little by having her turn her feet. Those changes allow her to relax and move, breaking the feeling of stiffness.

Sometimes, you'll get a subject into a pose that just looks awkward. Don't shoot. There won't be any miracles that will fix it while the film is being processed. If the whole pose looks bad, the problem is usually in the foundation of weight and direction. If you've been trying something new, just go back to the basics. Start over with foot position and weight distribution and build from there.

If the awkwardness is just with the hands and arms, as is often the case, the solution is similar. Just go back to the basics of a simple hand pose. You've either attempted something that can't be done gracefully, or your subject has gotten stiff and uncomfortable. Either way, if you just move the hands to a simple pose that you're comfortable doing, you'll solve the problem.

If you don't know what to change to correct a pose, just change something. Your instincts are probably correct. Often, just moving the subject relaxes her and cures the defect.

It's just as important to go ahead when a pose looks good as it is to stop when it looks wrong. If you're using the basics of direction and weight distribution, most of your poses will look pretty good when you first set them up, so don't keep fooling around until you make them look clumsy. Record them on film quickly, while they're at their best.

Our earlier discussion of hand posing concentrated on how to do it. Let's talk about what to do. Hands should either be doing something that makes sense, should just be hanging naturally, or should be out of sight altogether.

People don't usually go around resting their hands against trees, candles and pillars. Yet photographers insist on showing them that way. If you're going to pose a bride's hand with a candle, she should be lighting it, or doing something else logical.

If you want to rest her hand on a prop, rest it on something appropriate, such as a railing, banister, chair or ledge. That object must also be at the correct height, just high enough to comfortably support the weight of her hand and forearm. If it's too high, she'll look like a short little kid, reaching up to the item. If it's too low, she'll look like she's trying to lift it.

Men come with built in hand props—their pockets and waistbands. You can place hands in front or back pockets with all four fingers in the pocket, and the thumb protruding. Alternatively, you can hook the thumb in the pocket, or in the waistband, and let the fingers curl naturally.

Another possibility with men is to photograph them with their arms crossed. Just have them do it naturally, or stand beside them and demonstrate what you want.

Pockets, belts and waistbands provide natural resting places for men's hands.

If you're posing outdoors, the basics are the same as indoors. The chief difference is that you must work with the light as you find it, and it will dictate directions. You have to start with foot positions that will allow the sequencing of directions we've discussed, and end with the face pointing where you want it. We'll discuss the lighting in Chapter Ten.

You can get lots of ideas for posing by just being observant. Watch people in public to see how they stand, lean and sit. Study magazine ads, television and movies for other ideas.

Another way you can introduce variety into your poses is by building them around situations that develop during the day. You do that when you photograph candids, but you can also build more formal poses. You might, for example, notice the bride in a thoughtful mood while she's getting ready. You could first record the moment in a true candid, then ask her to re-assume that pose, add some soft focus, do something interesting with lighting, and create a reflective portrait.

We've talked about head tilts, but haven't given you much direction on the topic. Your subject's head can tilt right or left, up or down. If the right/left tilt is toward the shoulder nearest to the camera, the effect is very feminine and is, in fact, called the feminine head tilt.

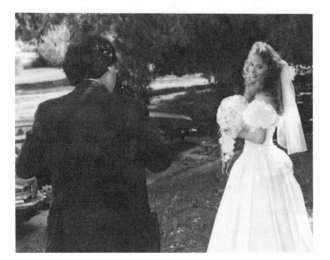

Tilting the subject's head toward the near shoulder produces a feminine look.

The opposite situation, with the head tilted toward the farther shoulder is called the masculine tilt. The masculine tilt can be used any time, for men, women or children, while the feminine tilt is never used for men unless a frivolous or comic effect is desired. The feminine tilt often looks awkward even with women. Use it sparingly.

Vertical head tilt is even easier to do correctly. The head should simply look level. If it's tilted up too far, you will see into the nostrils, and the eyelids will lower, giving a sleepy look. If it's tilted down, you begin to see too much of the whites of the eyes below the pupils. You usually want a slight downward tilt to avoid the nostril problem.

With all of this discussion about tilts it's important to note that we're talking about very slight tilts. Never tilt the head so much that it's really noticeable as tilt. You will notice it on the proofs, but your customer should never be aware of it.

Thoughts From J. C.:

I think the use of feminine head tilt is largely a matter of taste. Piare and I agree that it should probably be used only when a women tends to fall into it naturally.

I found that I seldom used a feminine tilt at all. Even when a woman's head seemed to naturally tilt to the near shoulder, I often directed her to change it. I just found the masculine tilt to be stronger in most situations, and I used masculine tilt at least ninety per cent of the time.

Piare uses the feminine tilt much more than I ever did. He estimates that he uses it with half of his women's poses.

Notice that this argument only applies to images of females. We totally agree that we never photograph a man with the feminine tilt.

You can always improve your posing technique. Study the proofs from every wedding, looking for things that worked well, and for things that didn't. Your principal gauge should be whether or not the pose looks relaxed and natural.

Ask other people to look at your proofs and make suggestions. Pay special attention to the sales receptionist. She quickly learns what customers like. Look at the finished albums before you deliver them, too. That will help you be aware of the poses that people are ordering.

Whether you're looking at proofs or looking into the viewfinder, you should train yourself to see in a special way. Especially when framing your composition in the viewfinder, you need to see the frame from corner to corner and edge to edge. That seems like a simple idea, but it's really a violation of how we naturally see.

Human vision is a complex blend of eye and mind. Our eyes take in a wide view, close to 180 degrees. But we see clearly only the very center of that span, and have the interesting ability to ignore the rest. The camera has no such selective talent. It reveals everything in its frame with the same clarity unless focus or movement obscures detail. That's why it's easy while shooting to miss details that seem so obvious later.

You have to train yourself to see all the details before you trip the shutter. Just begin forming a habit of looking methodically, corner to corner and edge to edge.

Posing Couples

All the basics of posing individuals are at work when posing couples. Good weight distribution and direction lead to relaxed, natural poses.

Your standard couples pose works like this. Stand the couple facing slightly toward each other. They can be facing almost directly toward each other, almost directly toward the camera, or anything in between. One of them can be facing more toward the camera than the other. They should be close enough together that they can comfortably touch at the shoulders. When you ask them to look at the camera, you get the proper sequencing of directions for both, just as with individual posing.

Weight distribution is also the same. Have each one stand with the weight on the foot farthest from the camera, put the other foot slightly forward, and bend that knee. It's simply two individuals, posed next to each other.

Have the woman put the arm that's farther from the camera around the man's waist, then have him put his arm around her waist. That takes care of those two arms in a natural way and helps them stay close together. The nearer hands can hang naturally at their sides, or you can use any of the hand techniques you would use with a single subject. If you want them to hold hands, the man's hand goes underneath the woman's.

Learn to see in a special way by looking at the frame from edge to edge and corner to corner.

For the basic dance pose, just pose two people side by side.

Add variety to couples' poses by facing both in the same direction, a combination of two single poses.

You'll use the basic dance pose that we just described for almost all photos of standing couples. Less often, you may want to pose a couple with both facing the same direction. It's still just like posing two individuals next to each other. Use the same rules of weight distribution and direction. You'll typically pose the woman in front of the man.

You will use the same kind of routine to get the maximum from a couple's pose as you did for individuals. Start with a full length cropping. Then move in for three-quarter or close-up versions.

Want a kiss photo? Just have them look at each other, and take that image, then have them kiss lightly, and release the shutter again. It'll all be quick and natural. You can then move your camera position to get interesting angles where one of them is in profile, and the other nearly full face. If you want them both in profile, you can do that from the basic pose with both turned in the same direction. Just as with individuals, you can get half a dozen very different images in a very short time.

Posing overweight people as couples presents a special problem. It can be difficult to get them close without emphasizing the weight condition. You can minimize that problem by facing each of them more toward the camera than you would for a slimmer duo. Since that gives you more base for your photo than you probably wanted, you may need to use a camera vignette to darken the lower part of the image. You may also want to do only three-quarter or close-up photos in some instances.

The final posing routine with couples is also very much like that with individuals. Have the pair lean a little closer together, then make last second adjustments in head and eye positions. With couples you almost always want their heads tilted slightly toward each other. That automatically achieves masculine head tilt for both.

You have to produce a hundred pictures in three hours. Use your time wisely by sequencing your images from a single set-up. Start with a full-length of the bride, then a close-up. Add the groom for a full-length and close-up of the couple. In minutes you have made several pleasing and saleable photos.

Grouping the Groups

You probably think we're going to tell you that posing groups is just like posing a bunch of individuals. You're right. The routine is really very simple. Start with the central couple, posing them just as you would without the group. Then start adding other couples and individuals. Everyone will face toward the center of the group. Everyone will have most of the weight on the foot farthest from the camera.

When you have them look at the camera, you get correct direction, just as we've seen with all other posing. Because most people photograph best from their left side, you'll want to stand on the left side of the camera to direct groups. That way, everyone will be looking slightly to their right.

The composition of the group as a whole is also important. Typically, you'll have taller people near the center, and shorter ones at the edges. Small children can usually be put in front of the adults. You can use the altar steps to get height variations. The faces should be clustered within a triangular shape or an oval shape. You're probably okay if you just avoid putting a tall person at the edge of a group or having someone too high, too low, or too far to one side. From the camera position, be sure you can clearly see every face in the group, and that the composition looks balanced, side to side.

When all are in place, look for final head tilt adjustments and begin making exposures.

If you have a very large altar it gives you more opportunities with groups. You can allow a little more space between individuals. You might try posing a large group as three or more smaller groups. Put three to five people in each smaller group, posed as you would do to photograph just those people. Cluster the groups together to make an interesting composition.

Don't leave a lot of space between the groups; leave only a little more than you allow between individuals within the groups. Don't pose an entire wedding this way until you get the hang of it. Try just one group in each wedding until you're comfortable with the technique.

You won't often have a huge altar. You'll more often have huge groups to pose at tiny altars. If you can't take those groups outdoors, you'll have to be resourceful. You can often seat the younger women on the floor in front of the group. Stand the children behind them, then the adults.

Group poses are collections of individual poses, but they don't have to be boring.

Seating the women at the front of a large group helps fill your space better. The little girls can continue to stand because of their short height.

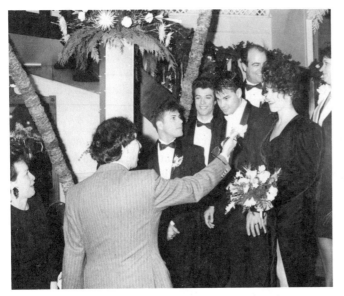

Work quickly with groups. Give instructions by voice and with hand signs. And have fun!

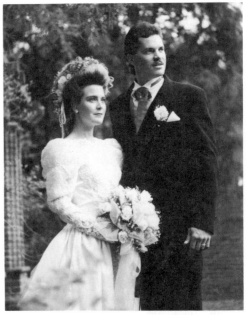

This simple pose has the relaxed feeling your clients want. Start with correct direction and weight distribution, then add a lush background and use the beautiful natural light. It sells.

Work quickly with your groups. People tire and get tense quickly. Groups are time consuming at best, and time is a precious commodity at a wedding. Good verbal instructions will get every one posed correctly without your having to pose people individually. Look for details that cause problems, but don't worry about perfection for each individual.

Be sure you can clearly see every face. Don't overpose the people. Do the work quickly, and keep it natural. No matter what you do, a group photo will look like a group of people standing together to have their picture taken. They aren't works of art, but they are often very valuable to the people you're photographing, and they sell.

Posed Candids

The term, "posed candids", sounds like an oxymoron. We use it, though, to distinguish all those standard photos that you pose from the true candids that occur spontaneously and which you catch on the run. The photo of the groom and best man checking their watches is a posed candid. An impromptu image of a child sampling the cake icing is a true candid.

The less posing you do for posed candids, the better. Simply stage the situations and record what happens. That doesn't mean that you do no posing at all. If you're well versed in the basics of direction and weight distribution, you'll probably do those things without thinking, as you should. Don't take clumsy, awkward-looking shots when you can make naturally comfortable images.

You'll certainly want to keep a sharp lookout for details that could cause problems. Look corner to corner and edge to edge before each exposure.

Also, look for the occasional opportunity to create a posed portrait from the situations of your candids.

A Last Word on Posing

Good posing is a lot of work, but it should never look like work, and—for your subjects—it shouldn't feel like work. It must be comfortable and natural, and it must be quick. Don't be afraid of posing; it has no mysteries. Remember the basics of weight distribution and direction, and you'll become adept at it sooner than you think.

Chapter 10
Understanding And Using Light

A photographer has many powerful tools. He or she has cameras, lenses and meters that capture precisely sharp, well exposed images. He has a personality that helps create vibrant facial expressions. That same personality helps him win and please customers, which gives him work to do in the first place.

The most basic tool the photographer has is light. Without it there is no photography. The coming digital age of imaging will ultimately change cameras and lenses, and eliminate film, but lighting will not change. Modern flash equipment is a far cry from flash powder and hot lights, but light still works just as it always did. It works the same way for you as it did for seventeenth century painters. If you learn to use light as a tool, and understand what it does to and for your images, it will always serve you well.

Look At Your Light Source

Most photographers know some of the basics of lighting, and probably understand a little about light and shadow. Many do not understand light sources and light itself, so we'll start there. Don't run away: this isn't going to be a physics lecture. You don't need to know whether light is a particle or a wave. We won't talk about photons, or electromagnetic radiation. What you need to know is whether light is harsh or soft, and what color it is. Those things are determined by the light source.

A light source is a device that emits light, but it includes the reflectors, filters, diffusers and other things that alter the light before it falls on your subject. In the practice of wedding photography you use single or multiple electronic flash heads, and a variety of available indoor and outdoor light sources.

The light emitted from a given source will have certain color characteristics that may affect the color of your image. If you photograph under the church's altar lights, which are more orange in color than the light your film was designed for, you'll get orange colored images. Happily, that's probably what you intended, because it simulates the warm color of candle light.

Other than that, you want natural color rendition for most of your work. The 100 to 400 speed color negative films you're probably using will give you good color under electronic flash or daylight. Your photo lab can easily correct in the printing for variations in the color of those light sources. That's probably all we need to say about the color of light at this point.

Let's study the harshness or softness of light. We'll call that the quality of light. What we're really talking about is whether a light source casts hard, crisp shadows or soft, fuzzy shadows. There is only one thing that directly determines the kind of shadow a light source creates, and it may not be what you think it is. It's not diffusion, and it's not bouncing the light off of something.

You can get soft light in a variety of ways. You can use umbrellas or soft-boxes on your lights. You can work outdoors in the open shade. You can bounce your flash off the ceiling. You could probably study those three light sources all day long and never see why they produce soft light, unless you look at them from the position of the subject. Sit where your subject sits and look at any soft light source. What you'll see is a big light source.

In the case of the umbrella or soft-box, that's obvious. In the case of light bounced off the ceiling, you may not see the flash tube and reflector at all, but you do see the large area of ceiling and wall that the flash illuminates. That ceiling and wall have become part of the light source;

they've become the reflector. The resulting light source is quite large.

If you're sitting in the open shade, you might say you can't see the light source at all. The sun is the light source, and you're in the shade, but the light isn't coming to you directly from the sun. It comes by reflection from the open sky and clouds. The light source in this case is huge. It is the entire sky.

Quality of light is determined by the angular size of the light source. That's the size of the source as it is seen from the subject's position. A large light source loses its softness as it is moved away from the subject, because it becomes smaller as viewed from the subject's position. Similarly, a relatively small light source becomes larger and softer as it is moved closer to the subject.

Putting a three inch diffuser on a flash unit does very little. It does spread the light from the tiny flash tube evenly over the surface of the reflector. That's an almost imperceptible change. Most of the effect the diffuser creates is achieved by scattering light around the room. Some of that light bounces back to the subject and reduces contrast by filling the shadows. It doesn't really soften the character of the light. That little diffuser is a very inefficient and unpredictable fill light. The same thing happens with a small white reflector used close to the flash unit. It does little, and is even less efficient than the diffuser.

A large light source becomes noticeably softer when diffused. That's because there are really two sources at work when the source is a bulb in a reflector. Some of the light that falls on the subject comes directly from the light bulb or flash tube; some of it bounces off the reflector. The exposed bulb is a fairly small, harsh light source. The larger reflector is softer. The diffuser takes the bare bulb out of the formula by spreading the light over the full width of the reflector. Now all the light coming from the source is soft. All diffusers also provide some fill light by scattering light around the room.

Here's what it all means to you. You're probably well advised to throw away the little clip-on diffusers and reflectors that came with your flash unit. They cost you more in output than they give you in softness. If you want soft light from your portable flash units, you'll need umbrellas or soft-boxes. You can sometimes bounce your flash off walls, ceilings or from the corners of rooms. That's very inefficient, but it is often beautifully soft.

You can get very soft light outdoors. Outdoor light is beautiful because it's complex. There are really lots of light sources at work. The principal source may be the blue sky, which—because it's so large—is very soft. A couple of bright white clouds may add a subtle, slightly harsher touch. Openings in the shading trees will add other sources. Nearby objects or terrain will also reflect light to your subject. You can't duplicate that complexity in the studio, no matter what you do.

Thoughts From J. C.: An Orange Car Can Help

In the 1970s we did a tremendous number of outdoor portraits. One studio I managed photographed as many as 180 seniors per week outdoors.

Later that year, after I bought a new car, I noticed something I especially liked about some of the portraits I was taking. They were all done in the shade of a certain tree in the afternoons, and had a subtle warmth in the shadows. It didn't take me long to figure out that my bright orange Volvo, parked in the sun a few yards from that location, was providing the effect. No other photographer could duplicate it.

Another soft light source at your disposal is window light. It's really outdoor light of course, coming to you through the window. You can control its softness to some extent by changing your working distance. The closer you are to the window, the larger the angular size of the source, and the softer its effect.

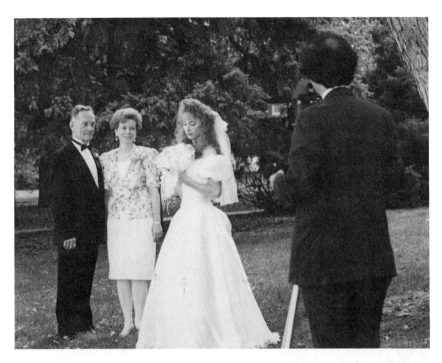

Outdoor lighting is beautifully soft and complex. There are many light sources, and the open sky is a huge one.

Why do you care whether light is harsh or soft? Is soft light always better? Soft light is often used for photographs of people, because it de- emphasizes the texture of the skin. It makes porous or wrinkled skin look smoother. It accents the skin with wide, subtle highlights rather than small, sharp highlights. If that's the effect you want, soft light is your choice.

If you want to maximize the effect of skin texture, however, you need harsh light. If you want especially snappy highlights, use harsh light. You might want to do that if you're photographing a very young groom, for example. Outdoors, you often have both kinds of light sources at work and the effect can be gorgeous.

Your portable flash unit is incredibly harsh. Diffusing it makes very little difference in its harshness, though it will reduce its contrast a little. If you bounce that flash into an umbrella it will be much softer. Put it in a soft-box and it's softer yet. Bounce it into the corner of a room, and it will be very, very soft.

Window light and open shade outdoors provide soft, but complex light, with varying colors and some hints of harshness. Direct sunlight is extremely harsh, even if it's filled by flash or reflectors.

Four Functions of Light Sources

You can have light falling on your subject from dozens of sources. Outdoors, where lighting seems so simple, light is at its most complex. But no matter where you're working, all the light sources you might employ can have only four functions. Those functions are: key light, fill light, background light, and kicker.

The key light defines the shape and form of the subject. There is only one key light source. It should usually be the only light source that casts any noticeable shadows on the subject itself, or on the background.

The fill light, in conjunction with the key light controls lighting contrast. It adds light to the shadows left by the key light. It doesn't eliminate those shadows; it just fills them with even illumination, so they don't appear as dark. The fill light should cast no shadows that are visible from the camera.

A background light lights the background. It can be a separate light source added by the photographer; it can be available light; it can be light that spills over from the key or fill lights,

but its purpose is two-fold. First, it erases from the background any shadows cast there by the other lights, and second, it brings the level of illumination on the background up to a level predetermined by the photographer. There's not much more to say about it.

Kickers are lights used for any other purpose. The most common use of a kicker in portraiture is the hair light. It simply adds highlights to the hair and perhaps makes it stand out from the background. Other applications of kickers are seldom used in wedding photography.

The Key Light Shapes The Subject

If you've studied lighting before, some instructor or book may have taught certain standard lighting patterns, given them names, and tried to teach you rules for when to use each one. We're not going to do that. Neither are we going to tell you to set your lights up in one single way that will work for all people and situations. Actually, we could do that. There are some lighting arrangements that will give you satisfactory results in most situations. We just think it's better for you to know what light is doing for you. So we'll try to teach you how light works.

The key light reveals the shape of the face, but you don't have to memorize standard lighting patterns to do beautiful lighting.

You could do an experiment to learn how the key light works. If you did, you'd ask two people to help you. One would pose, right in front of the camera, looking directly toward the lens. The second person would aim a small, fairly harsh light source (even a flashlight will do) toward the subject from every direction. You would stand at the camera position and observe.

You'd quickly learn that most places you can put that light don't work. You can't put it anywhere behind or directly above the subject's face, because it doesn't light him at all from there. You can't put it below the subject's eye level, because the resulting appearance is ghastly. If you put it close to the camera lens, it illuminates the subject with flat light, and doesn't show the form of his face.

You'd learn that all the locations that yield interesting shaping of the face fall into a pattern. They are all in an arc, starting at the subject's eye level, on one side of his face, moving up and forward to a point right in front of the subject and fairly high above his eye level, then downward and back on the other side to his eye level again.

That arc is like the daily movement of the sun, starting at the horizon in the east, moving to a high point in the south, then to the horizon in the west. In this analogy, your subject is facing south. Sounds pretty natural, doesn't it? It is natural. That's why it looks good.

You can put your key light anywhere on that arc, and it will reveal the shape and form of your subject's face. The farther to the side you put the key light, the more it slims the face, because it leaves more of it in shadow. The farther to the front you place it, the fuller the face looks.

Just where you put the light on the arc is a judgment call. Move the light and study how it treats your subject. Watch how the interplay of light and shadow describes the shape of your subject's face. Put the light where it looks best. You'll soon be good at it, and you didn't have to learn a single rule, or the name of even one standard lighting.

Most of the time, you won't have the subject's face pointing directly into the camera; she'll be facing a little to one side or the other. If you place the key light on the side of the face nearest the camera, it will make the face look fuller, and will cause that near side of the face to appear a bit wider than the far side.

The opposite is also true. If you light the side of the face farthest from the camera, you'll slim the face, and usually make it appear more balanced. This kind of lighting is most appropriate for most people, but it's still a judgment call because you can do beautiful photographs lighting the near side of the face. Do what looks best for the person you're photographing.

When you've determined what lighting is best for the face, you can probably move the camera to various positions without changing the lighting significantly. If the lighting looks good with the camera right in front of the face, it will probably also look good from a less direct camera position, or even from the profile position. The one exception with profiles is that you always want the key light on the side farthest from the camera. The near side of the profiled face should always be in shadow. That really is the key to creating striking profile views.

Since most people look a little better when photographed from the left side, and most people look best with the key light about halfway through the arc, and on the side of their face farthest from the camera, you could determine one key light position that would work for most people. You'd place the key light on the left side of your camera (as seen from behind the camera), about thirty to forty-five degrees out to the left, and thirty to forty-five degrees above the lens. Indeed, that position works well for most people. That's why you'll use such a light placement when you photograph groups.

For photographing individuals and couples, you'll probably do one of two things. You may use flash on camera, just to provide quick, easy illumination. Or you may want to light for each face and circumstance.

Outdoors, or with window light, you'll want to learn to light for each person and situation. It's so easy to do. Let's see how it works outdoors.

The appropriate outdoor location is one where both your subject and the entire background can be in complete shade. The best backgrounds are dark and simple.

As you approach such a location with the bride, look for evidence of the location of your key light source. You can probably find it by looking at the sky. If the location is open to the sky on one side, and shaded by overhanging trees on the other, that open sky is your key light source.

You can also look at tree trunks, or other rounded objects. The brightest side of an object is the one facing the key light. You can hold up your loosely clinched fist, watch the light on it, and make the same judgment.

Have the bride stand about where you'll want her for the poses, facing roughly toward the key light source, in this case the open sky. Then have her slowly turn her head from side to side

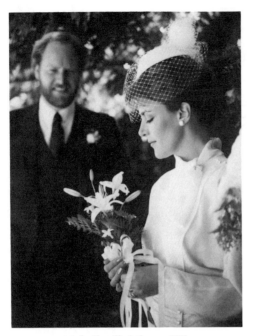

Out of doors you can't move the light, but you can still do beautiful lighting by positioning the subject. Notice that the same light source works well for both people.

as you watch the lighting. When you see the head position that catches the light in the most flattering way, you've found the direction her head will need to be facing for the photo.

Now, build the pose from the feet up so that her head ends up in the right direction. You're ready to start making exposures. There are probably several camera angles that will work for interesting poses. Of course you can do full lengths, three-quarters, and close-ups from the same place.

This is just like lighting in the studio, or at the altar, except that outdoors you can't move the light. The light is just there, and you adjust the subject and camera to it. If you're working with window light, it's the same as outdoors, except that you know exactly where the key light is before you start, and you have fewer options regarding subject and camera placement.

No matter where you're working, or what kind of light source you have, the principle is the same. You use the key light to define the shape and form of the subject.

Control Contrast With the Fill Light

Even the softest light may not produce a flattering effect if you use only one light source. That's because it doesn't light the shadows, and the viewer wants to see into those shadows. The answer is to use fill light.

A fill light should be placed close to the lens, a little above it. You don't want it to create any noticeable shadows. By placing it above the lens, any shadows it casts will fall out of sight behind the subject. If you can't put it directly above the lens, try to place it on the side opposite the key light so that shadows cast by the fill light will be wiped out by the brighter key light.

When changing camera angles to get varied views from one pose, take the fill light with you. For example, if you set up for a full face view, then move to camera to the side for a profile, you leave the subject and the key light where they are, but you move the fill light. It should still be just above the lens.

A caution is in order here. If your fill light is a small light source, such as a typical portable flash, it is possible to get it too close to the lens. If you do, light can reflect off the inside of the subject's eye back to the camera, in full face views. It will make the pupil of the eye seem to glow a bright red, a most gruesome appearance. The cure for red-eye is to raise the flash a little, perhaps eight to ten inches above the lens.

You'll get a pleasing image in most situations if the light areas (those lit by the key light) receive about three times as much light as the shadows (areas not lit by the key). If you're using

identical light sources for the key and the fill, you'll achieve that 1:3 ratio by having the fill light about 1.4 times as far from the subject as the key light. If, for example, the key light is ten feet away, the fill should be about fourteen feet away. If the key light is at five feet, the fill is at seven feet. If the two sources are not identical, you'll have to meter the ratio, or determine the distances by test.

There's nothing sacred about a 1:3 light ratio. You can create wonderful images with lighting that is either more contrasty or less. We recommend that you start working with the 1:3 ratio, then experiment gradually with different ratios. You'll soon learn what you like in various situations.

The Other Lighting Functions

You may never use a separate light source for background lighting in wedding candids. You can do it, but it's cumbersome, and time consuming.

Some photographers do use hair lighting for the bride, couples and groups. We'll not go into detail about the practice. Again, it's cumbersome and time consuming. In case you want to experiment with it, we will tell you that there are two common mistakes you should avoid. Don't get the hair light too bright. Its effect should be subtle, not glaring. And, don't let light from the unit spill into the camera lens. It will cause nasty lens flare.

Do You Really Want To Use All Those Lights?

Let's step back from this study of the nature of lighting for a moment, and question how much lighting is really appropriate for the various kinds of photography involved in a wedding. Wedding photos are called candids for a reason. They are not portraits. Your customers probably don't want formal posing and lighting throughout the photographic record of their day. Nor do they want the photographer to take over all the events, and become more important than the couple, so balance is in order.

Lighting is a powerful photographic tool, but like all tools it should be used with discretion. Attention to lighting can make your work more appealing, but other things are vitally important. You must tell the full story of the day. You want to capture the heart, the essence of ceremony and celebration, and you have to work quickly and unobtrusively.

It may be possible to employ the very best in lighting technique without compromising all the other essentials of wedding photography, but it may not be realistic to try to do that. It can also be expensive. You certainly need additional equipment to do elaborate lighting, and it is very helpful to employ assistants.

We advocate simplicity. You may choose to do all your flash photography with flash on camera, even though such lighting is flat and harsh. The truth is that good expressions and quick competent work are far more important to your clients. You'll certainly use flash on camera for true candids, unless you're working outdoors. Using flash on camera for other things will free you to concentrate on all the other aspects of your work. You can still employ sound lighting technique outdoors and by window light to create striking images of the bride and groom. Those photos may become the expressive centerpieces of your wedding style.

Alternatively, you may choose to use multiple light sources and more expressive lighting, but only for photos of the bride and the couple. You'll then employ flash on camera for all the rest. With this approach you can still create lots of images outdoors and at windows.

Flash on Camera

If you use flash on camera, the technique is relatively simple. We've already said that the flash head must be about eight inches or more from the lens to avoid the red-eye condition. The flash should be high, so any cast shadows fall behind the subject and out of sight.

There are several flash brackets on the market that position the flash head directly above the lens, at a distance of a foot or so. They work, but they can also cause problems. Some of them

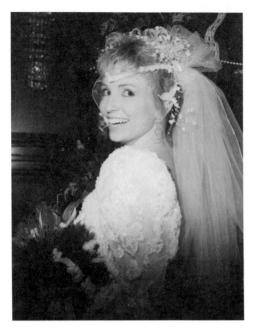

You'll use flash on camera for most candids. It isn't great lighting, but it frees you to capture emotions and expressions.

are bulky and hard to handle, and some don't hold the flash securely. If the flash slips a little, you can lose exposure of part of your image. That's especially dangerous when you're using short focal length lenses. Traditional flash brackets work well. They position the flash head well above, and a little to one side of the lens.

If you are using that kind of traditional bracket, you can give yourself some protection from distracting background shadows by just working a little further from backgrounds. If your subject is eight feet from the background, the effect of any shadows will be minimized, simply because the light on the background will be less intense. The cake cutting is one place where you may run into trouble because the cake table is often set up close to a wall. You can give yourself a little more distance by just stepping to the side, photographing the scene at an angle, rather than head on.

With flash on camera, or with multiple flash it's easy to get your backgrounds too dark, because you're working too far from them. In a large church, you might have your subject posed forty feet from the back of the altar. At that distance your flash will not provide sufficient illumination to record the background at all.

The solution is to use a slow shutter speed to allow some of the ambient light to record on film. You may use 1/30, or even 1/15 of a second. You can meter if you want to, letting the background be underexposed by one to two stops, or you can begin using 1/30 of a second in most situations and learn from experience when to change that.

The Techniques for Multiple Flash:

The idea of carrying and arranging lighting equipment is daunting when considered in the context of having to create a hundred photos in three hours. There are ways to make it possible.

The ideal position for a fill light is also the ideal position for flash on camera. So, it makes sense to use the same flash unit for both. If you were in the studio, you'd choose a soft source for a fill light. At a wedding, however, the convenience of having your fill light attached to the camera when you're working fast will more than offset the harshness of the light quality. You can try using a diffuser over the light head, but it probably won't accomplish much.

This is already sounding simpler. Now, what can be done with the key light? First, use a slave photo cell to trigger it, eliminating a synch cord. If the key light is battery powered, you've eliminated wrestling with wires altogether.

You can either put the key light on a stand, or you can have an assistant hold it. The assistant is much more efficient. Moving and adjusting a light on a stand is time consuming and tiring. Of course, the assistant is more expensive. You almost never have to write a check to a light stand. If you do use an assistant, it's very important that he aim the light carefully, and hold it steady. The assistant should check the light position constantly, and you should check it just before each exposure.

Ideally, the key light unit should have a modeling light. That's a tungsten bulb, built into the head in addition to the flash tube. It's not bright enough to affect the exposure, but it's on all the time, to show the photographer approximately what light from the flash tube will look like when the unit fires. You need the modeling light to see how the key light is shaping the subject's face, and it also helps you or your assistant be sure that the key is properly aimed. If you don't have a modeling light, you simply have to guess what the key light is doing.

Aiming can be a problem when you're working fast. Even with a modeling light it's sometimes difficult to see whether the light is aimed correctly. The best way to judge aim is to look at the light source from the subject's position. Place your head right between the subject's head and the light source. The light head should be pointed right at you. You can see if it's not. Use this check whether you're working with an assistant or a light stand.

If you're using different kinds of light sources for the key and fill light, you will need to meter or test to determine your light ratio. The best bet is to make some exposure tests before you use the lights. We'll discuss exposure tests in the next chapter.

Even if you don't use two lights for other photos, you may want them for large groups at the altar. Using one flash for groups, you may be forced to use a wide lens aperture. By the time you move the flash back far enough to cover the subject, it may be pretty weak. By using a key and a fill, you get significantly more overall illumination. Since you're looking for maximum illumination, you probably should not use an umbrella for the key light.

When lighting large groups, the modeling light may not be of much use to you. You can position the key light pretty well without it. Put it on the left side of the camera, about thirty degrees out from the camera-subject axis, and thirty to forty-five degrees above that axis. This placement should prevent any person in the group from casting a noticeable shadow on another person. Aim both lights at the center of the group. You'll want to test your lights before you ever use them, to learn how far away they must be to cover various sized groups.

If you should want to experiment with a hair light or background light, you should use them on stands and trigger them with slave cells. Be sure the lights and stands are not visible in your images, and that no light is aimed so it can spill into the camera lens.

Making the Most of Outdoor Lighting

You may be thinking that you're pretty well stuck with the lighting that's available to you when working outdoors. That's not really true. You can control outdoor light with umbrellas and reflectors.

You can either add or subtract light. To add light, you use reflectors to bounce sunlight into the scene where you want it. To subtract light, you can use a black umbrella or panel to cast a shadow or to block light.

If you're working in the shade, and the light is too flat, you can use a white or silvered umbrella from a few feet away to create a key light. The umbrella must be in the sun and positioned where you want your key light to be, with its hot spot aimed at the subject.

If adding light isn't practical in this situation, just subtract it. Use a black umbrella to shade your subject from part of the open sky. Use the umbrella close to the subject, usually on the side of the face nearer the camera. With any of these techniques, you can see exactly what you're getting and control the effect by moving and aiming the umbrella or reflector.

If you're forced to work in bright sunlight, you can use a silvered reflector or umbrella as a fill light. Just reflect the light from the camera position to the subject. This technique has a serious drawback in that your subject must look almost directly at the bright reflector. Many people can't do it without squinting.

There are a couple of other ways to work in sunlight. The easiest is to stand your subject with the sun at her back. You'll expose for the face, and let the sunlit areas be over-exposed. You should choose a setting where you have dark green foliage in the background. Since it will also be in shade, it should photograph fairly dark. The technique works best when the subject has dark hair. We don't advise it for portraits, but it can be used for posed candids.

Flash fill also works well in full sunlight, although it is harsh. Just use the sun for a key light, and use flash to fill the shadows. We'll discuss the exposure technique in the next chapter. Many people can't avoid squinting with this technique.

The Candlelight Look

Brides love candlelight photos. The truth is you don't take them by candlelight. You use either the available tungsten light in the church or the modeling light from your flash. If you use available lighting in the church, you need to be careful that it comes from a source low enough to get light into the subject's eyes. Often the altar lights are positioned very high in the rafters and will cast deep shadows in the eyes.

If all else fails, you can duplicate the orange light by using a deep orange gel filter over your flash, and underexposing by about a stop. It's a good idea to do some test exposures on this technique before trying it at a wedding.

However you get the orange colored key lighting for candlelight photos, the thing that makes them work is having candles in the photograph, and close enough to the subject's face that they appear to be providing the illumination. You use your shutter speed to control how brightly the candles are rendered. Begin experimenting with a shutter speed of 1/15 of a second.

With most of your photography in the church, you have to be careful to keep backgrounds light. Candlelight photos present the opposite challenge. It's easy to get too much exposure from backgrounds because you're working at slow shutter speeds. Be sure to select very dark backgrounds to start with, and keep as much light off them as possible. The candlelight photos require dark backgrounds to maintain the effect.

If you have to do candlelight images in an area that is too light, you can use a black piece of fabric behind your subject. Recruit a volunteer from the wedding party to hold it up for you. You'll have to do all close-ups so as not to show the edges of the cloth.

You can enhance the effect of candlelight photos by using soft focus or starburst lenses or filters on the camera.

Be very careful when working close to candles: the open flame can set clothing on fire, and the veil is a particular hazard. We don't need to tell you the implications.

Learn to See Light

Even if you choose to limit your flash photography to flash on camera, you can benefit greatly from the study of lighting. The most important thing you can do to become adept at lighting is to learn to see light. Watch how it works. Study light all the time, whether you're photographing or not. Watch the interplay of light and shadow in all situations. Watch how lighting is used in all kinds of photography. Watch TV with the sound off, and observe the lighting that has been used. Notice lighting in film, in magazine ads, wherever you find it.

When you see lighting you like, analyze it to see what's making it work. Figure out what kind of light sources were used, and where they were. See if you can determine how large the key light was. Look for the four functions of lighting—key, fill, background and kickers. Notice the light ratio, and how it contributes to the mood of a photograph.

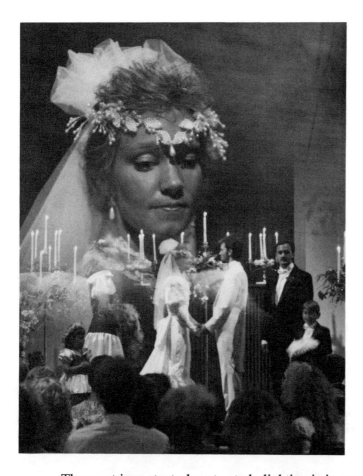

The principal light source for "candlelight" photos will be the altar lights. Dark backgrounds are best for these.

The most important place to study lighting is in your own work. When you look at your proofs, pay special attention to lighting. Learn to appreciate when it works well, and when it doesn't.

Apply what you've learned every time you work. Watch for the chance to make your lighting sparkle by turning the subject's head slightly, or moving the camera a few inches. Master light: it is your willing and powerful servant.

The Techniques of Wedding Photography

If The Exposure's Wrong, Nothing Else Matters

You'll spend your photographic career perfecting lighting, posing and expression. You customers will make most of their purchase decisions based primarily on expressions. After you first learn how to put images on film, you'll devote only a fraction of your energies to getting correct exposures. Still, all that other work depends entirely on exposure. If you don't get printable images on film, all else is wasted.

Your authors assume that if you're reading this book, you already know what f:stops and shutter speeds are, and how they work reciprocally with each other, that if you halve the time of correct exposure by the shutter speed, you must double the intensity of light by opening the lens diaphragm.

We assume that you know how to use a light meter. We assume that you know how to calculate flash exposure, or at least how to use the automatic exposure mode of your flash equipment. If you don't know those things, you need to get instruction from some other source.

Let's define exposure as the duration, intensity and color of light falling on film. Duration and intensity are reciprocal, and together control the level of exposure. The color of light is another matter, separate from exposure level.

Color Balance, and Long vs. Short Exposure

Your film is balanced to give you natural color rendering only when exposed under certain conditions. If you use a daylight color negative film with an exposure index lower than 200, that film is probably intended to be exposed under direct midday sun, or with electronic flash, and for times between about 1/10 of a second and about 1/1000 of a second. Some of the 400 speed films on the market are intended for longer exposures, typically 1/10 of a second or more.

Within a certain range, the photo lab can correct your prints for the light source you use. They can correct a wide range of color errors, and a sizable amount of exposure error. So, you can probably use your 400 speed film with electronic flash, and notice no defects worse than some increase in contrast. In fact, the lab could probably correct the color in your candlelight shots, almost to normal rendering. They just know from the candles, the color shift, and possible underexposure that you want the candlelight effect, so they print for it

You will probably get the best results if you use 400 speed negative film for your available light photos, especially if your exposures are longer than 1/15 of a second. You'll get better images outdoors and with electronic flash if you use the slower speed films.

What Is Correct Exposure?

You probably have a fifteen to twenty stop range of exposure settings on your camera. Obviously, most of those settings will be wrong in any given situation, so how do you know which one is best? Perhaps you set every exposure yourself after taking a light reading, or making a calculation with that little dial on the back of your flash unit. Perhaps you use automatic metering in the flash and camera, and just trust it. But, what constitutes the best possible exposure?

The bad news is that you can't trust the film manufacturer, or even your lab to tell you. The good news is that you can find out for yourself.

Film manufacturers, you see, are in the business of selling film. They seem to consider the marketplace as much as they consider test results when assigning a speed rating to a film. One

manufacturer sold a color negative film for years that was rated at ISO (it was ASA then) 100. They later replaced it with a film they rated at ISO 160. Many photographers who tested those films under normal usage conditions, rated both of them at ISO 80. That's one-third stop more exposure for the old film, and a full stop more for the new one.

Many photo labs put print exposure values on the back of every proof. Those numbers aren't standard, and don't accurately reflect the exposure of an individual negative so we can't tell you how to use them as exposure guides. They do, however, fluctuate with overexposure and underexposure, and your well-exposed negatives will fall within a certain range. The lab will tell you the range in which they like to see your negatives, but that is not necessarily the best exposure.

Labs sell you time. They sell you film and processing of course, but one of their largest costs is labor. Think about it for a minute. If they can save ten per cent of the exposure time on every proof or print they make—several million per year—they'll reduce labor costs substantially. It's not the difference between profit and loss for a lab, but it's noticeable. The lab would certainly rather see all their customers shooting slightly underexposed negatives than slightly overexposed.

Do Your Own Exposure Tests

How can you cut through all that confusion to learn what is correct exposure? You do tests under actual shooting conditions. The technique is simple. Photograph a person, at typical close-up range in each of the conditions under which you normally shoot. In other words, do one test in open shade, one in sunlight, one with flash, etc. For each test, use your normal method of determining exposure, and use the manufacturer's recommended film speed rating.

Make at least nine negatives on each test, ranging from two stops underexposed to two stops overexposed, and exposing a frame at every half- stop. Those nine images should be identical, except for exposure. Don't move lights, subject, camera, or anything else. Have the lab process the film and make the best possible print from each negative. You'll probably need to have them print the test more than once to get what you need. You want the highlights on the face to match, in each print.

Evaluate the test by laying all the prints side by side and picking the best one. The prints from the extreme exposures will certainly not be the best. We had you shoot those so you'll be able to easily recognize the effects of overexposure and underexposure. The underexposures will show loss of shadow detail, and off color shadow areas. Overexposures will show loss of highlight detail and sharpness. Notice what those effects look like on the extremes of the test, and eliminate all the prints that show even slight effects of underexposure or overexposure.

That should leave you with four or five prints. Now look at color quality and saturation. Eliminate the prints that you like the least. You'll probably end up with three or four prints that show little if any difference. The middle of the range of those final prints is the best exposure. It will almost always be from a negative that had more exposure than recommended by either the film maker or the lab.

This testing method is faulty in that it's affected by variations in shutter speed, lens efficiency, flash performance, and light meter sensitivity. So, it's testing all those things as well as film speed. Still, it's more realistic and reliable than any other test you can do.

You may want to test a couple of different cameras, and you should definitely test each flash head and each light meter you use. Your lab may get a little testy about running so many tests, but so what? You're the customer, and in the long run, it's in everybody's best interest for you to create the best negatives for your customer.

You should retest at least once a year, and before you use any new flash head or light meter. Retest any time the film manufacturer tells you they've improved or changed the product. Retest any time your work looks like you're getting overexposure or underexposure on some images.

If you're using multiple flash units for altar photography, you should probably also do a test to determine the flash to subject distances that yield the best light ratios. This is even easier than

the exposure test. The best place to do the test is in a church. Call a minister and ask if you can come in to make exposure tests on a weekday. Have someone pose for you.

Place your fill light at about the camera distance you'd use for groups of four or six people. Don't put your camera at that distance, however. You want to make close-up images so you can judge lighting contrast on the face. Leave the fill light in the same position throughout the test. Make a series of photos, moving the key light from a fairly close to a distant position. Be sure to record the distances you use for both the key and fill lights.

Have the tests processed and printed, and evaluate the results. Just pick the one you like the best. We don't care if its light ratio is 1:2, 1:3 or 1:6. We only care which one produces the most pleasing and saleable results. Once you've determined the correct working distances for your two light sources, you can use those distances until you change the lights in some way.

Test For Flash Fill Exposure

If you're forced to work outdoors in bright sun, the sun itself is your key light. The fill light consists of whatever light is reflected from surrounding objects, and diffused through the atmosphere. That fill light is usually only about one sixteenth as bright as the sun, but no color film can record full detail in a 1:16 light ratio.

One solution is to use flash to fill the shadows. The technique is simple: just use flash on camera. Exposure is pretty simple, too. You may find that using automatic flash exposure will give you good results under noon sun. Under weak sun, early or late in the day, or when haze is present, the automatic setting may give you too much flash fill.

If you're using automatic flash exposure, simply set your camera f:stop at the setting indicated by your flash. Then take an incident meter reading of the sun, and set your shutter speed to match the f:stop you're using. If you want less flash fill than the automatic exposure setting will give, use a smaller lens aperture (larger f:number), and set the shutter speed to match that smaller opening.

As with any other exposure problem, the best course is to run tests. Do one test under bright, midday sun, and one late in the afternoon. For each test, shoot one exposure at the setting indicated by your automatic flash, three at smaller apertures, and three at larger apertures. For each exposure, take an incident meter reading of the sun and set your shutter speed to match the lens opening you're using for that exposure. Have proofs made, and pick the exposures you like best for each lighting condition.

Reflected Light Metering Has a Trap

There is only one way to accurately measure light for determining exposure, and many photographers don't use that method at all. Only incident meters that measure the light falling on the subject, can be accurate. The meters built into your camera and flash are not incident meters. They measure the light that is reflected back from the subject. They can't give you correct exposure no matter how good they are, no matter whether they're center weighted, spot meters, or any other type. They can't be accurate because they measure light reflected from the subject.

A simple test can demonstrate the fault in reflected metering. You probably don't even have to do this test: reading about it will suffice. The test is this: photograph a black card, a gray card and a white card, using transparency film. Transparency film is better for this test, so that printing variations don't affect the results.

The cards should be big enough that you can fill the frame with the image of one card, showing nothing else. The gray card doesn't have to be a standard eighteen per cent gray card: any gray will do. It's a good idea to write, "Black," "White," or "Gray" on the corner of each one.

Photograph each card separately, filling the frame with the card. Take a reflected light reading of each card, and expose accordingly. Of course, you'll end up giving more exposure to the black card, and less to the white one.

If you want to make a comparison, do the same test using incident metering. The incident reading will be the same for all three cards, so the exposure will be the same for all three.

Have the film processed, and evaluate the results. Are you surprised to learn that there are no images of black and white cards from your reflected metered tests? All three of those shots will look the same. You photographed three different cards, and got back three images of gray cards. This is where you'll be glad you marked the cards, so you won't be wondering if you made a mistake.

If you did the incident metered test, it will yield a white image from the white card, a gray image from the gray card, and a black image from the black card.

What happened to the reflected meter test? The meter compensated for the subject brightness of each card, and made them all look the same. It caused you to underexpose the white card and overexpose the black card.

The effect would be the same if you photographed a fair skinned blonde bride, in a white dress, against a white background. Your reflected meter reading would cause you to underexpose, and you'd get a weak negative that would produce a low contrast print with color and detail problems in the shadows.

If you use reflected metering to photograph a dark skinned, dark haired woman in a black dress, against a very dark background, you'll overexpose the image. You'll get plenty of shadow detail, but you may wash out highlight detail and lose highlight sharpness.

We recommend using incident metering to determine exposure wherever possible. You can certainly use it outdoors and for available light photography. The correct way to use an incident meter is to hold it at the subject's position, and point its white hemisphere toward the camera. You should position the meter on the shadow side of the face, so it is being struck by fill light, but not directly by key light.

Be careful that the light falling on the meter is exactly the same as it will be at the time of exposure. Light reflected from your own white clothing, for example, could be reflected onto the meter at the time you take the reading, but it won't be there when you make the exposure.

Automatic metering, whether through the camera or the flash unit can only be done by measuring reflected light. You'll have to make manual compensations for bright or dark subjects to adjust for the reflected meter's errors. You'll probably never need to compensate more than one stop. Here are some suggestions for automatic flash:

Bride with well lighted white background	+2/3 stop
Bride at the altar, three-quarter length	+1/2 stop
Bride at the altar, full length	+1/3 stop
Groom, black tuxedo, dark background	-1/2 stop
Groom, black tuxedo, distant background	-1/2 stop

The (+) signs indicate more exposure is needed than the automatic metering would provide. The (-) signs call for less exposure. These are very rough guides. You can watch the exposure numbers on the back of your proofs to help you judge whether you're compensating properly for reflected metering.

You'll hear it suggested that you should overexpose photos of African- American people, but that's bigotry, not photographic science. Light skin should be rendered light, and dark skin dark. If you're using incident metering, expose for all people exactly the same, regardless of skin color. Even if you're using reflected metering, judge your compensation by the darkness of the clothing and background, rather than skin color.

In a head and shoulders portrait, the subject's skin usually fills considerably less than half the subject area. In a full length photo, it may be less than five per cent. Most dark skin reflects almost as much light as light skin. If any exposure compensation is necessary for dark skin, it is only with reflected metering, it is very slight, and it should be in the direction of less exposure rather than more.

Some Exposure Tips

When you're doing flash photography, you have great control over the brightness of backgrounds. The background is usually lit by light from your flash, and also by ambient light, from the room lights, windows, doors, etc. If your subject is correctly exposed by a flash unit eight feet away, and there is no ambient light exposure, the background three feet behind the subject will be underexposed by about one stop. Eight feet behind the subject, background exposure is off two stops. At fourteen feet, it's off three stops. Three stops underexposure is almost black. Just by varying the distance between your subject and the background, you have some control over background brightness.

Remember that the background is also illuminated by room light or window light. Your shutter speed doesn't affect electronic flash exposure, but it does affect ambient light exposure. If you're using a leaf shutter, not a focal plane shutter, you have almost unlimited control of background rendering. If you want a brighter background, use a slow shutter speed. For darker backgrounds choose higher shutter speeds.

A slow shutter speed keeps a little light on the background so it doesn't go black.

For a lot of your candid work, you'll want to use slow shutter speeds to keep backgrounds light. That's important for two reasons. It keeps your work from acquiring a dark, heavy look. It also makes the photos more interesting by relating people to the environment.

Sometimes you need dark backgrounds—for dramatic impact, for double exposure, or because the backgrounds aren't attractive. Just crank up the shutter speed. If the reception is in a church hall that has ugly cinder block walls, even if sunlight is streaming in the windows, you can improve the impact of your photos considerably by rendering backgrounds darker.

There is one other factor in obtaining consistent exposure. A couple of laws of physics conspire against you when you work very close to your subject. The result is a loss of exposure, for which you should compensate. We'll skip the physics lecture, and complicated formulae. Here's how to compensate.

Flash is taboo during the ceremony. Even if the minister should allow it, it's in poor taste and it irritates the guests. So you'll need to do available light photos from the back of the church. It's a good idea to take a meter reading at the altar before the ceremony, so you'll know how to expose. Be careful, though, sometimes the lights are dimmed or brightened for the actual ceremony.

If you don't get a meter reading, or if the conditions change, try this. Expose the ceremony shots on 400 speed film at of a second and f:5.6. If the altar seems brighter or darker than normal, compensate from there. These images will be printed as candlelights, anyway, so a little exposure error won't be noticeable.

Head and shoulder cropping	+1/2 stop
Tight full head shot	+2/3 stop
Tight close-up of hands & rings	+2/3 stop
Extreme close-up of face	+1 stop

That's right, you should be allowing one-half stop more exposure for a head & shoulders cropping than for a full length. Caution: if you did your exposure test at the distance for a normal head & shoulders photo, you've already built one-half stop of compensation into your normal exposure values. You only need one-half stop additional compensation for an extreme close-up.

Don't think this applies only to certain lenses, or only to cameras that have bellows. If you're close enough to fill your frame with the subject's head & shoulders, you need one-half stop more exposure, whether you're shooting with a twenty-four millimeter lens on a Nikon, or with a sixteen inch lens on an 8x10 view camera. If you're a math, physics and photo science whiz, figure it out with the formulae. We did.

Keep It Sharp

Why would we write about focusing? You all know how to do that, don't you?

Actually, many photographers don't get consistently sharp images. There are two causes for this—poor focusing technique, and camera movement.

Camera movement probably destroys more sharpness than poor focusing technique. When you're using electronic flash, the short flash duration probably controls the problem, but you'll often work outdoors and with available light.

Don't kid yourself. You can't consistently hand hold a medium format camera at shutter speeds longer than 1/125 of a second. You won't see obvious camera movement in your prints until you try to shoot at speeds longer than 1/30, but crisp sharpness just won't be there on some of your photos. Examine those under a magnifier. All too often you'll find that bright highlights or fine points of detail are slightly elongated. Those oval details that should be round are sure signs of camera movement. If you can see it under a magnifying glass, it's stealing your sharpness.

Movement can come from the camera itself. One very expensive brand of medium format camera has a problem with movement induced by the mirror. The camera body just seems to be too light to damp the vibration.

The solution to all the movement problems is a tripod. It needs to be a solid one. This is no place to get cheap in your equipment selection. Good, heavy tripods work better and last much longer than cheap models. No tripod does any good in the trunk of your car, however. It has to be under the camera. Use it.

While it's true that movement causes a lot of sharpness problems, focusing error is often the culprit. Many photographers look in the viewfinder, turn the focusing knob, think, "That looks sharp," and trip the shutter. That's not good enough.

There are three skills you have to learn in order to focus well. You must learn to mechanically focus the camera to its sharpest point. You must learn to see sharpness. You must learn to focus on the right part of the subject. Always.

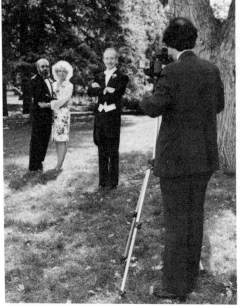

A good heavy tripod solves the sharpness problems, but it does no good in the trunk of your car.

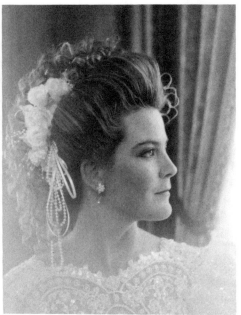

Soft focus isn't out-of-focus; every hair is distinct in this portrait. Note the slight vignetting at edges and corners.

Focusing on the right part of the image is the easiest to learn. When you're photographing people, you want the eyes and mouth to be sharp, and the eyes are by far the most important. Notice that when you talk with people, you look at their eyes most of the time. You look at their mouths fairly often, and you glance elsewhere occasionally.

You want to focus on people's eyes. Specifically you want to focus on the eyebrows, eyelashes, or possibly the rims of glasses. If you simply can't see the eyes clearly, you can sometimes pick a place in the subject's hair that is at the same distance from you as the eyes, and focus there.

Do not focus on the catchlights. The catchlight, that bright sparkle of light in the eye, is actually a reflection. It can be a reflection of your fill light, window light, or the sky. Optically, that reflection is located behind the eye. The convex surface of the eye serves to keep the optical location of the catchlight close to the eye, but it's always behind it. If you focus on the catchlights, you'll always be back focused. Your subjects will probably have sharp ears and out of focus eyes.

Learning to see sharpness is probably the most difficult of all these. You're halfway there if you've learned where to focus. The next part is learning to judge focus on the very finest detail you can see, and to make it as sharp as you possibly can. If you're focusing on the eyebrow, look at just one eyebrow, not both. Try to focus until you can see each individual hair of that eyebrow. Go even further. Try to be able to see the individual hairs as clearly as you possibly can.

If you practice that kind of routine, you will be seeing sharpness. Once you get the hang of it, you'll do it without thinking. You can reinforce the habit by looking for sharpness the same way in your proofs and finished prints.

If you're using a single lens reflex camera, you're focusing the lens image onto a piece of ground glass. As you turn the focus knob the image becomes more clear. When it looks clear, you stop turning the nob and squeeze the shutter button, right? Wrong.

To get the sharpest image, you have to seek out the best focus. Turn the focus knob until you see the finest details come into focus, then go slightly out of focus. Then you move the focus knob or ring in the opposite direction, until the details become sharp again, and once more go slightly out of focus. Reverse the movement again. Each time, you move the focus mechanism a little less. You're sort of rocking the knob or ring back and forth until you find the very sharpest

spot. If you remember tuning in radios before they were all digital, it's the same kind of movement. Just do it quickly, or expressions will die and clients will become annoyed.

Do these three things and you'll have crisp sharp images. Focus on the spot you really want to have sharp. Focus critically on the finest detail you can find. Fine tune the focus until its as good as you can make it. The entire process probably takes less than a second. When you've learned it, you'll do it without thought.

Now That It's Sharp, Make It Soft

We've already mentioned the use of soft focus several times. You'll use it often to add depth and feeling to your images. The first thing to know about soft focus is that it's very different from out of focus. If you look closely at good soft focus images, you'll see that they are both sharp and soft. Even when the image is very softened, you can see each eyelash, each individual hair. You might even see the pores of the skin. The softness is almost a glow.

This seeming contradiction is possible because some of the light used to form the image is brought to sharp focus, and some of it is only approximately focused. Soft focus lenses, filters, screens and other devices all do the same thing. They allow some of the light forming the image to focus sharply, while scattering or changing the focus of some of it.

The result can best be seen in a bright highlight such as the catchlight, or a reflection off of a metallic object. The bright highlight will be in sharp focus, but it will have an out of focus halo around it. The same thing is happening to every point on the object. Each has a sharply focused image point, surrounded by an out of focus halo.

If you're doing you're own printing, you may be tempted to shoot everything sharp and do your diffusion under the enlarger, but you won't get the same effect. If you diffuse at the camera, you scatter the highlights into the shadows: that's what gives you the glow. But if you diffuse in printing, you're working with your image as a negative, so you scatter light from the shadows into the highlights. Instead of getting bright open highlights and softened shadows, you'll get very dark shadows, and muddy, off-color highlights. The effect is anything but a glow.

The way you achieve soft focus at the camera is immaterial, as long as part of the image forming light is focused sharply, and as long as you can control and vary the effect. There are a variety of soft focus products on the market. Virtually all of them work well.

You can also make your own diffusion devices with bridal veil material. You can get it at fabric stores in at least two varieties, with coarse weave and fine. You can paint it black to minimize its effect for slight diffusion, you can leave it white for a more pronounced effect, or you can use multiple sheets of it for maximum effect. The coarse net painted black is so barely noticeable that you could use it all the time, even for photographing young men. You can barely see through four thicknesses of the fine white material, and it will nearly obliterate your image, but what remains will be sharp, and will have an almost ghostly quality.

Use soft focus judiciously. You'll probably use it a lot, because customers love it. It works best when you don't use it all the time, and when you use it in varying degrees for different effects. You'll use soft focus less often on men than on women, and you'll use lesser degrees of it on men. You'll use it more on older people than on younger. You'll probably use greater degrees of soft focus on high key images than on low key. You can use it very effectively to minimize complexion problems or wrinkles.

Thoughts From Piare: Flatter the Folks

Photograph the people as they want to be, as they want to look. That way you maximize your sales. You usually don't have to ask what they want. Ninety per cent of men want to look very strong.

If the subject is an artistic kind of guy, whose personality is softer, you might use a little touch of soft focus. Not too much; he's still a man, you know.

In the case of an older man marrying a younger woman, I'm going to make a compromise. I'm not going to make him look too old. I'm going to make him look a little better. I might even do some stunts, like photograph him slightly out of focus behind the bride. I'll give him some variety—soft and not so soft.

There are a few caveats about soft focus and diffusion. Be careful not to underexpose your soft focus images. Underexposure robs you of contrast, and the soft focus effect also reduces contrast considerably. Some soft focus devices reduce exposure slightly. If you then make close-up images without appropriate exposure compensation, you may underexpose enough to damage the image quality.

If you're using a high degree of diffusion, you may find that more contrasty lighting helps keep pizazz in your images.

Don't use diffusion when the subject's head size will be very small in the photograph.

Composition for Wedding Images

As with other topics in this book, we'll not write a lengthy treatise on photographic composition. There are countless articles on composition in other books, and we assume that you already know the basics.

Variety is probably the essential concept in composition for wedding candids. You're going to be putting fifty or more images in an album: at least half of them will be photos of the bride. Variety will make that presentation more interesting. Use everything from loose, open full lengths to extreme close-ups.

In wedding photography, you're often working in crowded environments and you may have little control over backgrounds. As a result, you'll need to work to open up your compositions and provide space in the images. You will also need to be constantly on guard to ensure that backgrounds are appropriate. A beautiful portrait can be spoiled by some unwanted object intruding in the background. But you don't want to eliminate everything from your backgrounds: wedding photography is story telling, and the contents of the background are the setting.

The final rule is one we've already given you: before tripping the shutter, check the frame from corner to corner and edge to edge.

We've used the term, "three-quarter length," rather loosely. It refers to any cropping that's looser than a head & shoulders photo, and tighter than full length. The specific cropping of such images depends on the pose. The typical three-quarter length photo is cropped a little below the waist.

Avoid cutting hands and arms in awkward places; as a general rule, don't show just part of a hand or arm. If your subject is leaning on something, that object must show. That's still true if the subject is leaning on his own knee.

You can even introduce cropping variety into your close-ups. The bride's close-up photos can be loose enough to show most or all of the veil. They can be done at the usual head & shoulders distance. They can be done so as to show only the face and just a little of the hair, or to just below the chin. The bride can hold her bouquet close to her face, and you can include most of the bouquet in the image, or you can move in and show only a hint of the flowers. Or you may rarely use extremely tight close-ups full face, cropping at the hairline, and just below the lips. Interesting lighting, tilted framing, plus diffusion can add to these close-ups. Extreme close-ups of profile poses can be very dramatic, portraying a variety of moods.

Close-ups of men can be varied, too. Crop the lower edge below the shoulders, at the tie knot, below the chin, or below the mouth. As with brides, you can add even more variety by occasionally working in profile.

Perspective Distortion

You'll sometimes read that short focal length lenses distort perspective, making closer objects appear too large. That's not strictly true. The distortion isn't created by the lens: it's the result of your working distance. If you are too close to your subject, you'll introduce distortion. Unfortunately, the circumstances of wedding work often force you to work very close. In a tiny dressing room, you have no choice but to put on a short lens, and stay close.

The rule of thumb, though, is to use the longest lens possible. That rule especially applies to close-ups. Long lenses move you far enough from the subject to give you more control over backgrounds and to prevent distorting your subject.

There are times when a little perspective distortion may be beneficial. If one person of a couple is considerably heavier than the other, you can turn the pair so the thinner one is closer to the camera, then mount a shorter lens and move in. The resulting distortion will cause the large person to be rendered a little smaller.

Creating Double Exposures

In the nineteen seventies, at least in our region, double exposed images became a staple of wedding photography. A few of them were thoughtful and expressive, some were interesting, and many were trite. Like most fads, they have lost much of their popularity. Some of your customers will ask for them, however, and you can create some nice images with the technique if you use it judiciously.

Thoughts From Piare: Did I Start This Thing?

When I came to the United States, I was the first photographer in the company I worked for to shoot double exposures. No one did them; they didn't even know how.

When the President of the studio chain saw my first wedding, he couldn't believe it. Here was somebody with a Rollei, doing double exposures. I'd been doing them ever since I was fourteen years of age, in India. Maybe I was born with a double exposure outlook on life.

There was one photographer who managed one of the biggest studios. That first wedding I did was for his studio. He was quite surprised when he saw the double exposures. This guy from India did something he doesn't know. So he came to the lab the next day, and asked, "How do you do it?" And pretty soon they were all doing them.

There's a technical secret and an aesthetic secret to a successful double exposure. The technical secret is that each exposure must leave a large area of the negative unexposed, to allow for placement of the other image. The aesthetic secret is that the images must tell a part of the wedding story. There is no other reason to use the technique.

The two most common ways to keep part of an image unexposed are to keep that part of the subject in deep shadow, or to use dark vignetting to hide part of the subject from the camera.

Let's study a typical setup for a double exposure. If one of the images is to be of the groom in profile, pose him well in front of any background or other items. Use one harsh light source, such as your portable flash unit. Mount it on a light stand, or have an assistant hold it. Position it so it lights only the front of the groom's face, and leaves the side of his head nearest the camera in complete shadow. Be certain that no light from the flash can reach the camera lens. Compose for a large image of the groom's face, with the shaded part of his face filling much of the frame. That large shaded area is where you'll place the second image. Make the exposure using a fast shutter speed, to eliminate background exposure from ambient light.

Let's make the second image in this example a three-quarter length image of the bride. Select a large open area, and pose her as far from the background as possible. Position the light source so it illuminates her, and avoids lighting the background. Just as with the image of the groom, use a fast shutter speed to keep the background dark.

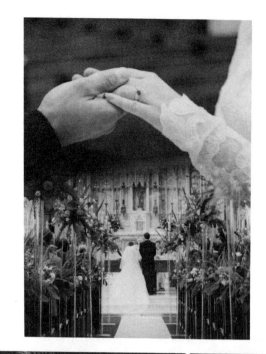

Double exposures should contribute to the telling of the wedding story. Don't do them just because you can.

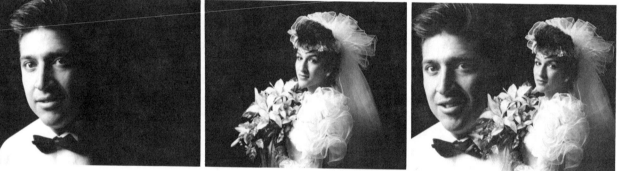

These are the components of a double exposure. Frame and light the first image. Expose it, but don't advance the film. Then frame and light the second image, expose it and advance the film.

It's obviously helpful to choose dark backgrounds rather than white walls. Working in large, open room areas helps keep the non-image areas dark by minimizing reflected light from the flash. Harsh rather than soft light sources are almost essential for the same reason. When you want softness, get it by using soft focus.

Be careful to avoid unwanted light sources such as candles or exit signs in the backgrounds.

You'll need to have some way to store images for double exposures. Occasionally you'll be able to expose the two images one right after the other, but most of the time you won't. For example, you'll need to photograph the outside view of the church well before or after the photo of the ceremony. The answer to this dilemma is simple. Store one of the images on a separate camera, or a separate camera back, until it's time to complete the double exposure.

There are many combinations of images that make sense for doubles. The classic is positioning the soft dreamy image of the bride as if she is in the thoughts of the groom. The opposite situation works just as well.

A photo of either or both of them combined with a view of the ceremony can work. An image of the outside of the church can be combined with a view of the ceremony, but if an idea seems hokey, don't shoot it.

If you use doubles at all, use very few of them, and use them to make a visual statement. If your clients ask for them, by all means meet their needs, but do it in good taste.

Misty Romantic Candlelight Images

We've discussed the creation of candlelight images pretty thoroughly, but here's a summary of the technique. The orange color rendering and the presence of candles in the photo are the key elements. The color rendering is derived not from the candles, but from exposing the images by the available light of the altar area. It's not necessary to underexpose, though slight underexposure will do no harm.

It's important that the background be dark, and you can't darken it by using a fast shutter speed, because you're not exposing by flash. You'll have to position your subject and camera so that you actually have a dark background. If that fails, ask someone to hold a black cloth behind your subject. (You'll need to carry such a cloth with you.) A starburst filter will add some pizazz, and emphasize the candles. Additional soft focus enhances the romance.

Silhouettes Are Big Sellers

One of the most popular images in wedding coverage is also one of the easiest to do. Simply pose the bride and groom facing each other, holding hands, in an archway or portico at the church. Even the open sanctuary doors will do, but the bigger the architectural detail you use, the more dramatic the photo.

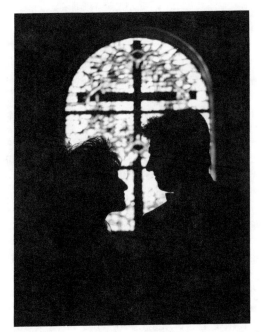

Your clients will like silhouettes and will buy them. Use open doorways, arches and windows for the background. Sometimes a stained glass window works well, as in this photo.

Both you and the subject will be in the dark interior, with a sunlit scene or open sky behind the couple. The couple should be illuminated by a couple of stops less light than the background. The background scene must be attractive and appropriate; the church parking lot won't do. You can get more sky, and less distracting background by working from a low angle. Put your camera right down on the floor if it helps.

Disconnect your flash unit, and expose for the outdoor light. This will render an attractive image of the background, with your subjects shown in silhouette. The same technique can be used for an image of the bride alone.

Gadgets & Gimmicks

There are dozens, even hundreds of clever gadgets on the market, designed to clutter up your wedding photography. We recommend that you leave almost all of them untried. The one we especially hate is the multi-image filter. That's the device that gives you six or more identical images with one exposure. Why would anyone want to do that? It makes no statement. It adds nothing to the wedding story. It doesn't even make sense.

If you can say the same things about any gadget or technique, don't use it. The test is simple. Does it contribute anything to the telling of the story?

We've talked at length about the use of diffusion and soft focus devices, and we've mentioned starburst filters. They're both very appropriate. We do recommend that you avoid overusing them. The starburst filter can be especially annoying if it shows up in too many photos. The starburst filter also softens the image somewhat.

One product that is quite useful is the Pictrol. That's a brand name for a device that places pointed, clear plastic fingers in front of your lens. It's adjustable, so you can have the plastic cover none of the lens, almost all of it, or anything in between. It delivers variable, controllable soft focus. If you're using a single lens reflex camera, you can see its effect in the viewfinder.

Another essential device is some kind of vignetter. You need it to darken or soften the corners or edges of images. The simplest vignetting mechanism is a set of plastic devices that can be attached to your lens shade. You can make your own or buy them pre-cut. The homemade versions are probably better, because you can cut more fingers, closer together, and with sharper points, than the ones you can buy.

Use black vignetters for low key images, and to produce dark corners and edges. Use translucent versions for high key photos, and to dissolve the corners of the image without darkening them. Oval openings are appropriate when you want to darken all four corners. Arc shaped vignetters can be used to soften only the lower part of the photo, or to block a significant part of the image for double exposures.

If you're making your own vignetters, you can cut them from processed, unexposed pieces of sheet film. Spray the clear ones with the matte lacquer you use for your prints. Spray the black ones with flat black paint.

Budget Your Film Usage

If you just show up at the wedding with a couple of boxes of film and start shooting as the spirit moves you, you're likely to get into trouble with your film usage. You may, for instance, run out of film and be unable to finish. More likely is that you'll realize you're running low on film as the day progresses, and start skipping some images you really should record. The most likely result is that you'll simply overshoot and create lots of images that your clients don't want.

A little planning can guide you to making more of the photos your customers do want, thereby enhancing your sale, as you economize on film.

The first thing to do in budgeting film usage is to plan how much film to use for different sized weddings. For the typical small wedding, you'll need to show about seventy proofs to tell the story. If you plan to show seventy, you should shoot about eighty. Some very small weddings may require less film, but the seventy-eighty minimum is usually necessary.

On the upper end, you'll probably record 150 or more images for very large weddings. There's really no upper limit, but even on the largest weddings you reach a point where additional proofs don't translate into more sales. That's because they don't show anything the customer wants to buy.

The time you spend at the ceremony will usually determine how much you shoot. The minimum will be for two and a half to three hours of coverage.

We don't recommend that you limit your film usage too severely. Even if your customers seem to be very economy minded, they will probably buy the images they want, if you've done your best work in creating them. With a little experience, you will be able to tell when people are likely to buy more than they've contracted for. In such situations, shoot what you think is appropriate, rather than what they've requested. You can't make any sales from the images you didn't record.

Always have plenty of film. For one wedding, carry at least twice as much as you plan to use. Fifteen rolls of 120 film is probably the minimum you should have. If you're covering several

weddings in one day, take enough film for each wedding, plus enough extra to fully cover the largest. You may need the extra film if you have equipment problems and have to reshoot anything. You'll never be sorry you have too much film but you may regret carrying too little. But if the weather is hot, don't just leave the film unprotected in the trunk of your car; keep it in a plastic ice chest with several cans of frozen soda pop.

In deciding what to record, your first guide must be the checklist. Make every reasonable effort to capture everything your customers have requested. Be especially conscious of getting images of any people they've mentioned. If the bride has asked for photos of her great grandmother, you can be sure she will buy them.

Of course, all wedding coverage should concentrate first on the bride, and to a lesser extent on the couple. You need a few good images of the bride alone, showing her exquisite gown. You also will want at least a couple of portrait-like renderings of the bride and groom together.

Your next priority will be family members. The group photos will always be the best sellers. Photograph every family group with the bride and groom. If parents have been divorced, be sure to record all the resultant new family groups. One image of each group is usually sufficient, unless you think someone may have blinked, or looked away as you tripped the shutter.

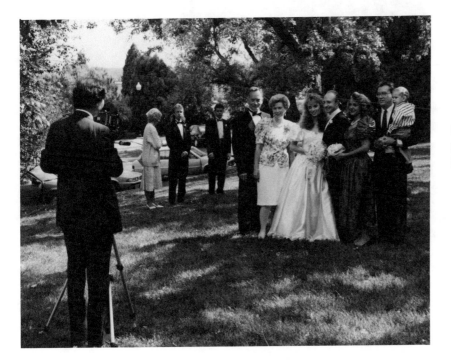

Group photos are big sellers: several of the people in the image may want a copy.

Regardless of the size of the wedding, you should do more photos of groups than of anything else. For small weddings, you should do a complete job of covering the groups, and cut back on some of the other things. As the size of the coverage increases, you can photograph more of the other details.

You only need a couple of pictures of the receiving line. It's easy to overshoot the line because it takes so long. The only receiving line photos most customers will buy are of Mom and Dad kissing the bride. Occasionally they'll choose one of another close relative.

For all the standard staged candids, one proof is enough. These include the make-ready shots, father and garter, bride and attendants, groom and groomsmen, etc. Don't shoot more than one of these unless you think someone blinked or looked away. And don't try to capture every possible posed candid photo. Concentrate on the ones the bride has marked on her checklist, and fill in as necessary. For a small wedding, three to five total make-ready shots of the bride are sufficient. For mid-sized weddings add more staged candids.

You'll always want to go light on reception photos, even on large weddings. Do no more than ten per cent of your photography as true candids. Try to make most of the reception images of people who seem to be very close friends or special relatives of the bride or groom. You can usually tell who they are by observing how they relate to the couple. If there are cute small children at the event, it never hurts to get one or two photos of them, but don't overdo it.

Pay attention to the couple's family and close friends. They offer the best opportunities for successful posed candids.

Some brides want you to photograph each of the tables and the people at them, but they rarely buy them. If you encounter this situation, agree to it only if the bride is willing to commit to buying each of those images.

People buy pictures of people, and they buy the most of people they love. Your job is to give them what they want.

The Elements of Wedding Photography

What to Photograph, and How

It's time now to detail the methods of wedding photography. You know how to promote, sell, manage, light and expose. On the day of the wedding your resources will be three hours of time, and a dozen rolls of film. How can you use those resources to provide the images your client wants?

Posed Candids, the Staples of Wedding Photography

Every photograph you take at a wedding probably fits into one of four categories—portraits, groups, posed candids, and true candids. Your authors believe that the staged, or posed candids are at the heart of wedding coverage. With respect to photography, they're what makes a wedding a wedding.

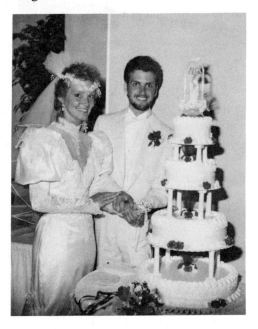

Use posed candids to tell part of the story. The best of them portray something that would have happened even if there were no camera present.

If staged candids are poorly done, they become trite. If they are done indiscriminately, without sensitivity to the character of each individual wedding, they are irrelevant. When done with care, thought and taste, they become a significant part of the wedding day, and a vehicle for preserving memories.

Thoughts From J. C.: Are Posed Candids Relevant?

I don't know that history tells us how these staged candids came into being. Some of them were certainly wedding traditions long before they became photographic traditions. Others were probably conceived as clever picture ideas, then found their way into wedding practice.

In our North American culture, in the past three decades, we have been about the business of re-examining our traditions. We've questioned the validity of many things we once accepted as part of our cultural fabric. As a result of that larger cultural

reassessment, we've experimented with how we conduct weddings and how we photograph them.

In this context, the validity of staged candid images should be questioned. Are they trivial holdovers from a disappearing era, or are they part of a valued tradition? I believe they can be seen either way. A lot depends on how they're executed.

Perhaps two questions can help clarify the value of any one picture idea. Would this thing happen if there were no cameras present? And does this photograph help tell the story of this day in the couple's life? If neither of those questions has a yes answer, perhaps the image is irrelevant.

The bride's checklist should be the principal guide in planning staged candids. Most people haven't seen a great many wedding albums, so they don't know which photos they might like best. In marking items on the checklist, they're probably thinking about which ideas seem relevant to them, and to their wedding.

The items the bride selects should certainly be done, if possible. Some of the other items, such as cake cutting, and tossing the bouquet, will probably be recorded simply because they are significant events in the day. Others, such as the groom's father adjusting his tie, may be used as one of several possible ways to show part of the emotional fabric of the day. In this case it's one way to show the interaction between these two men. Other candid ideas will not be used at all because they are not part of this couple's day. Putting a penny in the shoe might be a candid that's only appropriate if the bride selects it.

Younger couples seem to want more of the traditional ideas. They have less experience with weddings and are perhaps more romantic. They respond to lots of suggestions, and probably select some things just because they're on the checklist.

Older couples, and especially people in second marriages, often prefer to concentrate on photos of close family, children and friends. They'll select staged candids that have emotional meaning to them. Their more mature perspective will reject some of the gimmicks in favor of more spontaneous fun things. Couples who are having very large second weddings are probably more likely to request a lot of staged candids.

All these comments about who likes what are generalizations. If the couple you're working with seems to violate all the rules, do what they want. Otherwise, these suggestions may be valuable when the couple doesn't give you clear directions.

The Best Seller List of Staged Candids

There are some staged candids you'll probably want to photograph at every wedding, whether or not they've been selected by the couple. Experience shows that these images sell. Someone, the parents, other relatives, or friends, will want them. Here's a list:

Something of Mom and the bride, perhaps Mom fixing veil

Mom, Dad and bride; for young brides, show both kissing bride's cheek

Groom and best man, maybe adjusting tie

Something of the groom and his father, fixing boutonniere, tie, etc.

Every person in the procession

Time exposures of ceremony from rear of sanctuary

Every couple in the recession

Receiving line, very few images

Moms and Dads in large coverages, people wearing flowers

Couple leaving the church

Couple getting in car

Couple standing in sunroof of limo kissing, church in the background; it sells every time

Or the couple through rear window of car kissing (shoot with flash)

Couple entering the reception hall, they're treated like celebrities, and feel like celebrities

The toasts to the couple at the reception
Wherever they have spent a lot of money, such as ice sculptures, food, band, etc.
Anything suggested by the mother of the bride
Anything emotional or fun between either of the couple and their parents
Throwing bouquet
Throwing garter
Dances, bride & groom, bride & her father, groom & his mother

Look for those things the couple spent a lot of money on. They'll buy those images.

How To Create The Candids

There is a style of doing staged candids that makes them work. If you do any posing at all, it's only the basics, and you'll probably only do it if someone looks awkward. For the most part, people will stand and act naturally, and that's what you want.

You will set up situations, and direct people. You'll tell them where to stand, and what to do. If you've gotten thoroughly familiar with weight distribution and direction, you'll automatically set up situations that work, without having to pose the subjects. Once everyone is in place, look for anything that looks strained or unnatural. When that happens, it's almost always weight distribution that's wrong. You can fix it by having them move a foot, or, if they're leaning, a hand.

You'll often make two exposures of the situation, one that looks like a candid, one that looks posed. Here's how that works for a couple of the typical staged candids.

Make two exposures of staged candids. One looks candid, with people looking at one another or the activity. In the other they look at the camera, obviously posed.

To set up the penny in the shoe candid, you'll need a prop on which the bride will sit. If you have room in the dressing area to back up and do a full length photo, glance around to see if there's a nice looking chair or bench available. If not, use a folding chair, but hide as much of it as you can with the gown, and try to crop out the rest. Set the direction the bride will face by positioning the chair where you want it.

Seat the bride forward in the chair, which will get her weight distribution right. Then position Mom standing behind her. You obtain Mom's direction simply by showing her where you want her to stand. Then put Dad in place, probably kneeling, and positioned so you can see him in profile, as he holds the shoe and penny in place. You get his weight distribution just by telling him which knee to kneel on.

You're ready to go. You've gotten everyone in place, with correct direction and weight distribution, and it took only seconds, and no one even knows they were posed. Have Dad hold the penny and the shoe, with the bride's toes just inside the shoe. Have the bride look at Dad, and Dad look at the shoe; ask Mom to look at Dad or at the shoe. Trip the shutter. Immediately say, "Stay right there, please." Then have everyone look at you, get smiles, and take the second photo. The first image looks candid, the second looks posed. Both look good, because all the basics were handled properly. The whole thing may have taken a minute to stage.

Your props for the cake cutting are the cake, of course, the knife, and maybe one guest plate. Before you put anyone in position, figure out the direction you'll need to shoot for a good background and shadow control.

Put the bride and groom in place, determining their directions as you show them where to stand. They'll probably be almost side by side, partially facing the cake, and fairly close to it. The groom holds the knife, and the bride rests her left hand on his, with her rings showing. Have the groom position the knife, not yet touching the cake. Take one exposure with the couple smiling at the camera.

Then tell them to go ahead and cut the cake; photograph that as it happens, and proceed to record the couple feeding each other the first bites of cake. You get four photos in a couple of minutes. At least two of them will sell. Even the candids of the cake feeding are set up with good direction for the bride and groom, and nobody feels like they were posed.

Many of your staged candids, especially the make-ready photos will have to be done in cramped, jumbled settings. The dressing rooms are usually small. Sometimes they double for other uses and are cluttered, but with several women changing clothes and making up at the same time, they can quickly become disaster areas. You can clean things up a lot by choosing your camera position carefully. Move in closer, to limit the background area. Use low camera angles to limit the amount of floor and tabletops in the image area. Watch carefully, checking the frame, corner to corner and edge to edge, to be sure nothing distracting is creeping into your shot.

Long lenses show less background area than shorter lenses, given the same subject image size. Of course, you often can't use long lenses in cramped quarters, but where you can, it'll help.

Some of the staged candids require attention to particular details. Those make-ready photos of the bride and her mother are very important. You can often get a spark of the deep emotion they share. When you can, you should record it. It's important to them, and to everyone who loves them. When you capture that, it will sell well, but you would owe it to your client to tell that part of the story, even if no one ever bought those photos.

Photos of the bride and her parents often convey a lot of emotion, and they are an important part of the wedding story.

You can probably improve your chances of portraying that emotion by working just a little slower when getting those images, and by setting up situations where they have a chance to look right at one another. When you stop all the commotion for a few seconds, and have them make good eye contact, standing very close to each other, the emotion will almost surely flow. Make an attempt to record such a moment at every wedding. Your efforts will be well rewarded quite often.

You can use the same ideas with the groom and his father. You may not get the emotion as often, and it may be more restrained, but when you do capture it, it will make powerful images.

You won't always get good true candids of the moms and dads in the receiving line after the ceremony. They may not get there in all the confusion, or you might not be able to get into a good camera position. The way to handle those problems is to stage the receiving line photos. Just ask the moms and pops to stick with you until the guests have gone through, then have them step up to kiss the bride. Position yourself so you can get the image you need.

You can do staged candids at the dance with a minimum of interference, and get much better photos than with true candid photography. Just grabbing snapshots of dancing couples usually gets a lot of elbows, and backs of heads. Here's how you get the posed versions of dance shots: preset your focus for the image size you want, usually a loose three-quarter length cropping. Step up to the couple, and just touch the man to get his attention. They'll stop dancing, look at you,

and sort of cozy up to one another. You step back to the focus distance you've preset, and squeeze the shutter button. Step away, and the couple goes on dancing.

You'll also want to do a couple of true candids of groups of guests dancing. Don't shoot many of those; you'll probably only sell one, for the bride's album.

Use the posed candid technique for dance photos. True candids of dancers show mostly backs and elbows.

Shooting on the Run—The True Candids

The term, "true candid," applies to a photographic image that is captured as it happens, with no staging or posing. In practice, many of these will be re-staged, because it's the only way you can get them.

In a typical situation, the bride, or someone else, will do something interesting or funny, with no warning. It's over before it can be photographed. The alert photographer will fairly leap forward, and exclaim enthusiastically that the moment was beautiful. He'll then ask the subject to do it again, and he'll record it as it happens the second time.

The key to success is the enthusiasm. If the photographer is excited about it, the subject will have fun doing it again. It is the aura of excitement that will keep the re-staged version from being stale. The couple will remember that photo, look for it in the proofs, and probably buy it.

Photos of the procession and recession, and the ceremony itself, are true candid situations. They are predictable, but you can't direct them; you simply photograph them as they occur.

Use preset focus for images of the procession and recession.

Use flash on camera for the procession and recession photos. (This is usually permitted, but check with the church.) Use a slow shutter speed to keep backgrounds from recording too dark. A shutter speed of 1/8 or 1/15 second will usually do it. Don't try to focus on each person or couple. Instead, preset your focus at the distance which will yield the best image size, wait for each person or couple to walk to a point at that preset distance, and trip the shutter as they get there.

Record the ceremony itself only with time exposures by available light, no flash, and only from the rear of the sanctuary. If possible work from outside the seating area, or from the balcony. Don't allow yourself to become a part of the event. You shouldn't be seen or heard by the guests. Move discreetly and quietly.

Use the lens that fits the situation. If it's a large church, you may want a long lens to bring the altar as close as possible. If it's an impressive edifice, you may then want to take one with a short lens, to show the splendor. In a small chapel, you'll sometimes use the shortest lens you have for all the ceremony photos.

The subject matter for spontaneous true candids can be found anywhere, anytime. The photographer must be alert, watching the couple's family and close friends all the time for something interesting or amusing. Children are especially good prospects for true candids. Photos of children related to the couple will sell best. Older people are also good sources of true candids. They aren't so likely to do surprising things, but they usually get a lot of attention from family and guests. People often have animated conversations with them, resulting in great expressions and gestures.

True candid images will often be the spice that flavors wedding coverage.

You won't get a lot of spontaneous true candid opportunities, but there will be some. One such successful image per wedding is probably about average. You can improve your odds by always being watchful. Often the true candid images will be the spice that flavors your wedding coverage.

Say Cheese

There will be people in virtually all of the hundred or more images you create at a wedding. Every one will exhibit some kind of facial expression. Those expressions will be a key element in the success of your work.

Getting expressions should be even more easy and natural than posing. Asking people to say "cheese" isn't a very workable method and the word "smile" is sometimes like a threat to people. Many are very self- conscious about their smiles.

The thing that works best is to simply keep a fun atmosphere about everything you do at the wedding. The technical aspects of your photography should be second nature to you. You won't have to devote your energy to them. The bulk of your attention can be targeted toward the people you're photographing, and your relationship with them. It's just like selling. Phony interest won't work. Just be genuinely interested in people, notice them, pay attention to little things that show their emotions. When you're having fun, laugh. When you're touched by something, say so.

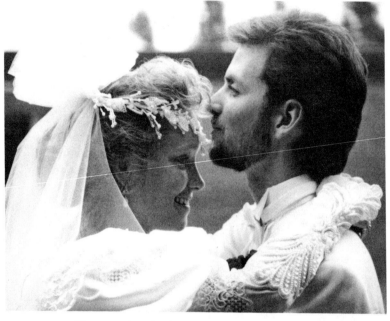

Be genuinely interested in your subjects and enjoy their emotions. You'll get great expressions.

You can do a lot for the rapport between you and your subject by using sincere compliments. It will be easy to find things to compliment, because everyone is trying hard to look the very best for this day, but be honest. If the bride you're photographing has a terrible complexion, don't say her skin is radiant. Instead, compliment her hair, her gown, her hands. It's fine to be a bit over enthusiastic. Have fun with it. Just don't compliment your subject on something that is obviously not praiseworthy.

Thoughts From J. C.: Piare Believes in Having Fun.

In the course of working on this book, Piare and I have had many conversations about our styles, techniques and philosophies. At one point I posed these questions to him:

One of your brides is talking to a friend after all the photography is done. Maybe the friend is planning a wedding and has asked about you as a photographer. The bride you've photographed says, "I really liked Piare because . . . ," and I asked him how the bride would finish that sentence.

Piare didn't hesitate, "She'll say because I was cooperative, easy to work with, and my product is beautiful."

I asked him what the bride is seeing when she says his product is beautiful. Is it expression, lighting, posing? His answer to that question is very revealing, "It may not be any of the above. It is how she thought of me as I handled her and the other people at the wedding. It's more how she felt than what I did. The most important thing is how the photographer relates with people, how the photographer gets accepted. That's the number one thing. Expression will follow."

He also said that sincere compliments help build a good relationship with the bride. His face lit with warmth and enthusiasm as he related how he might compliment a bride, "Wow, you could be on a bridal magazine, front page!" He went on to tell me that he can't say that to a bride who doesn't look so good. "It's okay to exaggerate, but fifty per cent must be real. A compliment like that gives the bride confidence; it makes her positive."

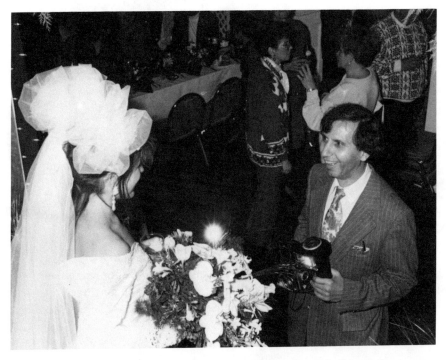

Enjoy your work. If you're smiling, you'll get great expressions from your subjects. They will like you and will like your photos even more.

You accomplish a lot just by smiling yourself. Many times your own pleasant smile can elicit exactly the expression you want from your subject, just at the moment you need it. It's vitally important to be yourself. If you're a natural cut-up, that will probably work for you. If yours is a quieter personality, use your warmth and your enjoyment of people to help you get expressions. Either will work.

You can also use other people. Get people joking with each other, and your job is half done. You'll see plenty of smiles, and the fun they're having will show in their eyes.

In group photographs that include small children you have two problems. One is getting the kids to do what you want. The other is that the adults tend to try to watch the kids—especially the kids' moms—instead of watching you. Tell all the adults to watch you, and maybe even to join in on what you ask the kids to do.

You can get great expressions from the kids by asking them to say something silly. They say it, then they giggle. That's when you shoot. Whether or not the adults joined in, the child's laughter will make them smile. Just after the flash fires, scan the group with your eyes to see if anyone was looking down or away. If you lost some, chastise them gently for misbehaving, (the kids love that) and repeat the photo.

For the bride and groom, and for their parents you will want a variety of expressions during the course of the day. For nearly everyone else, smiles are in order all the time. Everyone wants to see images of people enjoying themselves. The trick is not to get them to smile, but to get them to laugh. You're not looking for belly laughs and guffaws, however, but for little chuckles. You get the laugh, let it just start to fade, and trip the shutter. The result is a pleasing, in between kind of smile. If you shoot too early , while the laugh is in full bloom, you'll get partially closed eyes, too many teeth, and too many wrinkles.

Get your subjects to chuckle rather than smile, then the natural, relaxed smile comes naturally.

Direct the eyes with your hand. For natural expressions, keep speaking as you trip the shutter.

It's immaterial how you get the chuckle, as long as you don't offend people, or make them feel foolish. To get a hundred laughs in three hours, you'll need several one line or one word comments that work. You'll develop them over time. They must fit you. Here are some ideas: Okay, act like you're enjoying yourself.

Cheer up.

Happiness!

(To one serious person in a group:) Quit trying to steal the show, now.

(To one person of a couple:) Cuddle up, now; pretend you really like her.

Give him a little pinch there.

All those suggestions probably look a little corny on the printed page, but you're not going to show them the printed page. You're going to say these things with a chuckle. And it doesn't hurt to be a little hokey. People like it. It's humble. All you're really doing is giving them an excuse to chuckle for a second. They quickly get the idea that all you need is a little laugh. They like to laugh, and they're much more comfortable laughing than smiling.

Occasionally, you'll get someone with bad teeth, or a smile that just doesn't look good. You don't want to tell him not to smile, of course. Tell him to moisten his lips, then ask for just a hint of a smile. Take that one, but if you didn't like his smile, just ask him to stay in place for one more, ask him to look right at you, then take the photo with a neutral expression.

If you're talking as you release the shutter, your subject is probably watching you, and probably shows interest. That's perfect for the times when you want a pleasant expression, without a smile. Sometimes you can get a good effect by shooting as the subject is speaking. You get slightly parted lips, and good muscle tension in the face. If your timing is right, the photograph will have a pleasing warmth, almost as if the subject is talking to the viewer.

The eyes are at least as important as the mouth in expression. One way to keep the eyes alive in serious expressions is to have the subject watch your hand in the final seconds of the posing. That way, you can position their eyes exactly where you want them. You can also have their eyes slightly in motion as the shutter fires. It adds sparkle and interest to the expression.

When you want outright raucous laughter, set up a situation that will bring out the merriment, and just record it. This popular photo is usually done at the reception, possibly at the time of the

bouquet toss: seat the groom in a chair, and have the maid of honor sit on his lap. Get all the bridesmaids to cluster around him, as close as they can. They can't do that without some jokes and laughter. Your job is easy. You can do the same kind of thing with the bride, best man and groomsmen, only you probably don't put the best man on the bride's lap.

Laugh and have fun with your subjects. There are a couple of things to be wary of, however. Be very careful not to offend anyone with your humor. Off color language is out of the question. Don't use put-down humor or insults. If members of the family are getting laughs by putting each other down, do not join in. Don't be obnoxious or overly familiar. Don't invite yourself to join their family: if they wanted to adopt someone they'd probably select a small child, not you. Be warm and friendly, not intimate.

If you are a person they enjoy being around, you'll have no trouble getting good expressions.

Fun-filled situations produce genuine laughter. People enjoy posing for these photos and seeing them later.

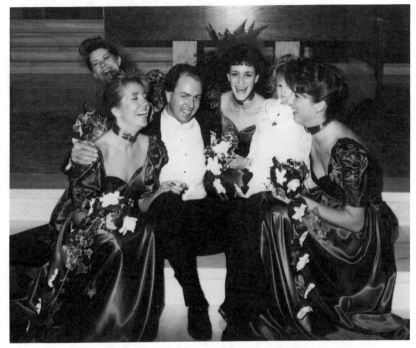

Put in Some Pizazz

There will always be some techniques or ideas that people especially like. Those things change from time to time. At one time, candlelight or"misty" photos, and double exposures were the items of fashion. We seem to now be in a traditional time, where glitzy fads aren't as popular. Whatever is hot today, will probably be pass tomorrow, but here are a few ideas that might have particular appeal.

Outdoor wedding photos aren't new, and they aren't unusual, but they are popular. People like the informality, the reference to nature, and the lush, dark green backgrounds. They're probably also responding to the soft, complex lighting, but they can't tell you about that.

If you're thinking of adding more outdoor work to your coverage, please remember the basics of good lighting, background usage and posing. Don't pollute your clients' wedding albums with a lot of harsh, direct sun photos, with squinty eyes and poor backgrounds. Poor outdoor portraiture is about as unappealing a thing as can be recorded on film.

If you're going to create more elegant, well lighted and staged outdoor wedding portraits, go for it. Your customers will love you, your authors will feel gratified, and we think you'll be able to smile all the way to the bank.

We find that people love silhouettes of the bride and groom. We've talked about how you create them, posed against the sky or a pastoral scene, through an open doorway. You can also do them against a large window, or possibly even a stained glass window. Once you've added this

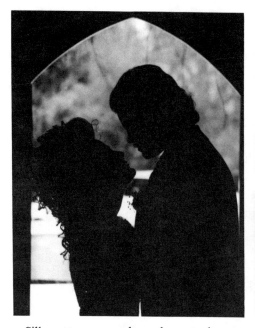

Silhouettes are popular and easy to do.

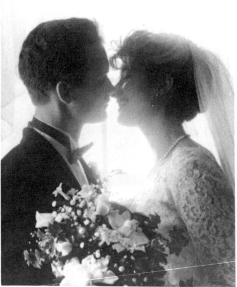

The loveliest kiss photos are made just before the lips touch.

feature to your repertoire, you'll begin seeing all kinds of likely locations. Don't overdo it, though. One or two of them per wedding will be plenty.

An especially popular pose for the silhouette image is that of the groom kissing the bride on the forehead. The secret is to get the exposure just before they touch, with his lips half an inch away. Otherwise, you'll lose the outline of her forehead. The same idea should work for a lip to lip kiss, with the same warning. Trip the shutter with their lips a fraction of an inch apart.

Try a dual profile. Have them both face away from you, towards the outdoors. She should be a little to his left (or right,) so you see their heads as distinctly separate. They can hold hands or he can rest one hand on her shoulder. Have them both look to the left and up just slightly, as if they're envisioning their future.

Experiment a bit. You'll come up with ideas as good as these. With those two or three new things you try on each wedding, you may invent the next craze. Talk with your customers when they pick up their proofs, and learn what they like. When you find a few people responding well to one particular idea, start trying it whenever you can. Watch your orders. If an idea sells well, add it to your bag of tricks.

Capture a Unique Mood for Each Wedding

Some things are easier said than done. This is almost easier done than said. Every wedding has its own unique mood and flavor. If you just record that without putting your own stamp on it, you will have succeeded.

The danger is in allowing your technique to become so pervasive that the wedding is being staged for your camera. If you over pose, over light, take too much time, and direct too much, you might create your wedding instead of capturing theirs. If you do, it will look a lot like the last wedding you did, and the one before that. Soon you will be bored with your own work, and so will everyone else.

If you don't get in the way, the unique people and unique place of each wedding will allow you to make a unique statement. The relationship you establish with each family will also be unique, and will make that one wedding different from all others, in your eyes and in theirs.

Wedding coverage is journalistic in nature. It's business is to report, convey, relate. At its best it records far more than the events of a three hour span. The best photography delivers the

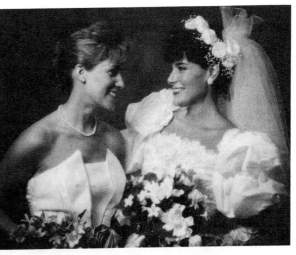

The way to make each wedding unique is
to watch for things that reveal personalities.

emotions of the time. It has heart. People who look at the album should feel almost as if they were there. They'll smile, maybe even laugh. If you give them that, you've created a wonderful gift.

In order to get that mood on film, you have to really be there. You can't be thinking about the next wedding, or the last one, or anything else. You must fit in, and become a part of what's happening at the event. There is no technique that makes your emotions a part of your photographs; it just happens. But first you must have the emotions. You must be in the flow of events.

We're not advocating that you put yourself in the limelight. You are not a key player. You're an involved observer. Experience the events, but don't create the experiences.

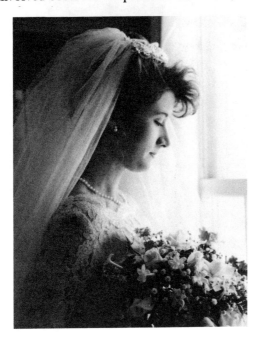

The portrait-like images you create are the way
you make your own personal statement in the
wedding coverage.

Some of the images of a wedding, including many photos of the bride and couple, are more portraits than candids. There is a difference in both the style and philosophy of creating portraits and candids. Portraits create beautiful images, and show people at their very best. Candids preserve moments, with realism and truth. With portraits, you make a statement, you bring your view to the scene. With candids, you leave your view and your expectations at home.

You can also keep your work fresh and interesting through variety. Try something new at each wedding. It can be a spontaneous idea, an idea you've created through thoughtful consideration of your own work, or something you've seen someone else do. It can be something from this book. Always be learning. It keeps you alive.

Keep your work fresh by trying something new at each wedding.

Chapter 13
Travel Light

A Wedding Photographer's Hardware

The tools of your trade are cameras, lights and gadgets. Many photographers spend inordinate amounts of time and money on equipment. They seem to think that the next new gadget is going to make all the difference. Your authors are not of that school.

Piare uses a pair of very old Rolleiflexes for wedding candid work. J. C. owns cameras that range in age from twenty to thirty years. For the last ten years that he managed studios, he photographed nearly everything with a single Mamiya RB67.

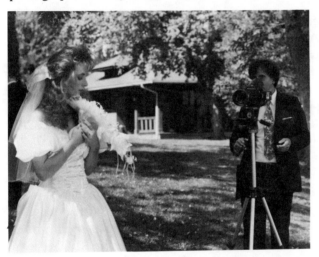

Simple equipment is ideal for weddings. You will create over a hundred images in three hours, so you must work quickly. Simple equipment speeds up the process.

You don't need the latest high tech cameras to do fine work. You can start with used equipment. You do need practical, reliable cameras and flash units.

You will carry one camera and flash unit for more than three hours at a typical wedding. Some days you may do three weddings. You'll come to appreciate a light weight camera and flash, and weight should be a primary consideration in choosing your equipment. The flash unit especially should be reasonably light.

Your camera needs a clear, bright viewfinder, because you'll spend a lot of time working fast in low light conditions. An easy to read focus distance scale is important, because you will often preset the focus distance, rather than focus for each image.

You must have a backup camera, flash and synch cords. You hope never to use them. If you're just beginning your wedding work, your backup camera could be 35mm, but we don't really recommend it; we suggest that you replace it with a medium format camera as soon as possible.

We don't recommend 35mm equipment for weddings at all. Films are much better than they were a few years ago, but no matter how good your film is, you'll get better images if you use a film larger than 35mm. Any of the 120/220 film formats are big enough to yield excellent results.

There is a lot to be said for showing square proofs, and therefore shooting square negatives. The square proofs eliminate most of the problems with horizontal vs. vertical formats on the album pages, and they are much more impressive to your clients than 3x5s or 4x5s.

Piare's Equipment List

If you were to peek into Piare's equipment cases, here's what you'd find: 2 Rolleiflexes (one is the backup camera)

1 Mamiya RB67, with a 12 exposure film back

65mm, 90mm and 180mm Mamiya lenses

2 Metz flash units

3 synch cords (1 on each flash, one backup)

Minolta Autometer light meter

3 Crosstar (starburst) filters

Pictrol (mounted on Mamiya 180mm lens)

Vignetters

Slave flash trigger

Three padded cases: one for the RB67, filters, and slave; one for the lenses for RB67; one for the backup camera and flash, plus film

1 Bogen tripod

2 light stands (kept in car)

1 black and 1 white umbrella (kept in car).

Here's how that equipment is used. All three cases go into the church for the ceremony. It's impractical to keep them locked up or to always carry them, so they're stowed in some out of sight place, usually under a pew at the back of the church.

One of the Rolleis is the backup camera; the other is used for all the candids and flash photography. That primary camera is typically used without any filters or gadgets. It's almost always set at f:11. It's used hand held, with no carrying strap. Piare presets the focus most of the time, and uses the sports finder, so he is viewing the subject directly.

The RB67 is used for all the portraits, candlelights, time exposures, and double exposures. Those are usually done without flash. The RB67 is always used on a substantial Bogen tripod. A Pictrol, and a bellows type lens shade, are permanently mounted on the 180mm lens.

Because the Pictrol diffuser was originally designed as an attachment for enlarger lenses, it is actually too small for the RB's massive lens. As a result, it vignettes the corners slightly on all the images. That vignetting is just right for most of the images for which the RB67 is used. Additional vignetting can be added to the lens shade. The Pictrol provides variable diffusion. A slight amount of diffusion is used for nearly all the RB67's work, even for portraits of men. Greater diffusion is used as needed.

One of the Metz flash units is mounted on the primary Rollei. The second is used as a backup or when two flashes are needed. The flash is almost always used on automatic, with the built-in exposure sensor, and set to provide illumination for an f/11 aperture setting. If two flashes are used, the second is tripped with a slave sensor. The second flash is usually employed as a kicker or background light, and is also used on automatic. No filters or accessories are used on the flash.

The starburst filters are used for candlelight photos, and for one or two of the time exposures of the ceremony. That's only a total of six or eight images per wedding. They are usually used without any additional diffusion.

Your Equipment Selection

We've given you this description of equipment and its usage only as background information. We don't necessarily recommend any of these particular items over other brands or types of equipment. Your personal working style will dictate the equipment you'll use for weddings.

You may, for example, want to use the same brand and model camera for all your work. In that case, you may find the RB67 to be pretty heavy, though some photographers do use it for everything. There are several 645 sized cameras on the market that are lightweight and easy to use. If you want to use a square negative, you'll have to make a different choice.

If you want to use multiple flash for your portrait style photos, you'll need to pay special attention to the light stands and umbrellas you select. Keep that equipment simple. You should be able to set it up in a minute or two, and carry it in one easy to handle bag or case. Simple umbrellas are probably a better choice than soft boxes. They produce soft light without hassle.

You can probably figure out how to make automatic flash work for you in multiple flash situations, but it is just as easy to use the manual mode. Determine your exposures by test, and always use the light sources at the same distance from the subject. If you don't trust yourself at judging distances, simply tie a string or cord to each light head. Cut the length of the cord to the flash/subject distance you want to use. When you set up your flash, stretch the string to measure the distance.

Keep Your Equipment Working

Even though you have backup equipment, you don't want to experience equipment failure. The best way to prevent problems is to take care of what you have. Keep your cameras and flash units in padded metal cases. Soft bags look good, and are easy to handle, but they don't offer the same protection.

When you cut the padding for your cases, keep an inch or two of foam between heavy pieces of equipment. If you place pieces too close together, they can bump against each other if the case is dropped or bumped hard.

Be careful with cords. People trip over them and tip light stands and tripods. If you set a camera on a table for a minute, set it near the center of the table, rather than close to the edge. It's less likely to end up on the floor.

Treat your equipment gently. Operate the controls with a delicate touch. Never use more force than necessary to move any control. You have to work quickly at a wedding, but not so quickly that you're dropping things, or banging your equipment into tripods and pews. Cameras and lenses are expensive, delicate mechanisms that must be in excellent working condition if they are to serve you. Treat them accordingly.

Keep your equipment clean. If it's in a closed case, it's pretty well protected from dust, but it's still a good idea to inspect it occasionally, and dust it with a soft brush. Pay special attention to the film transport areas. Be careful when dusting around focal plane shutters; it's easy to damage some of them.

The most important cleaning job is lens cleaning. Keep lens tissue and fluid in each of your camera cases. Use nothing else to clean lenses. Ever. Inspect your lenses before and after each wedding, and clean them any time you see dust or finger marks of any kind. Clean them carefully. Blow off excess dust before beginning the cleaning process. Don't drop lens fluid directly on the lens. Instead, put it on the tissue, then wipe the lens.

Before going to the church, check all your equipment. We talked earlier about how to do a flash synch test. You should also fire each shutter at each speed. You can get a pretty good idea that the speeds are functioning properly by looking and listening to their performance. Check each flash and each synch cord.

There is probably little to be gained by routine professional maintenance of cameras. The maxim, "If it ain't broke, don't fix it," probably applies here. Clumsy repair work can sometimes do more damage to your equipment than careless handling. Unfortunately, it's sometimes hard to find good, reliable repair service. The best predictor of possible camera failure is probably a good ear. You can often hear a malfunction before it actually interferes with camera operation. Listen to your cameras.

The opening advice in this section is also the closing advice. Be careful with your equipment. Some photographers are steady customers at repair shops. Others seldom see a repair bill. We think the difference is in equipment handling.

Props for the Wedding

Some photographers carry backgrounds, posing stools, benches, and other props to a wedding. Such a rolling studio is unnecessary, and probably counter productive. Time is a precious commodity. We believe you'll get more for your time by investing it in the relationship with your client than you'll get by carrying props around.

It might be a good idea to keep a couple of very small decorative wooden stools in the car. They can sometimes be handy in group shots, or to prop up someone's foot. We've known short photographers who carried a small stool just to get to the camera.

Call around and find an inexpensive source for red roses. You can probably get them for less than two dollars a dozen. They won't all be perfect, but you can use most of them by tearing off any bruised petals. Keep them on hand, and take one or two to each wedding. Substitute a rose for the bride's bouquet in a couple of photos.

For the most part, though, you can make good use of the props that are available at the church and reception site. Keep an eye open for attractive chairs and benches. You can use a piano in some photos. You'll certainly use the candelabra that are available.

Keep your hardware simple. If you don't really need it, don't use it. If it's cumbersome, replace it. If it takes time, find an alternative. Simple equipment frees your creativity.

Chapter 14
The Bridal Formal and The Love Portrait

Two Romantic Extras

In earlier chapters we discussed some of the reasons for creating one of these romantic expressions, well in advance of the wedding day. They generate additional sales. They offer an opportunity to become better acquainted with the bride and groom before the wedding day and to build trust with them. The occasion of shooting these portraits is a chance to build your wedding sales.

A large print from the sitting can be displayed at the ceremony or reception. The formal sitting and love portrait create beautiful sample photographs that will help you book additional weddings. The formal sitting is a special challenge, and it sharpens your photographic skills.

We've mentioned it before, but it bears repeating, that either of these sittings should be an enjoyable experience for the bride or for the couple. The formal sitting is a time for the bride to enjoy modeling her gown, and to reflect on and anticipate the ceremony. The love portrait is an opportunity for the couple to create romantic memories, and reflect on the love they share and their future together.

As the photographer, you can enhance the experience by building mood. There are a number of ways to do that. Allow the couple to walk together for a few minutes before joining them to do the photography. Add music, or maybe even a bottle of wine to the environment.

For the bridal formal, treat the bride with elegance, almost reverence. Have a fresh red rose for the bride, as a prop or simply as a gift. Develop your own ideas. If you're not particularly romantic, ask for help from someone on your staff who is.

The Formal Sitting

The bride's formal portrait sitting should probably consist of fifteen to twenty proofs, made from six to ten poses of the bride. At the minimum, you'll want to create two different poses each, in full length, three-quarter and close-up compositions. The full length poses should display the gown in all its splendor. Most gowns are as striking from the back as from the front, and it's a good idea to show that in at least one pose. You should capture a variety of moods and expressions, from pensive to joyous.

The formal sitting can be done in the studio, but it can also be beautifully executed outdoors, in a formal garden with regal architecture or in a sylvan setting. Imagine the bride posed against a background of white grecian columns, or on a wooden bridge over a peaceful brook. Picture how she might look surrounded by an explosion of spring floral color, or dreaming at an altar of deep green foliage.

Exquisite indoor locations are also possibilities. Consider elegant residences, restaurants (before their opening times), or hotel lobbies. Such settings are available to you.

Investigate old mansions in your area. Many of them are now owned by non-profit foundations, and you can arrange to use them for photography. Also consider public buildings that may have interesting architecture and handsome grounds. Restaurants and hotel lobbies are often available just for the asking.

Props can add to the glamour of the bridal sitting. You'll need flowers, because the bride's bouquet won't be ready for weeks. You can probably make a trade with a florist for a few artificial bouquets.

In the studio, an ivory colored posing bench, or antique love seat can be used. A small table with a conservative floral arrangement can be set in the background. We've posed brides with graceful benches, seated on formal garden walls, or standing at winding staircases.

Formal posing should be relaxed, simple and elegant. This book's chapter on posing gives you the basics. You'll work in the studio or outdoors just as you do at the altar, only you'll have more time. The fundamentals are the same—direction and weight distribution.

In the studio, you may have the bride seated for her close-ups, rather than standing. Use either a posing stool, or the love seat or bench you use for three-quarter length poses.

A graceful posing bench is the ideal prop for formal bridal portraits.

Look at bridal magazines for ideas about posing, props and locations. You're not doing fashion photography, but you can employ ideas from that discipline.

Use and show the gown. Display its train and veil. Ask the bride what she especially liked about the gown, and why she chose it, then do a pose that emphasizes that feature.

When creating the full length presentations, do one that will be suitable for a very large print. When we say very large, we mean 30x40 or larger. If you show prints that size, you'll enhance your sales of 20x24 and 24x30 prints. One of the secrets to making successful large prints is to have a lot of room around the subject. Crop loose, so the figure of the bride will be no more than eighteen to twenty-four inches high on the 30x40 print.

Thoughts From J. C.: Two poses I love.

Here's the how-to on a couple of poses I really like. The first is a full length. Position the bride with her back toward you, but turned thirty or forty-five degrees toward the camera. She'll be standing so that you see her back, but one shoulder will be closer to you than the other. The train will be displayed behind her, so the camera sees it all. Remember the basics of direction and weight from our posing chapter.

Now have her turn her head to the profile position. Judging from the camera position, you should turn her head toward you until you just see the far eyelash past the bridge of her nose. Place the key light almost behind her face, so that it lights her near cheek, but leaves the near side of her head in shadow. (Be sure no light spills into the camera lens.) Use normal to slightly weak fill lighting. Position one or more kickers to add highlights to the back of the veil and to that entire side of the dress.

Have the bride hold the bouquet in the hand nearest the camera, and let it rest against her thigh. Take one pose with her eyes looking straight ahead, shifting her eyes toward

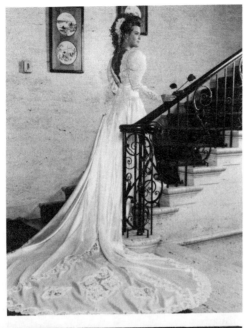

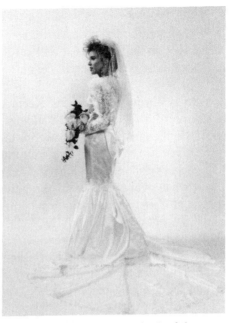

This pose highlights the back of the gown with elegance. Do it in the studio or on location.

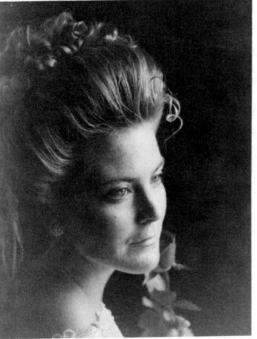

A high camera angle allows for a pensive look, but keeps light in the eyes.

the camera just slightly, with a near smile on her lips. Then have her look down at the flowers, let her expression go slightly serious, and capture that pose: it's the seller.

The second idea is for a close-up, and I adapted it from Rembrandt. The bride should be seated, turned away from the camera, just slightly past the profile position; you'll be shooting almost directly into her shoulder. Turn her head toward the camera until you see all of the far eye, until her nose no longer breaks the outline of her far cheek. Light from the far side, just as for the last pose, with light spilling onto the near cheek, but with the near side of her head in shadow. Use normal fill and hair lighting.

The secret to this pose is camera position. Place the camera very high, maybe seven feet above the floor, and point it down at the subject. The subject looks straight ahead, with an almost serious expression. The effect is pensive, as if she's looking down, but her eyes are alive and full of light.

With either of these poses, give the bride something specific to look at, even if it's only a spot on the wall. That will keep her from getting glassy-eyed. Changing that spot just before you shoot will help even more.

Get variety in your formal poses. Record two exposures of each pose, but vary the expression in each. Use profiles. Use over the shoulder shots. Change props. The more variety you introduce into the proofs, the greater your chance for multiple sales.

Be very careful of details. A hem turned up on the train, or part of the veil out of place lessens the elegance of the portrait. And elegance is what you're selling here. The story of elegance is best told when every element of the portrait serves that single purpose. Strive for perfect lighting, graceful posing, appropriate support with props. You'll need to work quickly, so as not to tire the bride, but do work carefully.

Studio lighting for this work should be soft. Both the key light and fill light sources should be large. Background lighting and hair lighting are almost essential. If you have the equipment and a large enough camera room, three hair lights are not too many. For close-ups, position one of these kickers on each side of the bride, and one overhead on a boom stand. For full lengths, two of the hair lights can be used as kickers, on the side opposite the key light. They should rim the full length of the gown. The other will be overhead.

Outdoors, simply follow the guidelines from our lighting chapter. Remember that the lighting must work for the full gown and train, not just for the face.

If you use interior sites such as mansions, you'll need to carry lighting to the location. Take lots of extension cords, both power cords and flash cords. You never seem to have enough. Umbrellas are good key and fill light sources on location. A hair light and background light are desirable. Be careful to keep all the cords and light stands out of your frame. You may want to get to the location to set up lights before the bride arrives.

The final touches for the bridal formal portrait are vignettes and soft focus. This is a romantic portrait, and these devices can add a lot of romance. Don't use them on every shot, but use them for variety and impact.

The formal portrait can be impressive whether done as a high key or low key rendering. For high key, all the props in the portrait should be white or ivory. The gown, of course, fits that scheme. A single red rose can create a vivid accent. A little soft focus, accompanying very soft lighting is appropriate. The light ratio should be slightly less contrasty than the ratio for your typical work. The background must be brightly lit and vignetting should be done with translucent vignettes.

Low key portraits use dark backgrounds, props and vignettes. They set the bride in dramatic contrast to her surroundings. Soft focus is still appropriate.

It seems that there are far fewer bridal formal sittings being done in recent years than in the past. The sitting requires quite a bit of time which might produce more sales volume if dedicated to senior or family sittings. Props and flowers can be expensive, and require storage space in the studio. It is sometimes challenging to schedule the formal sitting because the gown is often not ready until shortly before the wedding. There may also have been less customer interest in formal portraits because of the more casual culture of the seventies and eighties.

There are still good reasons to promote formal portraits. They are striking. If displayed in customers' homes, they will surely cause conversation that leads to referrals for future business. Samples from these sittings can be among your most impressive and valuable tools in booking weddings at bridal fairs and shows.

They can also be profitable in themselves. The best way to maximize profits is to sell large prints. If you show them you can sell them. You will be helping your clients create family heirlooms.

The Love Portrait

If the bridal formal portrait doesn't seem practical, or if your patrons simply don't want it, the love portrait is a very viable option. It's casual and informal, and brings the couple together for a romantic moment a few weeks before the ceremony.

The natural setting for this portrait is outdoors. The mood is very informal and very romantic. Where details are of great importance with the formal sitting, they are much less important here. The vital element in the love sitting is expression.

Posing should be extremely relaxed. It may be advisable to think of situations rather than poses. The photographer sets up situations, encourages the couple to relate to one another, then just records what happens. Get them to talk to each other, touch each other, kiss. The images won't be sexual, but they will be flirty. You're making romance, not pornography.

Thoughts From Piare: I'm Not There, Only My Camera

When I'm photographing the couple, I tell them, "I'm not here, only my camera is here. So, don't worry, only my camera is watching you. Act like I'm not here." I get them to relax, and flirt a little. The lady will probably be the one to start that.

I don't act too friendly with the bride. I try to analyze what kind of situation they have between them. If this is a very strong man, it doesn't matter too much what I say. If he's a kind of meek person, I have to become a little meeker. That way I don't overpower the situation.

Don't abandon sound lighting technique just because you're outdoors and working more informally. There'll be lots of profiles in this situation, and some backlighting will provide beautiful highlights and separation on the two faces.

Introduce variety by moving from close-ups to long shots, and by using vignettes and soft focus.

Have fun with these sittings, and use your best photographic technique to maximize the effectiveness of the images.

Chapter 15
Questions About Where You're Going

And How You Plan To Get There

If you've chosen to be a professional photographer, you've chosen more than just to make your living with a camera. You've chosen to provide valuable services to your clients, to uphold the standards of the profession, and to maintain your own personal ethics. Making a decision to do any of these things doesn't assure that they'll happen. If you want them, it makes sense to set some specific goals in these and other areas, so you can plan specific action to get what you want. We can't really help you set goals, but we can offer some questions. You determine the answers.

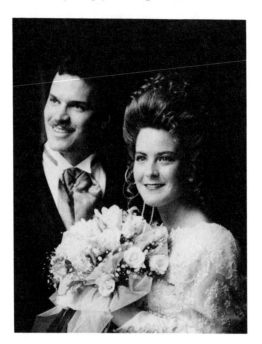

How good a photographer do you want to be? What must you do to work toward your goals?

Questions For Your Photographic Objectives:

What kind of photographer do you want to be?
How good do you want to be?
What do you still need to learn?
Are your photographic skills good enough to allow you to express what you want to express?
Does your photography have heart?
What are you doing today to improve your skills?
What one thing could you do in the next thirty days to improve your work?
What future plans do you have to improve your skills?
What photographers in your area do you admire?
What other working photographers do you admire?
What commercial or illustrative photographers do you admire?
What photojournalists do you admire?
What photographers from the past do you admire?
What painters throughout history do you admire?

What sculptors do you admire? Answer these questions thoughtfully. You might be surprised at what you learn from them. If you don't have answers to some of the questions about other photographers or artists, go study people who have worked in those disciplines, until you find some whose work appeals to you.

After you've answered all the questions, go back to the first ones, and write some specific goals about your photography. Then write about some steps you can take to realize those goals.

Questions For Your Philosophical Objectives

What is the purpose of photography?

What special purposes are served by portrait and wedding photography?

List the reasons you are in business.

Why did you become a photographer? Was it by choice?

What part of your work is the most fun?

What part is the most rewarding? There are fewer questions on this list. Perhaps that calls on you to answer them even more thoroughly and thoughtfully. There's no guarantee that these questions will suggest any goals to you, but they might.

Questions For Your Ethical Objectives:

What would you do in these situations?

You discover you've overcharged a customer, after you've been paid and the order has been delivered.

You overhear someone saying something awful about one of your competitors, and you know it's not true.

One of your employees tells you he's learned exactly what price changes one of your competitors will make in sixty days.

One of your competitors' employees asks you for a job. You don't need her in your business, but you can afford to hire her for a few months. She knows a lot about the competitor's business.

You learn that you can save fifty per cent on your printing costs by changing labs, but the cheaper lab uses an inferior paper for its prints. You've read test reports proving that the paper they use begins to fade badly after five years.

You learn that you can save fifty per cent on your printing costs by changing labs, but you've also learned that the cheaper lab illegally disposes of some of its chemical waste. Just as with the philosophical questions, these ethical questions may not alert you to any goals you'd like to set for yourself, or your business. Then again, they might. Ask yourself if they have any impact on your positioning philosophy.

Questions For Your Financial Objectives

Does your current income allow you to meet your financial obligations?

At your current income, how many years would it take you to pay all your current debts except mortgages?

Does your current income allow you to save for your retirement?

Do you have a sound plan for your retirement?

What do you expect your net worth to be at age sixty-five?

Do you have adequate health insurance?

Do you have children?

Does your current income allow you to save for your children's education?

Is your business financially sound?

Is your business adequately insured? What would happen to your business if:

Your place of business burned down?

All your equipment was stolen?

Each of your cameras wore out, and had to be replaced this year.

What percentage of your sales will you spend for new equipment, and studio improvements this year?

If you had an opportunity, this year, to buy out a competitor at a very favorable price, would you be able to do it?

Do you have any employees?

Do you have a retirement plan for employees?

Do you have a health insurance plan for employees?

What percentage of your sales will you spend for promotion this year? These questions should get to the heart of some of your financial objectives. Some of them may be uncomfortable to answer. If your financial situation is not as good as you need it to be, you may want to do some serious goal setting work on money. If you're less than thirty years old, it should be relatively easy to develop a financial plan that will work for your present needs and for your future. If you're over forty, and don't have a healthy start on building your retirement assets, you have a difficult challenge. If you are under thirty, do something now, so you don't have to meet that difficult challenge in later years.

Your Business Goals—How Many Weddings Should You Do?

If you've answered all the questions we've posed, and done some goal setting, you probably have a good idea how much money you need to earn. From there, it's a relatively simple matter to estimate how many weddings you need to do in a year to meet your goals. Study the discussion of pricing in Chapter Eight to learn how.

Goal setting is valuable. It can help you see how to accomplish the things you want to achieve in your life. It can protect you from making unnecessary errors. It helps you stay focused.

Goal setting by itself though, is of little use. It only helps when you put your goals into action. When you see a clear course of action that will improve your business, do it. When you see a way to accomplish your ambitions, do it. When you see a way to make your life more rewarding and enjoyable, do it.

Careful goal setting will assure that you're on the right course. Diligent action will assure that you get to your destination.

Glossary

Bridal Faire: a trade show, where suppliers of wedding services present their businesses to brides-to-be.

Bridal formal: a formal portrait of the bride, typically made outdoors or in the studio, days or weeks before the wedding.

Bridal salon: a retail store, featuring wedding gowns and other formal wear and accessories for weddings.

Bridal show: see Bridal Faire.

Candlelights: photographs taken so that they appear to have been made by candlelight.

Ceremony: the actual wedding ritual, where guests watch the bride and groom exchange vows before clergy.

Checklist: a list of possible wedding photographs, from which a bride selects those most interesting to her.

Formal: see bridal formal.

Long lens: a lens of a relatively long focal length for the film format in use; often called a telephoto lens.

Make ready: the time before the wedding ceremony, when the bride, groom and attendants are dressing and preparing for the ceremony.

Mistys: see candlelights.

Posed candid: staged photographs, made to appear as if they were taken in a candid situation.

Previews: proofs; a term sometimes used to describe proofs in a sales situation.

Procession: the event just before a wedding ceremony, when the bride, groom, attendants, and family members walk into the sanctuary, usually accompanied by music.

Professionalism: action maintaining, or worthy of, the high standards of a profession.

Proofs: the first prints from a photographic session; they are usually shown to the client for the purpose of selecting images for a final order; they are may be of the same quality as finished prints.

Reception: a festive event, after a wedding ceremony, where guests receive the bride and groom, and celebrate their marriage, usually with eating, drinking and dancing.

Recession: the event immediately after a wedding ceremony, when the bride, groom, attendants, and family members walk out of the sanctuary, usually accompanied by music.

Release: a publication release; a document signed by subjects of a photograph, giving a photographer permission to publish and display copies of the photograph.

Salon: see bridal salon.

Short lens: a lens of a relatively short focal length for the film format in use; often called a wide angle lens.

Staged candid: see posed candid.

True candid: a photograph that is not posed or staged, taken in a spontaneous situation.

Wedding coordinator: a person who assists in the staging of a wedding; may be employed by the church, or may be from an independent business.

Wedding party: typically the maid of honor, best man, and other attendants to the bride and groom.

Appendix

This appendix contains samples of printed and promotional material that Piare Mohan uses in his studio.

Please note that the authors make no claims for the legal correctness of any of these documents. Readers of this book are welcome to adapt any of these materials for their own use. They are advised to consult an attorney before using them, to make sure the materials are appropriate to their needs.

AGREEMENT

I hereby commission and authorize **PORTRAITS BY P. MOHAN** to create the photographs requested at my wedding with the understanding that:

 a. Any selections on the check list are subject to the studio's ability to photograph with respect to the conditions prevailing at the wedding.

 b. The studio's liability for any matters, including equipment failure, shall be limited to the retail value of the order indicated on the photographer's check list.

 c. PORTRAITS BY P. MOHAN is given permission to use these negatives to prepare prints for exhibition and advertising purposes.

 d. I have received the price list and I fully understand the prices and policies defined therein.

Bride's signature _____

Studio representative _____

Date _____

This form is used to limit studio liability & to obtain permission to reproduce.

Proofs are signed for using this form.

Previews for _____

 Tel. No. _____

 File No. _____

It has been a pleasure to photograph you. We hope your family will be delighted with these previews. We require that you return your previews within 7 days, or you will assume a charge of $ ___ each. You may purchase any or all of your previews when you place your order.

Signature _____

 Date taken from studio _____

 Date to be returned, on or before _____

Portraits by *P. Mohan*

1830 S. Wadsworth
Lakewood, CO 80226
988-2534

Piare Mohan

PREMIER PHOTOGRAPHY

160

1830 SO. WADSWORTH • LAKEWOOD, CO 80232
(303) 988-2534

- *Chosen Photographer of the Year - Colorado*
- *Chosen Photographer of the Year by Ms Photogenic USA Inc.*
- *Winner of 13 consecutive First Places - Colorado*

on wedding photography. . .

You've made some important decisions. . .they will have lasting effects on your lives. These decisions will culminate in a very special day, a day filled with anticipation and intimacy, excitement and delight. How beautifully this day is recorded photographically depends on another decision: your choice of a wedding photographer.

PIARE MOHAN PHOTOGRAPHY would like you to know why we consider ourselves your best choice! Each of our photographers is a professional: highly trained and accomplished. He has mastered a variety of special effects which he will use in photographing the romantic elegance of your wedding. Combining these techniques with sensitivity and artistic perception, he will cover the views you have personally selected on your checklist, as well as those which he considers especially nice. He will be as inconspicuous as possible, because we believe your wedding day belongs to you!

For a very special record of your wedding, we have created a selection of six elegant wedding collections.

THE BRIDAL HEIRLOOM	Sixty luxurious 8 × 10 color photographs, preserving all the special moments of your wedding, sprayed with a protective lacquer finish in a rich Art Leather aristohyde album. (Up to 200 previews to choose from)	$1340
THE HERITAGE	A generous collection of forty-four 8 × 10 color photographs recording your favorite wedding memories, sprayed with a protective lacquer finish, in a rich Art Leather aristohyde album. (Approximately 150 previews to choose from)	$985
THE WEDDING TREASURY	The complete story of your special day told with sixty 5 × 5 photographs, highlighted with fourteen of your favorite candids in 8 × 10, combined in a lovely Art Leather aristohyde album. (Approximately 150 previews to choose from)	$930
THE WEDDING STORY	A smaller version of the Wedding Treasury, with forty 5 × 5's and twelve 8 × 10's combined in an Art Leather aristohyde album. (Approximately 100 previews to choose from)	$795
THE WEDDING SPECIAL	Sixty 5 × 5's in Art Leather aristohyde Galaxie album. (Approximately 100 previews to choose from)	$690
THE ECONOMY PACKAGE	Thirty-eight 5 × 5's in a small album (Art Leather aristohyde album available for only $25 extra) (Approximately 70 previews to choose from)	$495

PARENTS ALBUMS may be purchased with any of the above collections at these special prices:

Twenty 5 × 5 candids in parents album $180

This price list was current for 1993.

Through the years we have observed that most weddings can be photographed in approximately three hours. With any package, there is no charge for the photographer's service during this time. Beyond three hours, there will be a charge of $45.00 per ½ hour. We will add ten more previews to view from for each extra ½ hour. A $50.00 charge will be added if the reception does not follow the ceremony, and fifty cents a mile is charged for traveling outside the greater Denver area.

Our minimum wedding candid order is $500.00. $300.00 is requested at the time our photographer is reserved for you. Balance of package and time charge is due when you pick up previews.

ALL the prints and albums from your wedding will be considered one order and will be invoiced to only one person. Our cancellation fee is $200.00.

before the wedding...

LOVE PORTRAITS...love portrait sitting:$20.00

Black & white glossy for newspapereach $15.00

BRIDAL FORMAL...complete sitting.$50.00

For Finished Portraits, please refer to our regular price list.

additional color candids...

No. Ordered	1-30	31-50	51-80	81-100	over 100
Each 5 x 5	$ 9.00	$ 8.75	$ 8.50	$ 8.25	$ 8.00
Each 5 x 7	$15.00	$14.50	$14.00	$13.50	$13.00
Each 8 x 10	$19.00	$18.50	$18.00	$17.50	$17.00

additional services...

The PACKAGE needs to be paid in full at the time the PREVIEWS ARE DELIVERED.

In addition, any time charge for weddings over 3 hrs. is payable at this time also.

Add 10% for orders placed 60 days after the wedding date.

Our photographers use large format professsional film, so any candid you especially like can be enlarged, retouched, and finished for framing.

SIZE: 11 x 14 $90
 16 x 20 $195
 20 x 24 $275

Please note: these are special prices, and are available only at the time your wedding candid order is placed.

To serve you better please call for appointment to preview orders or pick up finished photos.

1992

Our commitment to you is to provide you with the finest Wedding Candid photographs available. Please fill in the information on both sides of this form to assist us in all the details of your "Day of Days."

Date _____ Time _____

Photographer _____

PRE—WEDDING PHOTOGRAPHER

162

Photographer to Arrive at _____

Place _____

Time _____

Phone Number _____

CHURCH

Name _____

Address _____

Phone Number _____

Clergyman _____

BEFORE CEREMONY (AT CHURCH OR HOME)

- [] 1. Invitation and bouquet
- [] 2. Mother helping Bride with veil
- [] 3. Bride with maid of honor
- [] 4. Mirror reflection of Bride
- [] 5. Ring bearer with Bride
- [] 6. Flower girl with Bride
- [] 7. Bridesmaids gathered around Bride
- [] 8. Father putting garter on Bride
- [] 9. Father putting penny in Bride's shoe
- [] 10. Ring bearer & flower girl with Bride
- [] 11. Bride pinning boutonniere on dad
- [] 12. Bride pinning corsage on mother
- [] 13. Bride with both mothers
- [] 14. Bride with flowers
- [] 15. Bridesmaids with their flowers
- [] 16. Bride with her parents
- [] 17. Closeup of bride with parents softly behind
- [] 18. Bride looking at Groom's rings
- [] 19. Double exposure of Bride
- [] 20. Natural light soft portrait of Bride

Others _____

AT CHURCH BEFORE CEREMONY

- [] 21. Church exterior
- [] 22. Interior of church before ceremony
- [] 23. Ushers at front door
- [] 24. Groom and best man
- [] 25. Groomsmen gathered around Groom
- [] 26. Best man pinning boutonniere on Groom
- [] 27. Informal closeup of Groom
- [] 28. Groom shaking hands with father
- [] 29. Ring bearer with Groom
- [] 30. Groom with his parents
- [] 31. Minister counseling Groom with best man looking on
- [] 32. Groom with both fathers
- [] 33. Groom looking at Bride's ring
- [] 34. Guest book attendant
- [] 35. Guests signing guest book
- [] 36. Lighting of the candles
- [] 37. Grandparents being escorted down aisle
- [] 38. Groom's mother being escorted down aisle
- [] 39. Bride's mother being escorted down aisle

BRIDE

Name _____

Address _____

City, State, Zip _____

Phone Number _____

Mother _____

Address _____ Phone No. _____

GROOM

Name _____

Address _____

City, State, Zip _____

Phone Number _____

Future Address _____

Phone Number at Work _____

RECEPTION

Name _____

Address _____

City, State, Zip _____

Time _____

Package Requested _____

Extra Time Reserved _____

AT CHURCH BEFORE CEREMONY (Continued)

- [] 40. Bride, father and attendants in church foyer
- [] 41. Attendants in processional march
 Number of attendants _____
- [] 42. Ring bearer and flower girl in aisle
- [] 43. Bride and father coming down aisle
- [] 44. Father kissing bride before giving her to Groom
- [] 45. Father giving away Bride

Others _____

DURING CEREMONY AS CHURCH REGULATIONS AND TIME PERMIT

- [] 46. Time exp. of ceremony from balcony
- [] 47. Time exp. of ceremony from center aisle
- [] 48. Couple kneeling during ceremony
- [] 49. Double exp. of ceremony with exterior of church
- [] 50. Double exp. of couple overlooking ceremony
- [] 51. Ceremony highlights (Flash allowed? Yes ☐ No ☐)
 Special highlights _____

- [] 52. The kiss at the end of the ceremony
- [] 53. Recessional of the newlyweds
- [] 54. Bride and Groom's parents coming up aisle
- [] 55. Candid of soloist
- [] 56. Candid of organist

Others _____

AFTER CEREMONY AT CHURCH

- [] 65. Parents, relatives and friends congratulating couple
- [] 65. Mininster congratulating couple
- [] 65. Bride and Groom signing marriage license
- [] 65. Throwing of the rice at Bride and Groom
- [] 65. Bride and Groom in front of church

Others _____

FORMAL GROUP PHOTOGRAPHS (20 MINUTES - 1HOUR)

- ☐ 63. Bride & Groom with grandparents on both sides
- ☐ 64. Bride & Groom with his grandparents
- ☐ 65. Bride & Groom with her grandparents
- ☐ 66. Bride & Groom with parents on both sides
- ☐ 67. Bride & Groom with Bride's parents
- ☐ 68. Bride & Groom with Groom's parents
- ☐ 69. Bride with her parents
- ☐ 70. Groom with his parents
- ☐ 71. Couple with complete wedding party & ushers
- ☐ 72. Couple with complete wedding party
- ☐ 73. Couple with best man & maid of honor
- ☐ 74. Bride with attendants
- ☐ 75. Groom with groomsmen
- ☐ 76. Flower girl & ring bearer
- ☐ 77. Couple with flower girl & ring bearer
- ☐ 78. Couple with Bride's entire family
- ☐ 79. Couple with Groom's entire family
- ☐ 80. Special group shots _____

- ☐ 81. Bride & Groom with minister
- ☐ 82. Bride & Groom full length
- ☐ 83. Bride & Groom closeup
- ☐ 84. Bride & Groom looking at rings
- ☐ 85. Bride full length showing gown
- ☐ 86. Bride 3/4 pose
- ☐ 87. Bride closeup
- ☐ 88. Bride with flowers & new ring
- ☐ 89. Bride & Groom with candles, natural light-misty
- ☐ 90. Bride with candles, natural light-misty
- ☐ 91. Bride and candles with Groom softly behind
- ☐ 92. Sillouette of couple against stained glass
- ☐ 93. Sillouette of couple kissing under church archway
- ☐ 94. Closeup of rings with bouquet or bible
- ☐ Other special shots _____

RECEPTION

- ☐ 95. Receiving line candids
- ☐ 96. Bride & Groom greeting guests
- ☐ 97. Parents greeting special friends
- ☐ 98. Photograph of the table settings and cake
- ☐ 99. Closeup of cake only
- ☐ 100. Bride & Groom posed by cake
- ☐ 101. Bride & Groom cutting cake
- ☐ 102. Bride giving Groom first bite
- ☐ 103. Groom giving Bride second bite
- ☐ 104. Bride & Groom feeding each other
- ☐ 105. Best man proposing toast
- ☐ 106. Bride & Groom toasting
- ☐ 107. Photograph of orchestra
- ☐ 108. Bride & Groom having first dance
- ☐ 109. Bride dancing with her father
- ☐ 110. Parents join in the dancing
- ☐ 111. Bridal party join in the dancing
- ☐ 112. Candid photographs of special friends _____

- ☐ 113. Groomsmen gathered around bride
- ☐ 114. Bridesmaids gathered around groom
- ☐ 115. Photograph of head table
- ☐ 116. Candids of guests at tables and while dancing
- ☐ 117. Hostesses serving food and beverage
- ☐ 118. Candids of grandparents with newlyweds
- ☐ 119. Bride's girlfriends admiring ring
- ☐ 120. Candid of bride with dad
- ☐ 121. Candid of Groom with both mothers
- ☐ 122. Candid of Bride with both fathers
- ☐ 123. Candids of Bride and Groom enjoying reception
- ☐ 124. Bride & Groom at the gift table
- ☐ 125. Candid of Bride & Groom opening gifts
- ☐ 126. Bride throwing bouquet to single girls
- ☐ 127. Closeup of girl that catches bouquet
- ☐ 128. Groom removing garter
- ☐ 129. Groom throwing garter to male friends
- ☐ 130. Closeup of man that catches garter
- ☐ 131. Bride & Groom in going away clothes
- ☐ 132. Get away car being decorated
- ☐ 133. The decorated car, finished
- ☐ 134. Newlyweds saying goodbye to family & friends
- ☐ 135. The throwing of rice
- ☐ 136. Groom helping bride into car
- ☐ 137. Newlyweds in car
- ☐ 138. Bride & Groom looking back through window
 Others _____

ADDITIONAL NOTES

REFERRED BY

- ☐ Florist
- ☐ Bakery
- ☐ Caterer
- ☐ Bridal Shop
- ☐ Formal Wear
- ☐ Other

163

The bride uses this checklist to select the photographs she wants from her wedding coverage.

Wedding Candid Order Form

Print Number	Bride's Album	Bride's extra pts	Bride's Parents	Bride's Relatives	Groom's Parents	Groom's Relatives	Extras

164